More Praise for *Unplugged*

"*Unplugged* is the story of a young woman in
tion. Written with great insight and compassion,
able read that flows like a river. Enjoy the ride."

—Leigh Curran, author of *Going Nowhere Sideways*

"A wonderful reading experience. McComas creates a character of
strength and determination, using humor, empathy, and knowledge as
building blocks for her successful journey through darkness to the light.
He displays a deep understanding of the psyche and its relationship to
behavior, to the land, and to art. The lyrical text, the foundation of love
as a generating force for spiritual discovery, and the gentle narrative
voice foster meaningful images in this story of personal revelation."

—Don Seiden, Professor Emeritus of Art Therapy
and Art Education, School of the Art Institute of Chicago,
and author of *Mind Over Matter*

"*Unplugged* is a story I can't seem to get enough of—an exciting, messy,
whole human woman's story that leads us on an exciting, messy, whole
woman's journey toward her true self. I fell in love with Dayna; it was
easy to get inside her heart and her life and follow her anywhere she
went, discovering with her how the earth mirrors and reveals us when
we shed our skin and let love in. Brave, vulnerable, sexy, sensual and
believable, *Unplugged* inspired me to keep writing and living my own
story. And there is no greater gift than that."

—cin salach, poet, author of *Looking for a Soft Place to Land*

"*Unplugged* is an uplifting story in which a burned-out, suicidal young woman finds healing through nature, modern pharmacology and, not least, love. Author Paul McComas puts you inside the head of the clinically depressed and sheds needed light on a little-understood phenomenon. With his words he paints stark, lovely vistas of the Dakota badlands that make the medicine glide down."

—Tim W. Brown, author of *Deconstruction Acres*
and *Left of the Loop*

"With consummate skill, Paul McComas weaves together the interior wilds of protagonist Dayna Clay with the exterior wilds of the South Dakota Badlands. The reader cheers for Dayna on her spiritual and sexual quest, eager to see what she will discover as she leaves the ups and downs of the music industry for the zigzag terrain of the Badlands and her own psyche. McComas writes of women, depression, and bisexuality as if he has 'been there.'"

—Chris Glaser, editor, *Open Hands*
and author of *Coming Out as Sacrament*

"While reading *Unplugged*, not only did I share in Dayna Clay's journey, I found myself wanting to *be* her. For despite her many setbacks, the cosmos gives Dayna signals along the way, highlighting the connections between all living things and acting as her friend. In time, Dayna does something each of us should strive to do: she takes the person she grew up to become, searches for and finds her deeper, spiritual self, and then melds them into one. *Unplugged* is an adventure, an inspiration, and a call to action."

—Claire Massey, recording artist,
Suncat Muse, planetclaire.com

UNPLUGGED

A NOVEL

Paul McComas

2002 · JOHN DANIEL & COMPANY / SANTA BARBARA, CALIFORNIA

Published by John Daniel & Company
A division of Daniel and Daniel, Publishers, Inc.
Post Office Box 21922
Santa Barbara, CA 93121
www.danielpublishing.com

Cover photographs and bighorn icon: Paul McComas
Cover model: Leah Barnum

LIBRARY OF CONGRESS CATALOGING-IN-PUBLICATION DATA
McComas, Paul, (date)
 Unplugged : a novel / by Paul McComas.
 p. cm.
 ISBN 1-880284-60-X (pbk : alk. paper)
 1. Women rock musicians—Fiction. 2. Badlands (S.D. and Neb.)—Fiction.
 3. Identity (Psychology)—Fiction. 4. Suicidal behavior—Fiction.
 5. Friendship—Fiction. I. Title.
 PS3563.C34345 U57 2002
 813'.54—dc21
 2002001328

Excerpts from this novel have appeared in *Open Hands*, Vol. 14, No. 1 (Summer 1998), *The Awakenings Review*, Vol. 1, No. 1 (Summer 2000) and *Open Hands*, Vol. 16, No. 4 (Spring 2001).

My thanks to the following for feedback on earlier drafts: Roslyn Broder, Tim Brown, Jennifer Cowsert, Eric Diekhans, Faye Fisher-Ward, Ben Handelsman, Neal Katz, Shanna Khosravi, Doug Kozlowski, Amy Leonhart, Jan Martin, Christine Kozlowski McComas, Hazelyn McComas, Sarah Miller, Laurence Minsky, Kyla Baruch Sargent, the late Jim Schettl, Dr. Vicki Seglin, Nancy Soren, Karen Tompkins-Davis, Kayla Tompkins-Davis and Katia Zalkind.

Deep thanks to Faye Fisher-Ward for introducing me to "Ivana."

For Chris,
my beloved, who shared the journey,

and for the beauty of the earth

→UNPLUGGED

ONE

FIFTY-SIX HUNDRED VOICES chanted Dayna's name, blasting
the two syllables in fervent unison toward the recently vacated concert
stage as if intending, through force of volume and will, to conjure the
twenty-seven-year-old singer out of thin air.

Dayna Clay had just held the sold-out crowd in thrall for an hour
and a half, barely stopping for breath or bottled water between songs.
She and her band had torn through Dayna's current hit at the outset
but had yet to perform her breakthrough single—the song that, since
it hit the airwaves half a year earlier, had attained anthem status among
a large segment of the teens-and-twenties set from coast to coast. In so
doing, the song had brought both her major-label debut and Dayna
herself public attention as serious as it was sudden. And on this, the final
night of her seven-month North American tour, anticipation was high
that she was saving the best—or, at least, the most-in-demand—for last.

As the murky silhouettes of Dayna and her four backup musicians
finally re-emerged on the half-lit stage and took their positions, the
chant erupted into a cheer. Dayna adjusted the strap on her cordless
electric guitar—a sleek, custom-made, black and blue Stratocaster—
and stepped up to the microphone. "Thanks," she said, a spotlight train-
ing itself on her angular features. "Last encore. Last song."

She ran a hand through her dense chestnut hair and peered out

through the haze of cigarette smoke, surveying the sea of heads and up-raised arms billowing before her. Glancing straight down, she met the gaze of one of her younger fans: a boy half Dayna's age standing with palms pressed against the small wooden barricade that, along with a handful of security guards, separated audience from stage. He had spent the concert watching her fingers, intently studying her fret work—a budding guitarist himself, no doubt—but now stared worshipfully into Dayna's eyes.

She looked away. "Guess you all know this one..."

Another cheer—but one that, as Dayna stood silent and still, quickly subsided.

"I'm pretty sick of it myself. Though I..." She paused. "I remember when it still..."

A female voice from the balcony: "Still does, Dayna!" The comment generated a round of supportive applause, sprinkled throughout the balcony and main floor.

Dayna stared down at her guitar. "Lucky you." And with that, she unleashed the much-anticipated opening chord.

With a roar of approval that, to Dayna, had grown all but meaning-less with nightly repetition, the crowd began surging back and forth in time to the music. After the requisite eight measures of guitar intro, the other musicians kicked in, investing Dayna's ever-potent composition with their own energy and emotion and pushing the audience into an exhilaration bordering on frenzy. Spotlights and lasers bobbed and weaved, sweeping the stage with pre-programmed yet seemingly random abandon. Occasionally, two beams crossed paths at center-stage, and Dayna—head bowed, hammering away at her Strat—appeared to be pinned at their intersection.

Behind her, purple and red strobes flashed and pulsed as Dayna navigated her song's unusual chord changes and stop-and-go rhythm with proficiency and poise. Then her head rose, face constricted, eyes shut tight, lips straining toward the mike, and her acclaimed voice—a sear-ing, unsettling contralto, a rich and darkly radiant sound—seized the room with its familiar words of defiant accusation. The bass drum pounded menacingly, each beat reverberating right behind her ribs as Dayna delivered her unflinching account of childhood trauma and tor-ment. A multitude of voices joined hers as she reached the chorus:

Your virtual virtue, your make-believe soul
Took vicious advantage in taking their toll
Your counterfeit conscience, your replica heart
Can wear me and tear me but never apart

As her band charged into the song's bridge, Dayna's eyes fell again on the boy below. As before, he was focused on her fingers, scrutinizing — but then, sensing her gaze, he looked up. Dayna mouthed two words: "You play?" After a stunned moment's hesitation, the boy nodded. Dayna stuck her pick between her teeth, dropped to one knee and extended her right hand. Barreling over the barricade, the boy took hold of her forearm, and Dayna — nodding her OK to the approaching guard — hoisted her young fan up onto the stage.

Still playing, the other musicians watched with curiosity and concern. At the stage's edge, two more kids tried to follow but were promptly dissuaded as the rest of the audience voiced vicarious delight at the success of the first.

Standing beside her, the boy — five-foot-four and skinny, with a mass of chaotic brown hair — could almost have been the singer's twin. Both wore jeans, but in contrast to Dayna's black tank top, the boy sported a white T-shirt with a grainy, larger-than life photo of his idol's face printed across the front. Dayna removed her guitar and slung its strap over the boy's head, in the process blotting out her own image with the body of her instrument.

She offered her pick; he took it, hunted briefly for the right minor chord, then found it. All at once he was playing the song that, back in his bedroom with his own, off-brand guitar, he had played so many times before while envisioning himself backed up by just such a band on just such a stage before just such an audience.

The enormity of it all would have overwhelmed him if he had stopped to think about it, but he didn't; he just strummed and strummed and then, feeling the firm push of Dayna's hand against his shoulder blade, stepped up to the mike and belted out the next verse. He heard his voice — *his* voice! — booming from the monitors and speakers, louder than he'd thought possible. The boy sang fairly well; what he lacked in technique he made up for in clarity and sincerity, and by mid-verse virtually everyone in the building was either cheering his

effort or singing along. Dwarfed by the vastness of the crowd, the boy had never felt so colossal; knees trembling, he'd never known such strength or self-assurance, such explosive, runaway joy.

From his elevated vantage point, he could see the entire audience from which he'd just emerged. The audience, in turn, saw what the boy could not: the small female figure behind him taking two steps back and then turning, veering off to the side, moving quickly past the drum kit, ducking into the shadows and receding from sight.

A moment later, Dayna instructed a baffled roadie to "let the kid keep the Strat," then grabbed her jeans jacket and darted out the backstage door. In the alley she removed her ear plugs and pitched them into an open dumpster, took an instinctive step toward the waiting tour bus…and caught herself. *No*, she thought, turning the other way. *No good-byes.* Reaching the street, she hailed a taxi, jumped in—a pair of loitering fans recognizing her just as the car door closed—and headed for the airport.

The first airline she tried had nothing for Chicago that night, but the woman at the next counter promptly pulled up a seat on an undersold flight scheduled to leave in an hour. Dayna bought the ticket and then, in the gift store, a newspaper that she used as "cover," holding it open in front of her while waiting to board.

Seated alone in a right-hand row in the rear of the DC-10, Dayna flipped up the arm rests and sprawled herself across all three seats, her face turned in toward the cushions. Exhausted, she closed her eyes and managed, with less delay than usual, to fall asleep—but then the plane hit some turbulence.

Disoriented, she sat up; with bleary eyes, she scanned the cabin. A freckled flight attendant stooped to answer a squirming girl's whispered question. A lanky businessman, wearing expensive headphones attached to a Sony Discman, used pen and legal pad to tap out a perky, possibly Latin beat. A few rows back, someone sneezed; a woman mumbled, "Bless you." Pro basketball highlights played silently on a series of screens above: the same slam dunk five times over, in unison. Everything was in order; all was as it should be. And yet…

Dayna looked down at her knees, then closed her eyes.

She envisioned the future spread out like a minefield before her. Her mind raced, imagining the bleakest outcome for every circumstance in her life. Her current songwriting block meant that she would never compose again. The hollowness she felt while performing meant that her music had no substance, and soon the critics would expose her for the sham she was. Her chronic fatigue and recent weight loss meant that a cancerous tumor germinating somewhere within her was sucking up all her strength. The accusatory parting words of her most recent lover meant that, even if she lived, Dayna would spend her entire life...

Alone.

Her head throbbed; Dayna placed a hand to her brow. In desperation she called to mind all of the people in her life, but wound up focusing only on the sources of grief with which each was saddled. Her sound tech's painful, protracted divorce; her bass player's steady slide into multi-drug abuse; the severe physical disabilities of her producer's infant son...in recent weeks, Dayna had found herself paying the emotional toll for these and other burdens, carting them around from city to city like so much carry-on luggage. Tears now welled up in her eyes as she mourned in advance all the pain and suffering to come: for herself, for everyone she knew and for everyone she didn't.

Dayna sank down as if compressed. She curled up on her side and lay still, aching to escape the nightmare of consciousness, yearning yet unable to sleep.

Back home the next afternoon, just as she'd done a thousand times before, Dayna descended the back stairs, stepped into her garage, sat down behind the wheel of her midnight blue Mystique (a signing bonus from her record label), stuck the key in the ignition and turned. But this time, when the engine rumbled to life and she glanced into the rear view mirror, her usual view—the driveway, a sliver of lawn, the slightly tilted YIELD sign by the opposite curb—was nowhere in sight. All was cloaked in darkness, for this time Dayna had left the garage door closed.

She rolled down the windows and sat, hands on her lap, feeling...awkward. Unnaturally still. She reached up and turned on the radio, only to hear her own voice:

My spirit's fading like a fog into the air
No one can damage you if you're no longer there

Apparently, her recent record's title track and third single, "Give Me Oblivion," was already getting some air play. The title, she realized, would soon become more apt than she could have known. The media would eat it up; the lead-in of every Dayna Clay-related article and TV report would oh-so-knowingly invoke those three words, dwelling on the irony of it all before veering into half-assed psychoanalysis and somber speculation.

Take my hopes and fears, all I've said and done
Take my tears, my career, just give me…

She turned the radio off.

Dayna had placed Post-its bearing the names of a few friends and associates on some of the items upstairs—her non-touring guitars, her drum machine, her 16-track porta-studio, her CD collection, her dozen or so pieces of artwork by local as-yet-unknowns—yet had left no letter of explanation. She'd tried to compose one, but words had eluded her, a failure that Dayna, a supposedly gifted lyricist, had taken as further validation of her decision. Now, though, the crushing sadness lifted a bit; a kind of peace came over her, and with it a clarity of thought she hadn't known in some time. As car exhaust, odorless and invisible, filled the surrounding darkness, she felt a sudden need to express herself…or die trying.

Dayna picked up her cell phone, flipped it open and dialed her home number. The line rang twice, then connected. She heard her own voice—curt and confident, an old recording: "Give it up"—and then the beep. Turning sideways, Dayna pulled her feet onto the passenger seat; she swallowed, closed her eyes and spoke.

"There was this river, this…pretty little stream not far from the house where I grew up. Next to the woods, on the edge of town. And there was this old foot bridge that went over it. The bridge was made out of narrow wooden planks, laid out so you couldn't set foot on it without stepping on the…the places where the planks met. So my friends and I used to tiptoe across, in between the cracks. I don't know how or when this

got started—long before our time, anyway. But we always said that if you made a wish and then made it all the way across the bridge—making sure to step on every plank, but not on any cracks—your wish would come true."

A tickle in the back of her throat; she coughed, then continued.

"The summer I turned twelve…something happened. And for the first time in my life, I really needed something. I needed something to stop. Some*one* to stop. So every day for, like, three weeks, I rode my bike to the Wishing Bridge and asked for help. I'd make my wish—out loud, unless someone else was there—then cross over, repeat it and cross back. Sometimes I'd go through this two or more times, just to make sure; by the end, I was up to six or seven. I wished and wished, and later, in bed at night, I prayed. But it…it wasn't God that kept…coming to me there."

Dayna was beginning to feel drowsy, and there was a tart, acidic taste in her mouth. She licked her lips, pulled the phone snugly against her face and, her voice hoarse, pressed on.

"For the past few months, despite all the applause, all the limelight and praise, the…the fame and acclaim that have come my way—somehow, I've felt just as frightened and sad as I did back then. And every bit as helpless. I barely made it through the first time, and I just…I can't go through that again. I wish there was some other way; I…I wish it didn't have to come to this. But wishes…well, I don't believe in wishes any more. So…"

Another beep; her time was up.

Dayna put down the phone and, fatigue deepening, lay on her back. The placid hum of the car engine droned on, lulling her toward the edge of sleep.

She sensed death lurking nearby and wondered what, if anything, she would experience when it arrived. Would there be an instant replay of her life, twenty-seven years in the blink of an eye? Or a trip down a long, dark tunnel leading to a warm, welcoming light? Or would she see nothing; would death simply mean the end of all perception? Perhaps she would "blink out" as decisively as the signal on an old TV set: an isolated white dot, here one moment, gone the next. Dayna watched and waited, seeing nothing, nothing still, her thoughts slowing, overlapping, becoming foggy, evanescent, gently drifting away as she began

to lose consciousness. Then suddenly a
 jagged
 vertical
 line
 shot
 across her field of vision and
THUD—something fell onto the hood and bounced up against the windshield, startling her into half-awareness. Squinting, she could just make out the profile of some small shape lying against the glass, beside the left-hand wiper. She sat up and, coughing, pushed a jittery hand out the window, reaching around to feel the object. It was soft, warm…and breathing.

Dayna dimly remembered being chattered at from above while parking her car a month or two earlier, during a hiatus from her tour. She'd tried to shoo the squirrel out with a push broom but had succeeded only in guiding it even higher, up into the rafters. So she'd left the garage open overnight in the hope that its uninvited tenant would vacate the premises.

But it hadn't. And now, while lifting it from its resting place and bringing it into the car, Dayna found her bruised and battered heart swelling for this ill-fated creature that had unwittingly set up housekeeping in a suicide parlor. Its life, unlike her own, was not hers to take; its life, unlike her own, was worth saving. And its life was in her hands.

Dayna fumbled for the key and turned off the engine. Holding the squirrel to her chest, she grabbed the door handle and burst out of the car; gagging, she tumbled dizzily to the garage floor, coming down hard on one knee. The air down there seemed slightly cleaner, nearly breathable, so Dayna flattened out and crawled soldier-like across the smooth, grease-spattered cement, heading for the garage's back wall.

She could see nothing, and her eyes, throat and lungs coursed with a dense, liquid pain, but soon her fingertips reached the brickwork. As if by instinct, Dayna shifted the squirrel from her hand to her mouth, teeth clamping on the scruff of its neck. Grabbing the wall with both hands, Dayna pulled herself to her feet and conducted a frantic tactile search: heating pipe, bike rack, paint cans…where was the button for the door? *Should've turned on the headlights*, she thought. *Then I could see what I'm…Christ, there's a door opener right on the dash; I could've*

used that! Turning back, she found she could not see the car; disoriented by the fumes and the darkness, she wasn't even sure in which direction to look. Tasting blood—hers, or the squirrel's?—she desperately resumed hunting for the button.

Each fragment of breath Dayna took was agony; it felt as if she were drawing not air, not car exhaust but fabric, thick, coarse scraps of burlap into her sinuses, down her throat, straight through the fragile membranes of her lungs. Nor was she aided by the castigating voice in her head—the one pointing out the absurdity of her predicament, dismissing her efforts and advising her to give in. Light-headed and heavy-hearted, she was on the verge of complying when one quivering finger stumbled onto the edge of a small, circular recession. Dayna pushed the button and fell to the floor.

Unseen gears ground into motion, and daylight filtered into the toxic, black box, a line of blurry sunshine starting at ground level and stretching upward, taller and brighter by the moment. Dayna lunged forward, half-rolling, half-throwing her body toward the light. Once clear of the garage, she crawled around the corner, her raw lungs greedily sucking in all the air they could, and, in a secluded spot where cement gave way to grass, she collapsed. Her mouth opened, and its passenger dropped limply beside Dayna's face; the back of its motionless head was the last thing she saw before everything washed out to white.

She woke up, coughing, an indeterminate time later. A light rain was falling, and no one else was in sight…the squirrel included. The spot it had occupied was vacant and offered no clues as to the animal's whereabouts. Dayna stared at the grass, perplexed.

Her nose was running, and her eyes stung; her throat, though no longer ablaze, continued to smolder, but the raindrops felt soothing against her face. She rolled onto her back, letting her skin drink in the balm from above.

The creature's disappearance puzzled her. Maybe it had regained consciousness and scampered—or stumbled—off to resume its nearly-relinquished life. Or perhaps some neighborhood cat or dog had chanced upon the two sickly, sleeping forms and made off with the smaller, more portable one. The squirrel had been either saved or savaged; Dayna could conceive of no third, less decisive outcome. She

realized that she might never know whether it had lived or died, and for this ignorance she supposed she was grateful.

She herself, however, had unquestionably survived. And for this she was…what?

Dayna sat up; she peered over her shoulder at the garage, silent and open and gray.

The jury was still out.

>·<

If there are ghosts, then this must be how they feel.

There was an unreal air about the whole experience: climbing the steps, inserting the key, turning the knob and stepping inside—in short, returning to the home that she thought she'd left for good. The name-laden instruments, the answering machine with its eternally blinking light, the stack of unopened fan mail on the coffee table, the half-eaten slice of wheat toast in the kitchen sink…the whole tableau was to have been discovered and documented by the authorities, not quietly reclaimed by the home's owner, who now felt distinctly out of place within walls as unnerving as they were familiar.

Dayna closed the door behind her and headed for the bathroom. There, hoping to assuage the irritation in her throat, she filled a glass with cold water and drank it down. By the final gulp, the pain was less acute.

But her throat was only part of the problem. The cause, she realized, was probably less physical than psychological, but the carbon monoxide had taken its toll on her entire being. She felt arid and hollow, less a living person than a stale and smoky husk, as if car exhaust not only had coated her body but had seeped straight through. Not since age twelve had she felt so polluted, inside and out.

Dayna took off her clothes, stepped into the shower and turned the knob: warm water sprayed against her collarbone. She adjusted the shower head, directing the jets to hit her at full force; she turned, allowing the water to cascade down her back, her buttocks, the backs of her thighs. Turning again, she stepped forward, the steady stream bracing against her face.

Drawing back, Dayna pulled the silver band off her left wrist and placed it beside the soap dish. Her bracelet soon was joined by her

anklet, the two rings from her right ear lobe, the tiger's-eye stud from her left and the small, silver hoop she wore in her left eyebrow. Without knowing why, she'd found, removed and set aside everything extraneous. Now she touched her ear lobes and eyebrow, her fingertips locating each tiny hole in turn. All that remained was her.

Reduced to her bare essentials, Dayna became unusually conscious of her physical self: her parts and dimensions, shades and textures, movements and scent—and the murmur of life coursing just under the surface. She guided her hands over her neck and shoulders, stomach, thighs, knees and toes: all of this was alive, and all of it was her—her, and nothing but.

When she stepped out of the shower, she had no idea what to do, where to go or even how to feel, but she had the beginning of an identity: *I am this body. And this body is alive.*

Standing at the sink, Dayna toweled off, then picked up her hair brush. The mirror was foggy; she reached to wipe it clean, then paused and put the brush down. She placed a fingertip against the mirror and lowered it, moving her hand from side to side. She drew purely from memory—but this memory was so distinct, the process was closer to tracing.

After she'd finished, Dayna stepped back. There in the condensation, she had recreated the cryptic vision that had come to her with such vivid brevity in the car, at the intersection of life and death. She stared at the simple zigzag design, uncomprehending. What was it? A bolt of lightning? Or some kind of fissure, a rip or tear—in earth, in paper, in flesh? And what, if anything, did it mean?

Her eyes re-focused; she looked not at the line but at the erratic partial reflection of herself within it. As a depiction of her internal state, the image was a bit too apt. Dayna swept her palm across the mirror, erasing the jagged line and extracting her intact likeness—*I am this body*—back onto the glass.

The phone rang.

Having obtained a measure of tranquillity, Dayna hesitated. She could imagine no one with whom conversing would be enjoyable, numerous people with whom it would be arduous...and one with whom it would be unbearable. No; she couldn't take the call. Nor did she wish to hear the message left, or even learn the caller's identity.

Instead she turned on the conveniently loud overhead fan, closed the bathroom door and reached for her clothes.

Once dressed she retrieved her jewelry, ran the brush through her hair a few times, turned off the fan and opened the door. She padded barefoot into the kitchen, opened the fridge and stared inside: there was little there, and none of it appealing. She closed the door. Dayna walked into her bedroom and curled up on her unmade bed, limbs enmeshed with the tangle of sheets. *Ghost bed,* Dayna thought. *I was never supposed to sleep here again.* And yet, within minutes, she was doing just that.

<p style="text-align:center">➤·◄</p>

She woke that night to the sound, again, of the phone. Her mind clinging to the edge of some complex, meandering dream—one into which the ringing had insinuated itself as a narrative element—Dayna reached over, picked up the receiver and croaked, "Hello?"

A female voice: "Dayna?"

Oh, I was…asleep. She considered hanging up but was too groggy to deliver.

"Day, is that you?"

She cleared her throat. "Who's this?"

"Jayce. What's wrong with your voice?"

"Jayce. How's it goin'?" What *was* wrong with her voice?

"You sound awful. Are you sick?"

Was it the carbon monoxide? She hadn't spoken since her cellphone sign-off back in the car. Maybe her vocal cords just needed loosening up. "Sore throat."

"At least it held off till the tour was over."

"Yeah." She burrowed her face under her pillow, taking the receiver with her.

"Listen, Day, what's with the disappearing act? Granted, giving the kid your guitar was a nice touch—very fan-friendly, egalitarian, 'come as you are' and all; I hear the crowd ate it up—but if you're gonna ditch the bus, would it kill you to let someone know? Me, for instance…or better yet, your tour manager? I'm at Sonora, I'm having dinner with this label rep—*your* label, in fact—and no sooner does the soup arrive than I get this frenzied call from Z.J.: 'We lost Dayna! She ran out in

the middle of her encore and never came back!'"

Dayna rolled onto her other side. "What kinda soup?"

"Think you're funny, don'tcha, Clay?"

"Was it that...cold avocado?"

"Of course it was. Christ, Dayna, you sound awful."

It was true: her voice was raspy beyond recognition and wasn't improving with use. "Guess it's my new sound."

"Don't even joke; grunge is dead. Anyway, I figured you were just in a mood and heading home, so I told Zeej to leave without you. He's got your stuff—your suitcase, your guitars. I'll have him overnight it."

Have him burn it. "No rush."

"He said your wallet was missing, but I assume..."

"I took it with." Dayna rolled onto her back, trying to find a comfortable position.

"I hope you can get those pipes in shape pronto, 'cause we've got some major commitments coming up on both coasts."

Dayna shuddered. She was in no shape to do the meet 'n' greet, grip 'n' grin routine with the radio programmers, video promo people and other industry types her agent was so proficient at lining up. "Jayce, I...we've got to talk. I can't..."

"It's the movie, isn't it?"

"Well...among other things." She could hear a dog yipping on Jayce's end of the line—that nasty little corgi, no doubt, that had once sunk its teeth into the sandal-clad singer's big toe. Unsettled, Dayna pressed on. "See, I'm not..."

"We've been through this. You don't think you can act. Maybe you can, maybe you can't; I guess we'll find out. But you've got presence. Not just in concert, but on the screen, too; your videos attest to that. Hell, you're so strong in 'Virtue,' it's scary. And presence is what this part is all about."

Dayna's head pounded; even over the phone, all the way from L.A., the incessant background barking was getting to her. "Can you make that thing stop?"

"Benito!" Jayce admonished. "Down!" *Yip-yip-yip!* "Oh, fuck-all; hold on." A quarter-minute later, her beast presumably banished, Jayce resumed her pitch in mid-thought: "A solid supporting role—it's the perfect showcase. Plus, with the soundtrack tie-in..."

As her agent rattled on, Dayna found the receiver trembling in her hand. She could no more see herself tackling her first movie role than walking on water; actually, she had a hard time picturing herself doing much of anything, with the possible exception of sleeping. The very thought of appearing in public made her queasy.

Not long ago, she and Jayce had shared the same objective: to position Dayna, both critically and commercially, within the top tier of rock recording artists worldwide. Dayna had treasured Jayce's representational acumen and driven, take-no-prisoners approach to client promotion. But now, with that top tier in view, the woman's every word was an assault.

"...wrap just in time for the European tour—you start in Amsterdam and end in Rome. Then Australia, Japan, and after that...well, at that point I suppose you'll want to head back into the studio."

"All planned out," Dayna muttered.

"That's my job."

"To look out for me. For my...interests."

"What's your point?"

Dayna hesitated, trying to decide how much information to divulge—weighing the relative risks and merits of coming clean. But this quandary, like the others she'd faced in recent weeks, defied solution. Tell Jayce everything? Tell her a little; downplay the problem? Or just play along? Each course of action seemed inadequate, dangerous...or both. The more Dayna struggled to make sense of the situation, the more disjointed her reasoning became, degrading, finally, to such an extent that she lost track of her options altogether.

"Dayna?"

She drew her knee up and examined its muted, purple bruise, a souvenir of the tumble she'd taken in the garage. Dayna placed a fingertip against it—*I am this body*—and pressed. *I am this pain.* "Yeah?"

"Something's wrong. Isn't it?"

"Uh...yeah."

"I'm here." Jayce waited, then gently prodded, "What is it, Day? What's the matter?"

Dayna continued to stare at the bruise. "I...I'm not sure. It's just that I...feel like I'm not...myself lately."

"Go on."

"And I'm so tired, Jayce. All the time." She swallowed. "And today, I tried…"

"Exhaustion. From the tour. You need a break, some time off."

"Yeah."

"A few weeks."

The rest of my life. "Well…"

"I hear ya. So we space things out a little. Reschedule the first four or five dates in Europe—move 'em to the end."

She doesn't get it.

"I'll call Warner, find out if there's leeway on the movie. Maybe they can bump your scenes back. If not, we'll have to play it by ear, see how you're feeling by the time they start shooting. But otherwise, there's nothing that can't wait—well, except for Letterman."

"Letterman?"

"A week from Friday, just you and your guitar. The way you wanted it—remember?"

It did sound vaguely familiar, albeit remote, like something she'd read weeks ago in a magazine profile of someone else. Yes, "Dayna Clay" no doubt had agreed to the appearance…but where was "Dayna Clay" today? *I am this body, and this body cannot possibly go on network TV.*

"Dayna?"

"I remember."

"I'll make some calls about the rest of it and get back to you."

"Great."

"Take care of that throat. See your doctor, wouldja?"

The voice that lays your golden eggs. "Right."

"Day—you with me?"

"With you." Dayna hung up, slid out of bed and stood, all in one motion. She found herself driven to distance herself from the phone, the bed, the bedroom. She felt drawn to the street—as if in fleeing her home, she likewise could flee the responsibilities and obligations that had inundated her while she'd sought refuge there.

Dayna put on her socks and boots, grabbed her jeans jacket and headed for the front door. She knew it made no sense; she had, as Jayce had put it, "commitments on both coasts," and walking aimlessly through Chicago's Bucktown neighborhood would do nothing to alter

that situation. Still, her body, focused only on the moment, craved one thing: escape. Dayna, having no better ideas of her own, followed its lead and stepped out into the night.

→·←

Even on her home turf, the combination of a quick pace, a blank expression and a bowed head usually allowed Dayna to walk about unrecognized, or at least unapproached, particularly under the partial cloak of night. So now, eyes riveted on the stretch of sidewalk just ahead, she marched forward, little more than a blur of brown hair and blue denim to the people passing by on either side, the Latino kids hanging out along the curb, the customers ambling in and out of the storefronts and bars to her left.

The street was awash with sound: horns honking, doors slamming, live reggae throbbing out of the club on the corner, hip hop declamations blaring from a passing car, plus a multitude of voices, male and female, young and younger, lively and lazy and livid, speaking English and Spanish and something else, Tagalog, maybe…but Dayna heard none of it. Within the helmet of her head ran a continuous loop of suspicions and apprehensions, returning time and again to the same chilling phrase: "commitments on both coasts."

Maybe she should have leveled with Jayce—disclosed everything, *made* her understand. Why had she felt so cowed, so frightened of standing up to her own agent? Jayce worked for *her*, not vice versa! Where was the strength, the assertiveness that Dayna had wielded so easily and expertly on her climb to prominence? What had become of the cut-to-the-chase candor, zero-bullshit-tolerance and sexy self-assurance that, in her fans' eyes, went hand in hand with the name…

"Dayna—Dayna Clay?"

A voice from the left; without stopping, Dayna turned her head toward its source. Expecting some anonymous admirer, she was surprised to find someone she knew—had once known, in fact, intimately.

"Hey, I thought you were on tour"—walking toward Dayna, a cautious grin spreading across that familiar face.

"It's over." She quickened her pace.

"What's the rush?"—a hint of hurt.

"It's over."

Dayna hurried off, impervious to the entreaty and, then, the epithet hurled at her from behind. Her shell shattered, the street sounds now surrounded her; she felt exposed, as if stripped of her skin and thus apt to unravel any instant. She broke into a run and, reaching the corner, turned right, dashing down a side street. Her ex-lover didn't follow— except in Dayna's mind, which spun out a frenzied reply:

You must think I've turned into a total prima donna some kinda venal celebrity bitch but honest that's not it I can't face anyone now let alone you we were semi-serious once you know me well enough to know I'm fucked up but not well enough for me to deal with your knowing and I'm sorry how things turned out I have this talent for bringing out the worst in those who get close to me probably so it'll be easier to dump 'em I may be the famous one but the truth is you deserve better and I oughta have the courage to say all this to your face or call you or at least write you a note but I don't I can't I won't and now that I've seen you oh God I swear I can barely…

A flash in the night—fire? Sure enough: a four-story brick building farther up the block was blazing from within. Flames flared around the doorway, along the sills, across the awning and up on the roof, a ragged yellow line flickering up into the still, black sky. Grateful for the distraction, Dayna slowed to a walk and drew nearer, wading unnoticed into the small crowd that had gathered just in front of the crackling conflagration.

"Anyone in there?" someone asked.

"Not at night," another answered. "It's just a warehouse."

"Anyone report it?"

The lack of a response seemed to Dayna a kind of collective shrug. She pushed the hair out of her eyes and glanced around, searching for a pay phone; finding none, she turned back toward the blaze. It was then that the flames emerging from the top row of windows leapt high enough to illuminate the foot-tall words engraved in the brickwork above: M. Culver & Son's Fireproof Storage.

Dayna stepped a few yards to the side and sat down on the curb. Forearms on her knees, she watched the fire in silence, all but hypnotized by the flames—the constant inconstancy of their motion, the whip-quick delicacy of their dance. It suddenly occurred to her that she needn't remain a mere observer. There were no walls or barriers; she

could cross over. She could stand up and step forward, straight into the midst of that welcoming warmth. She could dive right in and join the dance. *Last dance…*

A cool mid-September breeze swept over her; she shook off the chill, and with it her line of thought. *Yeah, that'd be real effective.* She rubbed her stiff hands together. *Probably end up rescuing a fucking canary.* She shoved her hands into her jacket pockets…and discovered, on the left, something tucked within. She pulled out a small, white envelope with no stamp, no address, just "Dayna Clay" written by some unfamiliar hand in violet marker.

There was, at each of her concerts and in-store appearances, a contingent of fans that insisted on showering her with flowers, drawings, cassettes, the occasional piece of jewelry and, especially, letters and cards. Male and female in roughly equal number, they threw their offerings before Dayna's feet when she stood, remote and inaccessible, on the stage above—or, given the chance, shoved them shyly toward her as she hurried by. Someone must have pressed this envelope upon her amidst the confusion of her final tour date; she'd pocketed and forgotten it, and so it had followed her, tiny and discreet, all the way back to Chicago.

She had read less and less of her fan mail over the course of the tour, finally stopping cold a month ago. Toward the end, the chasm between her followers' estimation of Dayna and her own grew wider with each week, each day, each letter, and this escalating disparity was hard to bear. In addition, most of her correspondents were disaffected kids leading lives so barren, so loveless—sons and daughters of alcoholism and divorce, victims of rage, neglect and worse—that Dayna ended up "catching" their anguish as if by contagion, painfully subsuming it into her own.

She ran a finger along the cursive letters of her own name, trying to decide whether to tear the envelope open or tear it in two. There was no reason to read it; nothing this fan had written could begin to address Dayna's own situation, let alone improve it. And yet…

She ripped open the envelope, removed the single sheet of starfish stationery and, by the light of the raging fire, read the letter. The writer was an eighteen-year-old college freshman named Melinda who had obtained the date and hour of Dayna's birth from one of the several

unofficial Dayna Clay websites and prepared an astrological chart on her idol's behalf; her letter comprised a summary of her findings.

There was much elliptical talk of congruencies and confluences, air and water "magicks," Mercury's retrograde alignment and Neptune's ascension; Dayna skimmed the front, then turned the sheet over, searching for something more concrete. It wasn't until the end that Melinda offered a single sentence of interpretive advice: "Now is the time to dig in your heels, ignore all distractions and throw yourself wholeheartedly into your career."

Dayna stared at Melinda's signature and the perky little musical notes she'd drawn all around it, then re-folded the letter and placed it back inside the envelope. Reading it had given Dayna a sudden and unanticipated feeling of determination and focus, even a sense, fleeting though it might prove to be, of purpose.

She stood and stepped forward, crumpling the envelope in her fist. Then, with a long, arching pitch, she sent Melinda's missive spiraling into the now-exposed ground floor of M. Culver & Son's Fireproof Storage. She could just make out the distant wail of an approaching siren as she turned from the building and began heading home.

For the second time in less than a day, Dayna descended the back stairs, stepped into her garage, sat down behind the wheel of her midnight blue Mystique, stuck the key in the ignition and turned. But this time, when the engine rumbled to life and she glanced into the rear view mirror, she saw her driveway, a sliver of lawn, the slightly tilted YIELD sign by the opposite curb—and behind it, the first, tentative rays of the new morning's sun.

While on tour, Dayna generally had kept her window shade down and headphones on whether asleep or awake. Over the course of the trip, she had steadily retreated not only from the eight others traveling with her but also from her surroundings, catching only rare, peripheral glimpses of landscape. Now she pulled a road atlas from the knapsack she'd placed on the front passenger seat and opened it to the two-page-spread map of North America. She'd just spent seven months crisscrossing the self-same continent…yet the map held few associations.

There, on one side, was L.A., and there, on the other, New York:

commitments on both coasts. And halfway in between—dead-center, the very middle of middle America—as far as one could get from both? Kansas. Nebraska. South Dakota.

Dayna closed the atlas, reached for the gear shift—and paused as her cell phone began to ring. She picked it up and studied it, her manner cool, dispassionate, as if she were examining some artifact of unknown origin. Then she opened her door and placed the phone just behind the front left tire. She pulled the door shut, put the car in reverse and, to the accompaniment of a muffled *crunch*, backed out of the garage.

Dayna shifted gears, turned the steering wheel and began to move forward. "Kansas," she said aloud, feeling the sound of the word in her mouth. "Nebraska. South Dakota." Any of the three would do; she'd decide when she got there. The important thing was to go.

TWO

AN HOUR WEST OF Chicago on Interstate 80, fields and barns zipping by on both sides and the sun rising behind her, Dayna turned on the radio. Determined to steer clear of her own music, she tuned in the local "classic rock" station. "Virtual Virtue" probably would show up there—around the time she hit menopause. Assuming...

Assuming I live that long.

But she *had* assumed it. And the notion that she might be alive twenty years hence was, Dayna realized, the closest she'd come in weeks to having a hopeful expectation about the future. Then again, if life continued along recent lines, the prospect of another two decades was hardly cause for celebration.

She shook her head, annoyed with her own relentless negativity, her intractable, iron-clad pessimism. "Whatever," she said aloud, and turned down the volume. She hated the early-1970s mega-hit that was playing, disliked most everything by the pretentious art-rock band that had released it—but had heard it often enough to know it was nearly over. As the final chord faded, the deejay enthused, "Doesn't get any better than that, does it?"

Dayna grimaced. "Please."

"That was for Ed in Joliet. Said that song's gotten him through some

tough times and he kind of needed to hear it this morning. Coming up next on WMVX, your less-talk, more-rock station, we'll have the Doors, Janis Joplin, some vintage Hendrix…"

The roll call continued, but Dayna's thoughts were fixed on the deejay's previous statement. While she'd never felt anything but contempt for the record Ed in Joliet had requested, there certainly were songs with which Dayna had "connected" over the years—songs that had given her comfort during her less-than-idyllic childhood, the trials of her teens and the heartaches of her twenties, right up to the present. At one time or another, each of these songs had told her, through a singular meshing of music and words, that someone out there understood; that naming one's demons was cathartic; that love was transformative, and romance a kind of magic; or that life was worth living. To hear one of these songs today was to be embraced, reassured, replenished…to believe. For three or four minutes, anyway.

Dayna wondered what hardships Ed in Joliet was facing on this bright, clear, early-autumn morning. Job loss? Deteriorating marriage? A losing battle with the bottle? Regardless, she was glad he'd gotten to hear his song. Clearly, the piece had merit. It was all a matter of taste anyway, wasn't it? So that band had never appealed to her. Dayna's favorite groups and artists—or, for that matter, her own modest body of work—no doubt left plenty of people just as cold. She wasn't the sole arbiter of quality in popular music; her opinions were no more valid than Ed's or anyone else's.

She turned the volume up. The next time she heard Pink Floyd, she would listen.

Fourteen classic rock hits later, her stomach—in perfect sync, strangely, with some acid-rock guitar distortion—released a grumble, reminding her that she hadn't eaten in more than a day. *I am this body, and this body needs fuel.* Glancing at the gas gauge, Dayna saw that her Mystique was in similar straits. She hit the turn signal and veered toward the exit.

After parking, she sat gazing through the windshield at the young father and two girls filing into the quaintly unattractive roadside eatery. The odds were slim that anyone in this obscure corner of rural Illinois would recognize her. Then again, she'd been featured in some national magazines recently, and her videos had gotten a lot of play. Dayna

grabbed the Toronto Raptors cap from her knapsack and put it on, pulling the bill down over her eyes.

The safest bet at diners, she'd learned over the years, was to stay away from anything containing (or reputed to contain) meat, so when the waitress—a stocky, bored-looking blonde—came by, Dayna ordered vegetable soup and a fruit plate. The fruit might or might not be fresh, but it would be grease-free, and the soup, which the dad at the next table was wolfing down, appeared homemade and delicious.

The dad in question was in his thirties, with daughters of about eight and four. The girls were drinking chocolate milk—a glass apiece—and splitting a grilled cheese sandwich with potato chips. As Dayna watched, the younger one reached toward her father's plate, grabbed his unopened packet of Saltines and held it up, inspecting the contents. "Can I sce 'em?" her big sister asked. No sooner had the four-year-old handed her the crackers than the eight-year-old drove a fist directly into them, saying, "Here's the best way to break 'em. See? Then just tear it open and dump 'em in."

With a wail, the younger girl yanked away the packet of crumbs. "Daddy!" she shrieked, eyes welling up. "Jodie killed 'em!"

Her father shot Jodie a stern look. "No, she didn't…"

"They're dead!"

"They're not dead, sweetheart. They were never alive. They're *crackers*. Why don'tcha come sit on my lap?"

But the girl would not be consoled. She pressed the packet of cracker smashings to her chest with both hands, lower lip trembling, tears streaming, and glowered at her sister, who blithely resumed eating.

The waitress set Dayna's lunch down in front of her. "More water?"

Her throat was still sore; maybe some tea with lemon…or, better yet: "You have lemonade?"

"Fresh-squeezed."

"Great." As the waitress turned away, Dayna's eyes fell on the unscathed packet of Saltines lying beside her own steaming bowl of soup. She looked over at the next table, torn, her impulse toward empathy colliding with her quest for privacy. The safe thing to do was nothing; *but then again*, Dayna reasoned, *what the fuck*. She picked up the packet, stood, walked over and held it out. "Here you go, honey."

The man and his daughters peered up in unison, as startled by

Dayna's raspy voice as by her intercession. After a moment, the younger girl reached out and took the offering. "Thank you," the father said, then turned quickly to the older girl. "Don't even think about it."

Wide-eyed and innocent, Jodie threw out her hands. "What?"

Dayna returned to her own table, sat down and started in on her soup. It tasted even better than it looked, so she made quick work of it, scooping and swallowing gulp after gulp. The fruit plate wasn't bad either, and the lemonade, when it arrived, was cold, tangy and unbelievably good. Dayna had dined at her share of swanky bistros in Manhattan and L.A., but she couldn't remember the last time she'd enjoyed a meal this much.

The trio at the next table got up and left, the older girl turning back to stare—a glint of recognition?—before walking out the door. Dayna watched her go, then reached for the lemonade. Lately, she'd been acting more like the thin-skinned, somewhat pitiful younger girl. But the eight-year-old, Jodie, reminded Dayna of herself at that age: same wiry build, tomboy haircut, exaggerated gestures and appetite for mischief. Of course, in Dayna's case there had been no siblings to torment, no father to glare at her across the table. Just Mom—and then…

Don't.

Dayna pushed her empty dishes aside. She took a pen from her jacket pocket and, on the paper place mat, drew again the jagged vertical line she had either seen or imagined just before her would-have-been demise. Zig left, zag right, sharply left, farther right—then a shadow fell over her work. "Looks like a heartbeat."

Her eyes shot up: the waitress, bill in hand, was standing at the table's edge. Dayna felt a twinge of embarrassment, as if some innermost secret had been revealed to a stranger.

The waitress pointed at the place mat. "Y'know, vital signs. Like they have on those screens, the, uh, monitors in intensive care."

Dayna glanced back at her drawing. "You're looking at it from the side. It goes up and down, like a lightning bolt—not across." Hearing herself, she wondered why she'd spoken in so dismissive a tone.

The waitress shrugged, placed the bill on top of Dayna's design— "I'm only sayin'"—and walked away.

Dayna set the bill aside. Returning to her drawing, she went back over the line from the top down, making it darker, thicker. Once

finished, she stared at the design, waiting for some kind of revelation to emerge…but none was forthcoming. With a shake of her head, she put the pen away.

After paying the tab, she got back in her car, headed farther up the access road to the first service station and filled her tank. She paid for the gas, plus a bottle of spring water, then continued west on I–80. The radio signal was fading; with every mile, the "classic rock" emerging from her car's speakers seemed to recede a bit further back into the defunct decades from which it had come. Rather than re-tuning, Dayna turned the radio off. The music had grown monotonous, and so the silence was downright melodious.

She had made good time before lunch; within half an hour Dayna was leaving her home state behind and driving onto the great metal bridge that spanned the Mississippi. Gazing down at the rolling waters, she realized that her tour bus must have traversed the river at least twice: once going, once coming back…yet she recalled no such crossing. On the other hand, since leaving Chicago that morning she'd spotted numerous meandering brooks and rambling rivulets, the memory of which only enhanced her current awe at the Mississippi's composure, its width, the majestic inevitability of its steady forward progress.

An hour later, on an empty stretch of Iowa farmland, Dayna spotted a car parked on the right shoulder. A young woman was seated on the back bumper, staring at the ground. As Dayna's vehicle drew near, the woman—tan-skinned and strongly built, with long, sturdy limbs—raised an arm, thumb up, but didn't bother lifting her head. Dayna felt as if she'd regained a measure of her old confidence, and so empathy, in its running battle with privacy, maintained its recent edge. Decelerating, she passed the parked car and pulled over in front of it, then cut the engine and grabbed her sunglasses off the dash.

Her first association while walking toward the vehicle was "road kill"; less car than carcass, it had deteriorated to the point that Dayna, who knew cars, couldn't have identified the make and model to save her life. She continued back to where the vehicle's presumed owner still sat, hands now folded on her knees. Dayna stopped beside her, wondering whether the woman would ever stir. A convertible drove by; a crow flying over the adjoining field cawed. Dayna cleared her throat. "Car trouble?"

The woman raised her head—she looked to be twenty-two or -three—and surprised Dayna with a serene smile. "You could say that."

"I can take you to a service station. I think we're close to Iowa City."

"'Bout a dozen miles." The woman stood; she was nearly six feet tall. "If it ain't outta your way…"

"Not at all." Dayna returned to her own car, opened the door and glanced back. The woman was emptying out her glove compartment; she stuck the contents into her rather large handbag, slammed the door and walked up to join Dayna, who by then was starting the engine.

"Thanks a lot," the woman said, placing her bag between her feet as she sat. "By the way, I'm Michelle. My friends call me Shelly. Really good friends call me Shell. Sometimes Jake calls me Seashell. He's my boyfriend."

Dayna was grateful for Shelly's lengthy self-introduction, as it had given her time to come up with an identity of her own. "I'm Lenore." She had never known any Lenores, but it was a name she'd always liked.

Shelly reached for her seat belt. "Do your friends call you Lennie?"

"No," Dayna said, shifting into gear. "They call me Lenore."

"Oh." Shelly looked at Dayna, then straight ahead. "It's pretty."

"Thanks." She pulled back onto the highway. "Do you know Iowa City very well?"

"Not really. I'm from Marble Rock; that's up north. Jake had an aunt in I.C., but she passed on before we met."

"Well, it shouldn't be hard finding someone to come out and tow your car."

"Oh, I ain't comin' back for *that* thing."

"You're not?"

Shelly laughed. "Would you? I mean, jeez—did you see it?"

"Yeah. What kind of car is it, anyway?"

"No idea. I'm prob'ly about the fifteenth owner—no; with the luck I've had, make it the *thir*teenth!" She laughed. "Anyway, Jake thought it was a Pinto, but then he got a good look at a Pinto engine somewhere, checked mine out and said, 'Guess not.'"

"You're just going to leave it there on the side of the road?"

"If I had Jake's rifle, I could put it out of its misery." She noticed Dayna's mystified expression. "I left the key in; if anyone wants it, and if they

can get it goin', they're welcome to it. But I've shelled out three times in upkeep what I did to buy it." She rolled down her window and stuck her elbow out. "I'll tell ya, Lenore, it feels good. Liberatin'. A load off my shoulders and a weight off my mind. Ain't you ever just up and left something behind?"

"Sure."

"And how'd it feel?"

Dayna glanced into her rear view mirror. Shelly's decrepit car was but a faraway fleck of gray; as the road dipped, the fleck vanished. "Too soon to tell."

Her passenger said nothing, and Dayna, who had become adept at recognizing such moments, was conscious of being watched. Finally, Shelly spoke: "Could you take off your sunglasses?"

The request seemed a bit forward, but Dayna complied.

"Know who you look like?"

Here we go…

"That rocker gal. I seen her on the MTV—what's her name…?"

"Dayna Cray?"

"Clay. I think it's Clay."

"No," Dayna said, "I'm pretty sure it's Cray. Like the blues singer."

"Anyway, you're a dead ringer. But I guess you've heard that before."

"You don't know the half of it." Gaining steadily on a lumbering truck, she switched lanes and accelerated to pass it. "I don't know where she came from, but wherever it is, I wish she'd stayed."

"I kinda like that song of hers. Though me and Jake, we're more into country. You know: Wynnona, Randy Travis, Dixie Chicks, LeAnn Rimes…" Shelly shook her head. "Jeez! You look just like her—that Cray gal, I mean. Sure don't sound like her, though."

"Listen, Shelly, where are you headed?"

"To Jake's; he's in Cedar Rapids. But if that's outta your way, drop me in I.C."

She remembered Cedar Rapids from the map. Driving there would mean a detour north, maybe an hour round-trip. As Dayna was in no hurry—had, in fact, neither deadline nor destination—she saw no harm in helping this garrulous stranger. And besides, if such a thing as karma existed, she sure could use a little of the good kind. "Cedar Rapids it is."

As the miles passed, they continued to chat, their dialogue encompassing a wide range of topics: Shelly's job (Dayna had guessed gym teacher, but the answer was road repair worker); "Lenore's" (Shelly had guessed "some kinda scientist," but the answer was travel-guide writer); Shelly's recent trip to visit her cousin in New York City; how the Manhattan night life compared with that in Cedar Rapids; home schooling (Shelly's older sister, a farm wife, was an ardent proponent); Shelly's ancient yet energetic cat, Señor Fuzzle; her sporadic success pitching for the local softball team; the recent fire on the University of Iowa campus; and, throughout, Jake. Shelly managed to steer every subject into a mention, ultimately, of her boyfriend, no matter how circuitous the route or tenuous the connection.

Dayna didn't mind the rather Shelly-centric tilt of the conversation—the less she herself had to make up about "Lenore," the better—but found the incessant Jake references annoying. Her passenger seemed compelled to repeatedly invoke the man's name, his opinions and various banal details of his life in order to keep his memory alive throughout her absence from the one place in the world she obviously longed to be: by his side.

"They ain't made a final determination yet, but Jake says it looks like arson to him."

"He does, does he?" Dayna all but snapped.

"Well, yeah."

"What makes him such an expert?"

"His job. He's a fire inspector."

Dayna stared at the highway. "Oh." She turned on the radio; country music began to play. Recognizing the song, Shelly joined in and sang along, her clear, strong voice eclipsing the one coming over the airwaves. "You sing well," Dayna said.

"Thanks. Jake says I could do it professionally."

"Jake's right," Dayna said, inwardly wincing.

"Maybe I oughta try." She laughed. "Jeez. Too bad you *ain't* that Cray gal; I could pick up some pointers!"

Dayna gestured toward an approaching road sign. "Eight miles to go."

"You're gonna want the first exit." Shelly turned down the volume. "I really appreciate your pullin' over like you did." She smiled the same

luminous, carefree smile as when they'd met. "'Course, I knew you would."

"Is that right?"

She nodded. "I was prayin' for a lift when you stopped."

Dayna glanced at her. "Yeah, well…" It suddenly threatened to become a long eight miles indeed. Probably best to change the subject—yet she couldn't help responding. "You got lucky. Not all prayers are answered."

"Sure, they are."

"Take my word on it: some are ignored. If they're heard at all."

"All prayers are answered," Shelly said, "but sometimes the answer's 'no.'"

"Where'd you get that from?"

"I think it's in the Bible."

"Let me guess—the book of Jake?"

Shelly opened her mouth as if to speak, but no sound emerged. She turned her head and looked out the window.

Jesus. Where'd that come from? "Sorry," Dayna said. "I didn't mean anything. It's just…it's a touchy subject for me."

Shelly didn't move. "For me, too."

Dayna wondered whether her passenger was referring to prayer, the Bible or the boyfriend. Or all three. "It's just that I've…had this conversation before." She paused, groping for words. "See, I'm dealing with a lot, going through a rough stretch, and…"

Shelly turned toward her. "But that's when you really *need*…"

"…and if anyone tried to 'save' me right now, I couldn't take it. OK?"

Shelly said nothing.

They rode in silence, whatever rapport they'd established now lying far behind them like Shelly's abandoned car. Dayna wished she'd backed off, changed the subject, steered clear of the dispute. She liked Shelly; why had she hurt her? Perhaps there was still a way to salvage the earlier feeling between them. She'd pick something safe, some uncontroversial topic that Shelly would welcome, and draw her back out. "So, you and Jake…is it serious?"

Shelly looked at her. When she spoke, there was a new quality to her voice, a sobriety, a maturity that hadn't been there before. "Let's talk about you."

This was unexpected...but at least they were speaking. Dayna forced a smile. "What about me?"

"You seein' anyone, Lenore? Romantically?"

"No, I...I was. We broke up recently." A particularly maudlin country song was playing on the radio, as if in perverse accompaniment to this new and rather unwelcome line of discourse. "About a month ago."

"How come?"

"It was my fault. I drove..." Dayna hesitated, wondering how to proceed. A pronoun was needed; candor indicated one, discretion another—but then, discretion had never been her strong suit. "I drove her away. I got impatient, gave up, started doing and saying things I knew would make her want to leave." The song ended, replaced by a jarringly loud hardware store commercial; Dayna reached over and turned the radio off. "We weren't...I don't think we were in love. Maybe we could've been, in time. Who knows?"

She looked over at Shelly, who was staring straight ahead—and had shifted a good three inches away.

Though not surprised, Dayna couldn't hide her disappointment. "Don't freak on me, Shelly; I'm not gonna attack you. You're not even my type." In truth, she had several "types," into one of which Shelly quite snugly fit, but Dayna opted to give her candor a rest.

Shelly looked at her. "This is prob'ly gonna sound real...real 'Iowa' of me. But I don't see how you could get the same feeling from another woman that I do from Jake."

"I don't." Dayna paused, mentally offering herself sarcastic congratulations for having kept this new line of discourse controversy-free. "It's different. Not better, not worse..."

"How would you know?"

"I've had boyfriends; I like guys. I'm attracted to women *and* men; always have been. Gender just...never mattered." Dayna smiled bleakly. "I've had twice as many opportunities for failure as other people, and believe me, I've made the most of 'em."

This disclosure put Shelly somewhat at ease. "How is it different?"

"It's hard to put into words. These things don't really lend themselves to..."

"Try."

Dayna gave it some thought. "With a guy it's, you know, a joining

of opposites. So there's this feeling of…completing something. Each other, I guess. And when it's right—when he's the right guy—that can be really powerful."

Shelly nodded. "Yeah."

"But with another woman, it's a joining of…well, not opposites, but equals. A celebration of common ground. The feeling…it's more one of echoing each other, reinforcing each other." A string of images rose, unbidden, to the surface: copper-colored hair splayed across a pristine pillow…trusting gray-green eyes, half-open and intent…dexterous fingertips tracing out, on Dayna's ribs, the place between tickle and caress…her own name, spoken aloud in a drawn-out whisper, "Da-a-ay, Na-a-a, Da-a-ay, Na-a-a," again and again like some mystical password to…

Let it go.

Her voice tightened as she pushed on. "So there's a symmetry to it, a sense of balance and a basic, physical kinship that…" Her throat caught. *Forget her.* "…that's…"

"That's what?"

She grabbed her sunglasses off the dash, slid them on and pointed to the road sign ahead. "That's your exit."

Dayna pulled off the highway, and Shelly directed her to Jake's home, one of 300-some identical condominia in a sprawling complex on the sleepy southern edge of town. Dayna pulled into the lot and stopped the car but left the engine running. She felt self-conscious, as if this were the abrupt conclusion to an especially odd first date. "Nice meeting you," she said.

"You, too," Shelly responded, extending her hand. Dayna took it, shook it, let it go. Shelly grabbed her bag and got out of the car, then bent down and peered back in through the open passenger window. "Thanks again."

"No trouble," Dayna said softly. Pitfalls notwithstanding, the past hour constituted the closest bond she'd established in a long time. And it frightened her.

"You want to come in? Jake's home, so it'd be the three of us. I mean…" She laughed nervously, scowled at herself. "Jeez. I mean…"

"No, thanks."

As before, Shelly stared. "You sure you ain't that Cray gal?"

Dayna met her gaze. "To tell you the truth"—she turned the steering wheel, and Shelly stepped back—"there's not much I'm sure of at all." Dayna released the brake and veered out of the lot, back onto the street, up the block and into the distance.

Returning to the highway edgy and preoccupied, she drove more quickly now, as if to out-race the setting sun. Her head began filling with negative thoughts; it took all the concentration and resolve Dayna could muster to mentally shoot down each one in turn as it slid into view. Even so, there were some she missed—and these thrived and grew.

Thus, it never occurred to her that the sun should now have been sinking toward the right horizon rather than the left. It wasn't until she reached the sign for Waterloo—a town name so foreboding, she knew she hadn't passed it before—that Dayna pulled over and consulted the map. It was clear what had happened: instead of backtracking out of Cedar Rapids, she'd continued north. As a result, her previous and intended route west, Highway 80, now lay a good hour and a half to the south.

Idiot.

She couldn't bear the thought of turning around and covering that same stretch of land all over again. To do so would be to empower her error, erase her progress—and feed her resurgent defeatism. Besides, another major route west, I–90, was less than two hours north. That would be just as good. She could hook up with 90 and take it through southern Minnesota, right into South Dakota.

Dayna closed the road atlas with a decisive snap and pulled back onto the road. Passing the exit ramp, she smiled shakily. Perhaps she had met her Waterloo, but she would neither surrender nor attack; she would drive past.

Go ahead. You can run, but you can't...

"Fuck off," she muttered, and gunned the engine.

Soon it was early evening, and Dayna—though an avowed night person from early childhood on—found her mood darkening along with the sky. She cursed the encroaching inner shadow, told it to desist, slammed a fist into the dashboard, shook her head from side to side. Why was this happening? Where did it come from? How could she fight a force that proved immune and, indeed, lethal to her considerable determination, her every iota of will?

Dayna had spent the past few years hurling herself against walls, partitions and deadlocked doors, kicking the debris aside in her largely unobstructed march forward. In the process, she'd carved out a unique and subtly subversive persona, as well as the start of a stellar career. Sure, she'd been bruised here, bullied there. But in the end, her single-mindedness and sheer, stubborn tenacity had always gotten her through. Always…until now.

She'd written of it, sung about it hundreds of times: the invasive, opportunistic evil that "can wear me and tear me, but never apart." Now, on this dark, deserted stretch of north-Iowa farmland, her own words came back to haunt and taunt her. Never apart? *Not so fast, Dayna. Never say never.*

"How clichéd," she muttered. "Is that the worst you've got?"

But it wasn't; not by a long shot. For with nightfall, the blanket of gloom unfurled further, dropping down around her on every side. She told herself to concentrate on driving—to focus on the road before her, the beams of her headlights, the green minivan up ahead, the yellow traffic signs to the right, the black sky above, black as her future, impenetrable as her heart and dark as her soul, her life was doomed, it was only a matter of time, she should have stayed in her garage and sucked in the fumes, by leaving she'd only prolonged the pain, she'd been a coward to run away, driving cross-country was pointless because the enemy was within, there was only one hope for escape, one means of blotting out the pain so speed up a bit, that's right, now a bit more, pass the minivan, good, but watch out, wouldn't want to take anyone else along for the ride, you've done enough damage already so unfasten your seat belt, just like that, drive faster, good, faster still, now you're ready to find a nice telephone pole off to the side, some merciful pillar or concrete abutment, anything solid enough to…

REEE-ooo-EEE-ooo—first she heard the siren and then, in her mirror, she saw the flashing lights. Released from her trance, Dayna yanked her foot off the gas and caught a glimpse of her speedometer dipping back from 90 to 85, 80, 75 as the state trooper gained on her. She applied the brakes, activated her turn signal, began pulling over—and watched the patrol car zip past her at 100-plus. Dayna's surprise had barely even registered by the time the trooper's vehicle sailed over a rise in the road and vanished.

Surely, the cop had to have noticed she was speeding. He must've had bigger fish to fry: an escaped felon, maybe, or a burning building in the next town. Accelerating again, Dayna smirked. *Probably some "fireproof" silo.*

The crisis had passed, and with it her thoughts of suicide…but the gloom remained. It was in the doleful silence of a perpetual shadow that Dayna continued north into Minnesota and met up with I–90. But she took no pride in getting back on track, in having executed Plan B without incident and having made such good time in the process. Instead, she felt only the despair born of believing—knowing—that whichever direction she traveled, whichever route she chose, her unwelcome companion would be there with her.

Dayna wasn't hungry but knew she ought to be; it was past eight. Time, again, to stop and replenish both self and car. Exiting into the town of Albert Lea, she turned onto the main drag. She drove by Red Lobster, Shoney's and KFC, any of which should have sufficed but none of which struck her as appealing tonight. She ended up selecting a cheap-looking Cantonese restaurant because it was adjacent to a gas station. This time she filled the tank before eating in hopes of developing, in the interim, even the most meager of appetites.

She didn't. Still, seated off to one side in the poorly lit House of Yee, Dayna told herself to eat. Nothing would have any taste; when she felt this down, it was all corrugated cardboard with sawdust sauce. But she was this body, and this body needed nourishment. After glancing at her fellow diners—a young Asian couple and, farther away, two white-haired women, both smoking—she reached for the bulky red menu with the weather-beaten gold tassel and flipped it open.

First were the soups: egg drop; ginger; hot and sour. Then, appetizers: egg rolls; pot stickers; chicken wings. She turned to the entrées: beef with broccoli; Szechwan beef; Mongolian beef. So many options. Empress chicken; orange chicken; Peking duck. She had no clue what to order. Curry shrimp; scallops in garlic sauce; Yu Hsiang pork. Plus a whole column of vegetarian dishes. A wealth of choices. But which?

The waiter brought tea. Grateful for the distraction, Dayna picked up the steaming cup, blew on it, sipped…and, shaking, put it back down. Mint. Dayna hated mint—a longtime aversion that, for some reason, tonight held an overtone of fear.

She scanned the menu again, but the listings may as well have been in Chinese. Since when had such inconsequential decisions become so consequential? Dayna raised her menu higher, hiding. The task was too complex—too much pressure, too much responsibility. Before she knew it, a tear was trickling down her cheek; she wiped the back of her hand across her face. "God damn it," she croaked. "Who *am* I?"

All eyes were on her, but Dayna couldn't bring herself to care. The customers, waiter and hostess watched in stupefied silence as she dropped the menu, stood and ran.

Dayna spent the night at a rest stop just west of town, curled into a ball on the back seat. Insomnia, aided and abetted by a throbbing headache, kept snatching her back from the brink, keeping her captive in the realm of the conscious.

At one point she got out, crickets chirping at her accusingly in the dark, and opened the trunk. She removed the one guitar she'd brought on her trip—her old Gibson acoustic, packed with some hesitation at the last minute—and took it with her into the back seat. Dayna played not a note; instead she lay on her side, the instrument's wooden body clamped between her knees, her arms around its neck. It felt familiar, comforting…for a moment. But then the moment passed, and the swirling despair remained.

It wasn't until just before dawn that a lone positive thought—that with the new day's sun, some light might shine into her heart as well—took hold, and with it, sleep.

She dozed for a few hours, awakening around 11:00 to the sound of her own guitar: shifting, she'd dragged one hand across the instrument's neck, her fingernails accidentally strumming a dissonant chord. As the sound faded, Dayna sat up. In her sleep, her hips had rotated into an odd position; her lower back felt twisted and stiff, like a lid forced onto a jar at an angle. Dayna rubbed the sleep from her eyes, put down her guitar and got out.

The sun shone brightly out of a cloudless, azure sky. The warm air was tempered by a cool breeze tickling the tree tops, teasing the edges of the surrounding bushes, flipping a stray lock of Dayna's unkempt hair into her face. Wildflowers, orange and yellow and red, grew in a lush

meadow off to the left. Birds sang, and Dayna thought she could make out the babbling of some unseen brook. She leaned back against the hood of the car, closed her eyes—and shuddered. The scene was a mockery, a brutal joke, for her despair was still very much there.

She walked to the women's room and used the toilet, then splashed cold water onto her face and returned to her car. Not knowing what else to do, she resolved to hit the road and keep traveling till she felt better. Dayna entertained no illusions of being able to drive her way out of it, but this "beautiful" day was wasted on her, so she might as well cover some ground. And besides, she reflected while turning the key, maybe, just maybe there was a place out there somewhere that would feel right, some new locale where she might re-learn how to be happy. Somewhere different; somewhere she'd never been. Somewhere like…

The grave.

Dayna grimaced but went ahead and shifted into gear. *I am this body*, she told herself, *and no matter what you say, this body is still alive.*

She returned to I–90 and continued west along the southernmost stretch of Minnesota, windows up, air conditioning on. She knew it was nonsense, yet she couldn't help but perceive the brightness and warmth outside as a threat, as if sunshine and fresh air were toxic. Back in her garage two days earlier, the air *was* toxic—and because it was, she'd kept the windows *open*. Now, rather than exposing herself to an actual respiratory threat, she was protecting herself from a nonexistent one. That, she told herself, might pass for progress.

Still, the smallest, most benign developments continued to drag her down. While filling her tank in Worthington, Dayna glanced over at the supermarket across the road and caught sight of eight damaged shopping carts piled alongside a dumpster in a silent, inert heap. She had to stand still for a good minute, eyes closed, and choke back the sobs before she could step inside and pay for the gas. Then, returning to her car, she let go; the tears flowed freely, her sadness mixed with self-loathing. *Sure enough*, she thought, *I've become Jodie's little sister, crying over crackers.*

Half an hour later, she crossed into South Dakota, "Gateway," the sign boasted, "to the Great Plains." Again, the moment should have instilled a sense of accomplishment, but Dayna felt hollow, lifeless, numb. Perhaps her suicide attempt hadn't been a complete failure;

perhaps some part of her *had* died in that garage two days before. If so, then what was she now? Passing a billboard advertising a tourist-trap "ghost town" outside Sioux Falls, Dayna grimly considered stopping to fill out a job application.

Another hour west, the sun now dead ahead, she drove through the town of Mitchell, home of another much-ballyhooed tourist attraction, the Corn Palace: a full-sized structure constructed, evidently, from countless cobs of corn. "To Ear Is Human," the billboards advised, "To Visit, Divine"—and at another time, she would have. It was just the kind of campy kitsch monument to which Dayna and her college friends would have flocked, armed with bizarre sunglasses, flash cameras and healthy doses of sarcasm. But that was seven, eight years ago, before she dropped out to focus on her music and…and everything changed. Besides, it would defeat the whole purpose of a place like the Corn Palace to go there alone.

But alone was the only way she could bear to be. She sped past a pair of hitchhikers; she kept the radio off, as the malicious shock-jocks and relentless commercials made her cringe; she stopped for fast food at 5:00 but used the drive-thru so she could return to the road at once. All told, Dayna's second day of travel was far less eventful than the first, would have been downright tedious if not for the crushing sadness that turned it into something worse.

The monotony broke just before sunset. On a barren stretch of grassland just beyond the Missouri River, with no other cars in sight, Dayna noticed a sudden, spontaneous thickening of the atmosphere a half-mile ahead—a dense, billowing duskiness, as if the air directly above that desolate flatland had somehow become much more concentrated and, strange as it seemed, sprung to life.

She'd never seen anything like it. Mesmerized, she hesitated to react, and by the time she'd regained enough of her wits to hit the brake she was already within it and it was above her, upon her, around her, whooshing, whirling, loud and chaotic, blotting out sight, sound and light as Dayna, enveloped, stared blindly ahead.

Her right hand darted reflexively toward the passenger seat but, of course, no one was there; Shelly had been its only recent occupant, and she was a day's drive away. In vain, Dayna wished Shelly were there now to help her, hold her, stroke her head, take her into those long, strong

arms and speak calm words, drown out the sound, show her how to pray, *anything* to make it stop…and then it did.

As the whirlwind passed by her now-stationary car, Dayna found she had grabbed the steering wheel so tightly that her fingernails had cut into—*of all places*, she thought—her left palm. She was bleeding, slightly. Sucking the wound clean, Dayna glanced into her rearview mirror: the maelstrom was far behind but still visible, a remote, hovering patch of gray.

A dust storm. That's all it had been. She'd heard of them, read about them, seen one in some movie on TV. A simple atmospheric phenomenon, probably common in these parts. No reason for concern. And yet, for one awful instant while caught within its midst, Dayna had believed with all of her being that it was her fault—that the cyclone of sadness inside her head had escaped, expanded, laid siege against the world.

Heart still pounding, Dayna pulled off the road, cut the engine and sat in silence for an hour as night fell. Then she returned to the interstate and continued west, her car's headlights blazing, darkness cloaking everything save the road ahead.

As mile followed identical mile, Dayna's unshakable funk found a partner in fatigue. Her thoughts growing bleary and her vision blurry, she stopped at a run-down gas station in some afterthought of a town— Murno, Burdo, something like that—for coffee to go. She filled the cup, took it to the counter, paid—a man, a woman, she didn't notice— and turned away, head bowed the entire time.

As she went to leave the building, though, something caught her attention: a crude, photocopied flyer taped to the inside of the glass exit door. At the center was a washed-out snapshot of a smiling woman roughly Dayna's age cradling a three- or four-month-old baby. Above the picture, in large, bold-faced type, was a single word, TESS, and below it, smaller and handwritten: "Please come home! All is forgiven. We love you. Love, your family."

Sipping, Dayna stared. She discerned a faint sadness just behind the woman's smile—a sadness perhaps visible only to the chronically sad, understood as selectively as a foreign language. In college, Dayna had struggled with Spanish, but in melancholia she was now fluent. Thus, she couldn't help but take Tess' sorrow and her family's grief along with her as she opened the door, got back in her car and continued west.

It proved a heavy burden. And yet, just as each other time Dayna felt that she had reached the breaking point—that she'd endured the final twist that would render her insensate and immobile once and for all—she somehow managed to plod on, if not persevere.

Driving ever farther into the Dakota darkness, Dayna wondered just how much lower she could sink. Wasn't there a limit to how far a person could bend without breaking? "Can wear me and tear me, but never apart"—wasn't that a kind of life sentence? The walking wounded; that was her. Or...

...the living dead.

"I am this body," she said aloud, "and..."—and was silent.

The coffee helped, but only briefly; depleted as she was, Dayna's exhaustion returned with a vengeance. She longed to pull over, lie down and succumb to sleep but instead pressed on, straining to keep her eyes open, afraid of continuing but more afraid of stopping, especially here in this impalpable black void. She told herself to keep going, but at this point, was she even driving west? What did that sign say—240? She didn't remember turning; what had happened to 90? How had she managed to leave it...and where on earth was she now?

Dayna pulled off the road, put the car in PARK and cut the headlights. A fresh yet familiar wave of dread swept over her: something felt...off, perilous, wrong. But why? Simply sitting in PARK with the engine running, darkness all around her, just like...

Just like in the garage.

Dayna turned off the engine and staggered out of the car into the chilly, moonless night. She could see nothing yet was aware of ominous shapes towering over her, monolithic phantasms looming above, behind, all around, dark forms in the darkness, black upon black, dwarfing and diminishing her by their presumed presence.

Unable to go back inside the car, or to forsake it for whatever lay beyond, Dayna crawled onto the hood. The metal was warm, the engine having run for most of the day, and through her clothes that warmth felt pleasing. As she curled up and closed her eyes, the whirl of sorrow began to slow and then subside, releasing her into a far gentler embrace—into, at last, the sheltering arms of sleep.

→·←

Dawn. Bathed in the diffuse light of a low, obstructed sun, Dayna stirred, stretched, exhaled, swallowed, licked her lips, heard a distant bird call and then nothing more, wiped her nose, rolled over—rolled, in fact, right off the hood—and hit the ground with a *thud*.

Her eyes shot open, and she gasped. There it was, again filling her field of vision: the same jagged vertical line—zig left, zag right, sharply left, farther right—that she'd glimpsed for but an instant at death's door. Scrambling to her feet, her head turning upright, she saw the vertical rotate and become horizontal, watched the serrated line sweep sideways and stretch, left to right, clear across the horizon.

It made no sense, but what had not yet become clear was, at least, concrete. Somehow, what she had seen in her garage three days before was the stark silhouette of this vast Dakota land formation—the erratic, eruptive outline of this craggy range rising steep, silent and high out of the humbled earth below.

THREE

IT WAS GHASTLY, AND IT was gorgeous. Dayna could not reconcile her simultaneous first impressions and so gave up trying. Instead, she stood and stared at the looming, saw-toothed mountainscape for a full minute, and then for another…yet the longer she studied it, the less she understood.

Was the formation a hundred feet high or a thousand? Was its base a short walk away, or would reaching it take a day-long trek? A distant, dark bird flew in front of the range, swooping low, then angled deftly skyward…but this told her nothing. Since the bird cast no shadow in the dawn light, Dayna couldn't tell whether its flight path was closer to the formation or to the patch of prairie on which she stood. There was no frame of reference, nothing for purposes of estimation. She was on her own.

Turning, Dayna saw that the craggy wall continued all the way around her; moreover, from far beyond it, the tops of taller ranges poked into view. Whatever these gnarled, foliage-free formations were, they stretched out for miles in every direction. They constituted an immense maze, a surreal, sprawling labyrinth…and Dayna had driven into its midst.

She glanced at her car—an anomalous splash of blue in the tan grassland—then again looked forward. Back-lit by the rising sun, the

towering formation was proving hard to resist. But then, why *should* she resist it? Hadn't it come to her in a clear, compelling glimpse that she had clung to, carried like a road map, recreated on mirror and place mat alike? Now that she had found it, had matched a vista to her vision, there could be no turning back.

A chill crept up Dayna's spine as she took her first tentative steps across the flat prairie. She saw little of the terrain across which she was hiking; she glanced down only to circumvent the occasional prickly-pear cactus, thatch of brush or dried up ravine. Otherwise, her eyes remained riveted ahead and above, where the slopes and peaks jutted ever higher.

Halfway there, a breeze swept in from the right, and Dayna heard the sound of raindrops hitting the dry earth. Incongruously, the sun was shining steadily out of a cloudless, blue sky. Dayna stopped and glanced around, but the rain was nowhere to be found.

Baffled, she continued forward, passing close beside a lone, knotty cottonwood tree, and it was there that the pieces fell into place: as the breeze swelled and became a steady south wind, the tree's branches swayed, their stiff, green, heart-shaped leaves batting against one another—a kind of organic wind chime—and the sound that emerged from their random collisions precisely duplicated the *tat-tat-tat* of falling rain. So close was the resemblance, so convincing the illusion that as Dayna reached to run a fingertip across the smooth surface of a single leaf, she half expected moisture.

She resumed her approach, hastening as she neared her goal, and within minutes she had arrived. Standing at the looming mountain's base, she raised her head and looked up, all the way to the ragged top. Her proximity to the formation and the lowness of her angle conspired to alter the outline, stretching it lengthwise and flaring its peaks to both sides; it was distorted, but still recognizable. The effect reminded Dayna of herself...that is, of the self she had become. The one she half-knew: the quasi-impostor who had inhabited her body for the past few months, living—and occasionally trying to end—the life that was no longer her own.

Dayna widened her stance and raised her arms to the sides. She closed her eyes, took a deep breath and fell forward, her palms, arms and chest lightly hitting the mammoth formation's unyielding face. She

stood in silence, pressed against the mountain, feeling its firmness, its impenetrability, its rock-solid stability, wishing she could draw those same qualities into her own feeble form, her all-too-vulnerable heart, her rickety excuse for a mind.

One hand found a ridge, the other a small, knobby outcropping, and Dayna took hold of both. Locked in this strange, solo embrace, she leaned her cheek against the formation's surface, swallowed and spoke. "Like you," she said, her gruff voice quavering, her fingers clamping ever more tightly around their holds. "Make me like…"

Without warning, the knob in her hand snapped off. Startled, she stepped back. She examined the severed outcropping and found that it wasn't rock at all but some kind of dry, hardened earth; inspecting the spot off which it had broken, she reached the same conclusion. Dayna looked up, disbelief giving way to disillusionment. The formation was composed—each vast peak, every inch of this towering range was constituted—of nothing but dirt.

And yet…it stands.

She sat down, the knob still clenched in her hand, and peered back across the prairie. Colossal mountains made of dirt; trees that sounded like rain…what did it mean? What kind of place was this? Why had she ended up in this…this bewilderness—and what was she to do now?

A sudden, isolated burst of sound off to the right: footsteps; a voice. No: two voices—one loud and deep, the other softer, higher, insistent—in heated conversation. A pair of figures emerged from around the edge of a small formation to the north, perhaps a hundred yards away. One figure, the loud-voiced one, was taller. Both were dressed in khaki and blue, and the head of each was encased in a shiny metal helmet.

Dayna stood and, with some trepidation, began walking toward the mysterious intruders. Noticing her movement, the duo fell silent. The figures then exchanged a quick look and, without a word, themselves headed in her direction.

As the gap between Dayna and the pair narrowed, both figures—first the shorter, then the taller—reached up and removed their helmets. Dayna was relieved to see that the heads inside were recognizably human. The tall figure was a man, the short, bespectacled one a woman. Each wore cowboy boots, blue jeans and a T-shirt; both were dark-haired, like Dayna; and each looked to be older—and tanner—than

she. The man, whose angular, almost severe features reminded Dayna of her own, raised a lanky arm and waved. "Howdy."

Dayna stopped just in front of them. "Where am I?"

The man and woman exchanged another look, and then the latter—speaking with a peculiar formality and the remnants of an English accent—addressed Dayna directly. "Do you mean to ask which county, or...?"

"Which planet?"

The man laughed. "I hear ya. Otherworldly, ain't it? I reckon they shoulda called 'em Strangelands, or Oddlands, or Pretty-damn-weird-lands, but not 'Badlands,' 'cause they ain't so much bad as..."

"Badlands," Dayna repeated. "I'm in..."

"Yes," the woman said, studying her. "A federally designated wilderness area—of which a major portion is also a national park."

"A park?" Dayna glanced around, surveying acre upon acre of arid desolation. "Doesn't look much like a park, does it?"

"No, ma'am." The man was staring at her eyebrow ring; he pointed at it and—his companion rolling her eyes—asked, "Don't that hurt?"

"No," Dayna answered, "not at all."

The man stepped in for a closer view but stopped short and gave Dayna a look. She suddenly realized that, having worn, slept and sweated in the same clothes—and not having showered—since leaving Chicago, she'd gotten a bit ripe. *Jayce was wrong*, she thought; *grunge is far from dead.* "Uh...your helmets. What are they for?"

The man began to answer, but his companion cut him off: "Protection. My assistant and I are engaged in a paleontological excavation on the northeast corner of this formation. Our principal site is located inside a small cavern." She removed her glasses, letting them hang from the cord around her neck. "Occasionally, as a result of our digging, some of the overhanging rock works its way loose, and..."

"Rock?" Dayna lifted up the knob she'd inadvertently removed—"You call this a rock?"—and dashed it to the ground. The lump shattered and scattered, fragments ricocheting off in a dozen directions.

The paleontologist appeared unaffected...but then, that seemed to be the woman's normal, perhaps defining facial expression. "The badland formations," she began, her manner professorial, "are composed of tightly compacted mud, clay and silt, ribbed throughout with layers

of rock. Sandstone, primarily, but also limestone, shale, volcanic ash, an assortment of nodules and concretions—and, more to the point, the richest and most plentiful deposits of prehistoric mammal fossils on the face of the earth. Indeed, literally hundreds of species…"

"Doc," the man broke in, "I think you've answered the lady's question." He flashed Dayna a tentative smile—the kind, she thought, that one might offer somebody who pleased one's eyes more than one's nostrils.

"Actually," Dayna said, "it's funny: I was just sittin' over there, wondering what the deal was with these formations, when who should happen by but an expert!"

The scientist shrugged, indifferent.

"So these things are actually pretty solid, pretty…permanent. Right?"

"Yes and no," the woman replied. "'Permanence' here is a relative term. Badlands are a product of erosion. The rivers that carved out the shapes you see today receded ages ago; however, thanks to long-term exposure to snow and rain, erosion continues, a fraction of an inch per year." She waved an arm toward the surrounding range. "Come back in, oh, 500 centuries, and I dare say the scenery will prove somewhat less dramatic."

The man leaned toward Dayna. "Be sure to mark that one on your calendar."

The scientist cast a sideways glance her assistant's way, then addressed Dayna once more. "At any rate, we should take our leave; we've work to do."

"Yeah," the man said, "we only stopped on account of a…a minor disagreement."

The paleontologist turned again toward her assistant. "Indeed. It seems that one of us briefly forgot who, precisely, works for whom. Isn't that right, Pike?"

The man peered back at Dayna. "Doc here don't think it's safe to hash things out underground—helmets or no."

Dayna looked at the man, then at the woman and then back again. "Well, I…" She was having some difficulty deciding just what she thought of them…a reaction that the pair no doubt prompted in others as well. "Maybe I'll see you around."

The man smiled. "That'd be nice. 'Specially once you've gotten a chance to, uh…"

"Don't worry," Dayna said, approximating the man's western accent, and returned his grin. "I clean up real good."

His eyes locking on hers, he nodded slowly. "*Bet* you do."

The man's employer took hold of his sleeve and, leading him back in the direction of their work site, addressed Dayna over her shoulder: "Enjoy your stay." A few steps later, she turned back and added, "You'd do well to see someone about that throat."

Dayna waved, then watched the scientist and her assistant recede into the distance and duck back around the same ridge from which they'd emerged. Seconds after they'd left her sight, she found herself entertaining the possibility that the man, the woman, the entire episode had been but a figment of her imagination, some kind of absurd mirage.

Then again, there in front of her were two faint sets of boot tracks in the dirt.

Turning, Dayna headed back across the prairie toward her car. There was an odd dynamic to the way her new acquaintances had interacted—something percolating under the surface, a subtext to their bickering. For all his irreverence, the man hung on his employer's every word. Likewise, as much as he seemed to exasperate her, the scientist was remarkably indulgent where her assistant was concerned. Despite the man's mild flirtation with Dayna—a flirtation she'd been surprised to find herself lobbing back in his direction—she had the impression that what she'd stumbled upon was, in essence, a lovers' quarrel.

Eyes on the ground, Dayna sidestepped a gully. Perhaps opposites did attract. For the scientist, seemingly devoid of whimsy, had found a man with plenty to spare, while he appeared to rely on her for the gravity and sense of focus that he lacked. Whether they knew it or not, they comprised a not-quite-matched set; somehow, they seemed to "go together."

Dayna waded, hands in her pockets, through a thin patch of sagebrush. *They're lucky*, she thought, *to have found each other.* Stepping out of the grass, she spotted a solitary ball of hardened mud and gave it a kick; instead of shattering, it scuttled off across the plain, bouncing to and fro. She'd had her share of lovers, most of them similar to her

in more ways than not but few of whom had mattered beyond the moment. Yet hadn't she also had a chance—all right: three—for a deeper, more lasting connection with someone quite different?

There was Erin back in college: a year older, yet "younger" in so many touching, exasperating, heart-rending ways. How much of Dayna's frustration with her girlfriend's idealistic innocence, her naiveté, her utter lack of guile had been, quite simply, envy?

Then came Evan, the producer of Dayna's first CD. In the studio, they'd seen eye to eye on everything: song structure, instrumentation, every chord change, every *note*…a harmony of tastes that had carried over in bed. Yet when the morning came or the music stopped and they got to talking, he'd turned out to be wrong about, well, everything else in the world. But was he? Or was he just different from Dayna: her opposite, her complement?

And then, most recently—and most devastatingly…

Dayna shook her head. *Forget her.* She yanked her hands out of her pockets and picked up her pace.

It was getting warmer—too warm for her jacket, which she took off and tied around her waist. The sun had risen higher, and the formations had changed color, their previous brown-gray transmuting into sand; in addition, a series of horizontal bands had materialized across their surface. Dayna recalled the multitude of materials the scientist had listed—mud, clay, silt and so on—and guessed that deposits from different time periods must have accounted for the formations' various layers, their distinct…what was the word? Strata. She nodded, pleased, and wished the paleontologist were on hand for confirmation.

Reaching her dusty Mystique, she opened the door and grabbed her spring water; she uncapped it and finished it off. Dayna sat down on the hood—still warm, this time from the sun—and realized with a start that she was feeling good today. Maybe that was it; maybe she'd passed through the worst of it. Maybe her long, waking nightmare was finally over.

Stretching, Dayna caught a glimpse out of the corner of her eye: something was moving, perhaps thirty yards to her left. A lone, buff-colored, white-rumped animal was walking across the prairie with rather inelegant stops and starts. A deer? Not with that boxy snout, that oversized jaw; it looked as if someone had removed the head of a fawn and

grafted on a greyhound's. But if not a deer out there on the range, then what? *Where the deer and the* antelope *play.* No antlers—a female?—but that, Dayna felt certain, was what it had to be.

As she watched, the pronghorn antelope continued forward in its ungainly fashion—its front and back halves moving separately, as if hinged—then stopped, lowered its head and grazed. A magpie fluttered out of the adjoining brush, flew several yards away and landed on the ground. The pronghorn paused, raised its head and shambled over to where the black and white bird had set down. Again, the antelope stopped and lowered its head; again, the magpie flew away; again, the pronghorn broke off its feeding, looked up and followed.

Dayna watched in silence as the two creatures worked their way across the prairie. At no point did the bird tolerate the pronghorn's presence for more than an instant...but neither did it ever bother flying more than fifteen feet away.

Whatever its purpose, the repeating cycle of flight and pursuit had the appearance of sport, and Dayna found it significant that this game was being played not by two magpies or two antelopes but by one of each. It was almost as if nature were affirming—dramatizing, even—Dayna's earlier musings. If so, then what point was being made; what course of action was she now supposed to follow?

"Easy," she muttered. "I'll just find some nice bear or bison and settle down." She smiled crookedly. *Should've looked harder for that squirrel.*

Feeling restless, Dayna stood and stepped in front of her car. She turned in a circle, taking in the entire scene. The formations, near and far, tapered up into myriad shapes: some peaks resembled arrowheads; others, towers or turrets; still others, nothing on earth. One 'scape tapered up into a steeple, while the top of another looked for all the world like a sphinx. Beyond these, a hulking formation loomed high into the sky like a haunted hilltop mansion or some decaying, dystopic palace—Castle Dracula, perhaps, after a nuclear meltdown.

There was no denying it: the place was visually arresting. It had to it a kind of horrible majesty, an eerie, appalling grandeur. Ghastly and gorgeous, without a doubt...but what in the world to *do* there?

She watched, waited, listened to the wind, but it blew no answers her way. Then again, maybe none were needed. She had succeeded in extricating herself from the life she'd known before; she'd erased her

commitments, broken her ties with the turn of a car key. Other than the basics—eating, sleeping and so on—there was nothing that she "had" to do at all.

Sooner or later, she would find something out here to occupy her time...but not, intuition told her, by looking for it. Like the jagged line, that "something" would come to her; she had only to wait. Till then, nothing was expected of her. And since she had, after all, nowhere to go, the middle of it seemed the perfect place to be.

She got into her car and started the engine. Then, producing a good-sized cloud of dust in the process, she pulled back onto Badlands Loop Road, open to wherever it might take her.

TIP TOP INN.

BEST RATES IN BADLANDS REGION.

In truth, the establishment located behind the hand-lettered roadside placard looked little like any "inn" that Dayna had seen. It was, plain and simple, a cheap motel: a small front office and fourteen identical lodging units, seven above, seven below. Neither unsightly nor attractive, it struck Dayna as vaguely uninviting and utterly anonymous. It was, for her purposes, perfect.

There were only two cars in the parking lot. A good sign: there would be privacy—if, that is, the place were even open. She parked between the vehicles, got out and made her way to the office. The door was locked; Dayna rang the bell and waited, peering through glass and off-white lace into the shadowy domain beyond. Without warning the lock clicked, the door swung part way open and she found herself nose to nose with a sixtyish woman as austere as the motel she evidently ran.

The woman said nothing.

"Hi," Dayna offered. "I need a room. Are you...?"

The door opened the rest of the way, and Dayna followed the proprietor into her dimly lit office. Stepping behind the counter, the woman pulled out and presented a laminated card listing the off-season rates for single, double and family occupancy. Dayna pointed to the first column. "This one," she said, "single—but do you offer any, uh, long-term discounts?"

The woman stared at her for a moment, then pointed out the "week-ly" rate.

Dayna perused the figure, which was altogether reasonable. "I…may be here a while. Can I pay you in advance, one week at a time?"

The woman nodded.

Dayna nodded back: *Perfect.* Her expenses out here would be minimal, and anyway, she had a good-sized nest egg from which to draw. She would put the credit card company in touch with her bank back home, authorizing the latter to make direct payments.

The woman handed Dayna a pen and flipped open the guest registry. Printed on the top of each sheet were the words TIP TOP INN (crowned, as on the placard, with a crudely rendered silhouette of three badland peaks) and the motel's mailing address. No street name; just a P.O.B. in Interior, S.D. *Interior,* Dayna thought. *Why not? That's where I've been living for months.* She pointed at the address. "Is that where we are—Interior?"

"Outskirts."

Having assumed the woman to be mute, Dayna nearly dropped the pen. "Oh," she said, straining to hide her surprise, and bent low over the ledger. Distracted, she began to write her real name, then caught herself. She'd gotten as far as DAY—and the proprietor was staring at her pen point.

After a moment, she added TON, LENORE, along with a fake address. She took out her wallet and, as casually as possible, handed over her credit card: not the one reading DAYNA CLAY but the other, presumably untraceable one about which only she and Visa knew, a card billed to yet another pseudonym, Catherine Lawson, at Dayna's home address.

The proprietor looked at the card, then at the registry and then at the young woman standing before her. Dayna was about to improvise an explanation, but the woman stepped away before she had a chance. The proprietor processed the card and handed it back, along with a charge slip for the first week. Dayna scrawled Catherine's signature on the slip and tore out the Customer Copy. Turning toward a board on the wall, the woman unhooked the key to Room 4 and handed it to her newest lodger.

"Thanks," Dayna said.

The woman nodded.

Returning to her car, Dayna removed her knapsack from the front seat and her guitar from the back. Bumping both doors shut with her butt, she pondered her imminent transition to motel living. It would be like going on tour, only without the travel. Or the tour mates. Or the lights, or the equipment, or the table full of merchandise with her image on it, or the clamorous crowds of Dayna Clay fans at every turn. Come to think of it, aside from the fresh towels and soap every day, it wouldn't be like her old life at all. Which was, after all, the whole point.

Walking past the office, she caught a glimpse of the proprietor watching her from behind the re-locked door. As unusual as Dayna with her tattered jeans, unruly hair and eyebrow ring must have looked to her, the woman seemed just as strange to Dayna. Why had she spoken that single word and then no more? Maybe that was the only word she *could* speak, and the poor woman went through life uttering nary a sound until, in the natural course of conversation, an appropriate opportunity arose during which to remark, "Outskirts."

Unlikely. Still, Dayna's first two encounters with the locals had left her with a distinctly Twin Peaksy vibe. She found herself beginning to wonder if, in all her time there, she ever would meet anyone halfway normal…or, more to the point, anyone like herself.

Room 4 was much as Dayna had expected: fake wooden paneling, hideous, mustard-colored carpeting, drab yet serviceable furniture— a dresser, a night stand, a single twin bed—and a minuscule bathroom with sink, toilet and tub. No shower, damn the luck; she'd have traded the TV for one in a second. But all in all, she was pleased. The room was clean and well-kept and looked, in its tacky way, quite comfortable. What's more, the view out her window was spectacular: a dusky range of Badlands a mile or so away, sweeping up sharply from both sides into a steep central peak.

Feeling about as dusky as the formations, Dayna pulled the curtains, drew a bath, stripped and stepped in. The tub floor creaked in protest at the arrival of her ninety-some pounds, and when she sat, she found that she barely fit; Dayna wondered how the tub could accommodate anyone larger than her own small self. While the container was less than ideal, the water itself felt heavenly. Curling forward, she dipped

her face under the surface, submerging herself for fifteen tranquil seconds, then sat up and grabbed the soap.

While washing, she noticed again the four semi-circular abrasions on her left palm, where her fingernails had dug through the skin. The cuts were less distinct than before, and none had become infected; rather, they were starting to heal. Dayna pressed the wounds briefly to her heart, then reached for the shampoo.

Her libido, of late, had spent so much time missing in action—or, when present, muffled—that its occasional reappearance always seemed a minor miracle. Each such instance felt like a gift, not to be wasted. And so when she was done rinsing, her hair hanging heavy and clean over her face, the urge arose to linger in the tub, hand between her thighs, and celebrate the living body that, against all odds—and her own darker impulses—she still was.

Then again, could Dayna do that, here and now, without thinking of...of *her*? Unlikely; the harder she beat down those memories, the more determinedly they seemed to spring back up. She could try—could focus on Shelly the hitchhiker, say, or on the scientist's assistant, that rangy, cowpoky wiseacre, Perch or Trout or whatever his name was—but she feared that any face she chose would inevitably morph into the slender nose with the bump on top, the half-open gray-green eyes, the taut, tender lips that had bid her a decisive adieu.

And if, conversely, she gave in, allowing mind and fingers to go where they liked, then the aftermath would be unbearable, for her imagination couldn't erase half as well as it drew. She'd be stung anew with the realization that it was over and that Chloe—her friend and lover, her partner and confidante—was not her *anything* anymore. What had begun as a celebration would dwindle into a wake. And Dayna had grieved enough lately for a lifetime.

She stood and stepped, dripping, out of the creaky tub. As she grabbed the towel, her stomach grumbled. It was a welcome distraction, a timely reminder that Dayna had another, safer appetite to satisfy.

By the time she stepped into the quaint and cozy Stone's Throw Cafe a mile down the road, it was mid-afternoon, so it came as no surprise that she was the only diner present. Scanning the overhead menu, she

sauntered up to the Formica counter, behind which a black-haired, possibly Native American boy of seventeen or eighteen promptly appeared. Noting his age—he stood in the center of Dayna's core fourteen-to-twenty-two listenership—she lowered her hand back to her side: the sunglasses would stay on.

"Take your order?"

"How's the Lakota taco?"

"You'll wonder how ya lived without it. Hey"—he pointed at her eyebrow—"I like your ring."

"Thanks," she said, marveling at how little it took to stand out here in the boonies.

"Whatcha think of mine?" The boy stuck out his tongue, the tip of which sported, side by side, a pair of shiny gold studs.

"They're…great," Dayna blurted. "Nice positioning."

"My girlfriend thinks so, too." He grinned. "Y'know?"

She smiled back; perhaps this community wasn't quite as provincial as she'd thought. "Yeah, I know. I'll try the taco."

"Sour cream? Onions?"

"No, and yes."

"Anything to drink?"

"A large lemonade."

"'Zat it?"

"That's it."

He rang up the order. "Inside or out?"

"I thought I'd take it out to one of your picnic tables…"

"I'll bring it by when it's ready."

Dayna paid in cash, then headed outside and took a seat in the sun. She glanced across the road toward an embankment where four ash trees stood, their leaves just now beginning to turn: most were still green, but a few were easing into yellow with, no doubt, orange and red to follow. Dayna closed her eyes and breathed in. Even way out here, fall smelled like fall.

It was her favorite season. Had been from as far back as she could recall, not only for the colors of the trees and the crispness of the air but also for the costumed tomfoolery of her favorite holiday. Dayna had always considered the candy collecting incidental; the real treat had come from assuming some exotic, alternate identity—Pocahontas or

Princess Leia, ballerina or Batgirl—and, thus liberated, stealing off with her friends to race madly about a neighborhood that was, for one fleeting night, magically transformed.

Regrettably, one of Dayna's junior-high playmates, Roslyn Bailey, was unable to participate in her friends' annual revelry. She was forbidden to leave the house that night, costumed or otherwise, and the only candy she received was the stash that Dayna, drawing from her own take, brought to school for her the next morning. Rozzie's parents believed Halloween to be satanic—a cleverly disguised, societally sanctioned celebration of sin—and were determined that their daughter be safeguarded from it at all costs.

The Baileys also considered Dayna—who had, by age thirteen, immersed herself in goth rock, sporting that subculture's requisite black lipstick, eye shadow and clothes—to be a bad influence indeed. One autumn afternoon in Rozzie's basement, Dayna had overheard the girl's father holding forth. "You stay away from that Clay girl," he'd intoned from the top of the stairs, unaware that Dayna was standing just out of view. "Stop hanging around her house. She's turned herself into some kind of ghoul." Then, his voice lowered ominously: "She may well be a tool of the Devil."

What else was Dayna to do that October 31st but dress up as a big, red pitchfork and head straight for the Bailey abode? She could still see Mrs. B.'s bewildered expression behind the half-open front door, could still hear her hushed voice: "Dayna? Is that you?"

"Trick or treat!" Dayna had cried merrily, well aware that at that house, no candy would be forthcoming.

The woman's eyes had narrowed slightly. "What are you supposed to be?"

"Hell if I know. Ask your damned husband!" With that she'd turned and, cackling demonically, dashed off into the darkness.

But her laughter was forced; Dayna had cursed Mr. and Mrs. Bailey through tears all the way home. Because it was true: there *had* been something evil in Dayna's house…though of this particular evil Rozzie's parents were unaware. And it was an evil to which their daughter, on a single occasion one year before, had been exposed. *But*, Dayna struggled to convince herself, now as then, *it wasn't my evil. It wasn't my doing, and it wasn't my fault…*

"Here you go," the boy said, setting a tray in front of her.

Dayna glanced up too quickly, then recovered. "Thanks. Looks good."

He placed a pair of plastic dispenser bottles beside her tray. "Hot sauce. The red's kinda mild; the green…isn't."

"How hot is it?"

"The flies'll leave you be." He headed back to the door. "If that ain't the best taco you ever ate, then…" He thought for a moment. "Well, then I'd rather not hear about it."

Dayna smiled as the boy stepped back inside. She liked his looks — sweet face, pretty brown eyes, tight little butt — not to mention the way he carried himself. But then, she'd always been a sucker for that whole cool 'n' cocky routine. As long, that is, as it stopped short of arrogance…and the boy seemed anything but. *If he were a couple years older,* Dayna thought while reaching for her lemonade, *and didn't have a girlfriend…and if I weren't an intermittently suicidal basket case…*

She shook her head. "Drop it," she said aloud, then scowled, placing a finger to her throat. Her voice hadn't gotten any better — if one even could call it "hers." Once she'd finished her meal, she would quit reminiscing and take some present-tense action.

Not having eaten in a day, she made quick work of the taco, then stuck a two-dollar tip under her empty glass, picked up the tray and headed inside. The boy was hunched over a stove in the back, scrubbing lackadaisically at a dirty burner; his head turned at her approach.

"Delicious," Dayna said, setting her tray beside the register.

"Told ya. Anything else?"

"Yeah, one thing. Do you know any good doctors?"

Dayna returned to her room at the Tip Top, sat down by the phone — an old rotary model, the first she'd seen in years — and dialed the number the boy had given her. To her surprise, the doctor himself answered; he said he could see her the next morning, then provided directions to his office. His voice was deep, his mien serene; he sounded nice. Reliable.

"Oh, Ms. Dayton?" he asked in closing. "What's the nature of your problem?"

"Take a wild guess," she rasped.

The doctor laughed. "There's a lot of strep going around."

"I don't think that's it."

"We'll find out soon enough. See you at eleven."

Dayna thanked him and hung up. Rising, she turned toward the window: the view had changed drastically. Its sheer newness startled her, drawing her closer until she stood with hands atop the sill, nose touching the glass. In the short time it had taken to make her call, the sun had begun to set and was now drawing a heretofore hidden palette of colors out of the banded formations: gold here, orange there, rust and saffron and pink. It was, Dayna thought, how a rainbow might look if earthbound. Or interred.

She grabbed and pocketed her room key, then stepped outside. Again, she caught a glimpse of old Outskirts watching her, this time from the small garden beside the office door—but Dayna paid her no mind. For just as they had at sunup, the Badlands were beckoning, calling out to her without a sound.

The range visible from her room was a fair distance away; getting there would take some time, but Dayna didn't mind. The late-afternoon air was pure and clean, the ground firm beneath her feet. As the sun sank lower still, the peaks and ridges began casting dramatic, angular shadows down the face of the range, altering its shape—hollowing it here, sharpening its incline there—before her eyes. There was, she thought, a metaphor in there somewhere, but she was disinclined to look for it. Exhausted not only by her illness but also by all of the collateral introspection—by living in "Interior"—she now longed merely to experience, to see, simply to be.

Close to an hour after she'd set off, Dayna reached the bottom of the nearest arid mound. It was short, maybe sixty feet from base to summit, but steep: a kind of "foothill formation" that served as a stair-step to the far taller peaks beyond. To climb it, if she could—and if that possibly precarious foundation of dirt actually held—would be to gain access to the rest of the range, along with whatever sights, sounds and secrets lay within.

She flexed her fingers and, reaching for the formation's rough surface, gazed up. Then she planted one boot atop a craggy crest and began hoisting her body higher.

Dayna climbed well. She was light and lithe, both of which helped; more crucially, though, she turned out to have a keen "climber's eye," a natural talent for spotting the hand-hold that would, in fact, hold; the ledge that would not dislodge, but endure; the foot-hold that would bear her full weight.

Occasionally she would miscalculate and send a just-loosened fragment bumpily tumbling all the way down. Initially, Dayna found herself pausing to watch whenever this occurred; each such plunge seemed a cautionary demonstration of the descent her own body would make were she to seriously misstep…or lose her balance for even a moment. But after the first few times, she began to grow in confidence, to understand—less with her mind than with her arms and legs, her flesh, muscles and bones—that she was not going to fall. *For better or worse,* she thought, *I am this body, and this body seems to know what it's doing.* Thus affirmed, she picked up her pace; within seconds, she had reached the top.

Dayna scrambled to her feet and stood up straight, hands on her hips, giddily grinning from ear to ear. At first, she didn't know why, but then it hit her: this was the closest she'd come in weeks to feeling good…the closest in months to feeling good about herself.

Unbuttoning her jacket, she looked all around her. The elevated angle not only afforded her a view of numerous newly exposed slopes and peaks; it also revealed caves and crevasses, faults and fissures, hardy patches of scrub dotting the base of a neighboring formation—even the occasional juniper tree stubbornly jutting out of the rocky clay below.

How, Dayna wondered, could that be? How could anything draw sustenance from such parched and unforgiving ground? How could a tree take root in that inhospitable, even hostile terrain…and how, if at all, could she possibly do likewise?

Dayna kicked once, twice at the earth beneath her. *Perhaps,* she thought, *I've already begun.*

As if in reply, laughter—young and reckless and male—echoed somewhere off to the north. "Great," Dayna muttered, turning to look but seeing no one. More irksome, keening chortles: three, maybe four different voices. Frat boys, probably, out on a bender. But why couldn't she see them? Could they see her? And anyway, what was so goddamn funny?

Still scanning the northern formations, Dayna recalled an incident from early in her tour, when "Virtual Virtue" was just starting up the charts. In Vancouver, Seattle, somewhere up there, she'd given the song an impromptu preface. "I know how it feels," she'd said evenly, "and so do some of you, to be…taken. Taken advantage of. Taken for granted. Taken down by some scum you never gave yourself to in the first place. It's like by taking *you*, they've taken your spirit, taken your will…taken over your entire world."

The crowd had been silent, expectant. Looking out, she'd locked eyes with a blonde girl who was hugging her own arms and fighting back tears. "Y'know what?" Dayna had continued. "That world isn't theirs; it's yours. No matter what they said, or did, or do. You can take it back. And you can make it any kind of world you want it to be."

Then she'd heard it: a raucous male voice, clearly audible amidst the hush, drunkenly bellowing two simple words: "Party World!"

She'd handled it well—had retorted, "Wrong night, asshole; the Van Halen concert's next week," then ripped into "Virtue" amidst cheers and applause—but the episode had shaken her to the core. It was her first recognition that, having attained "star" status, her following now included a smattering of *them*.

The guys who'd scrawled limericks about Dayna's late-blooming breasts on her junior high locker; who'd repeatedly beaten up her gay black friend, Reggie, while chanting, "Nig-got, Nig-got!"; who'd drugged and date-raped Erin's college roommate; and who had, in general, made life unlivable for anyone the least bit interesting, creative or kind—somehow, a few of *them* had become her fans. The idea had turned her stomach, but there was no getting around it: she was now playing and singing, at least in part, for the enemy.

And now some of them, like Dayna herself, had ended up out here…though search as she might, she couldn't find them.

Abruptly, she detected movement in the distance: on a small cliff under a stony archway, a flat, black silhouette—not a flesh-and-blood figure but the shadow of one—was in motion. As Dayna watched the shadow, whoever was casting it—on hands and knees, it appeared—moved forward, head tilting up, triangular ear bending back, and…and howled? A coyote. For Christ's sake, that's all it had been: a bunch of coyotes!

Dayna shook her head, chagrined by her error—and unsettled by the resultant trip down memory lane. Perhaps the time had come to stop looking back: to the enemies and, yes, the friends of her childhood; to the tour she'd completed; to the roster of romantic partners now long gone. Perhaps she should put the past to rest and concentrate on the present. Wasn't that how she'd reached the top of this formation: by focusing all of her energy and attention, everything she could and had and was on the task at hand—not on then, but on *now*?

She looked down, reviewing the route by which she'd reached her current position. Dayna had gone rock climbing twice in her life, but this was different. The breakaway Badlands would defy professional equipment; their fickle foundation of hardened mud could never be counted on to hold a peg. Fasteners would be ineffectual, tools and accessories obsolete. All you had to work with was yourself.

The indigo sky was fading to gray; only the sun's top half now shone from between two disparate peaks along the western horizon. Night was falling and with it, quickly, the temperature. Dayna re-buttoned her jacket and began to make her way down.

Descent, she found, was a far cry from ascent: not the same operation in reverse but a whole new process. It was also, thanks to gravity and momentum, considerably more treacherous. She could cover some stretches crouched or even upright, but in the steeper sections she had to sit down and proceed, feet first and legs splayed, in a kind of half-sliding, butt-bumping modified crab walk.

Reaching the ground scuffed yet sound, she sat and listened, the coyotes' plaintive yips and yowls oddly pleasing to her ears, and it came to her: the answer to the question that had nagged her since her arrival. She had found not only something to do, but something she enjoyed—and at which, in time, she just might come to excel.

Dayna stood, dusted off her seat and set out for the motel. Soon, all would be darkness, with only a sliver moon shining above. She would have to make her way back across the prairie rather promptly…but no matter. She somehow knew that doing so wouldn't be a problem. Because this land was not only ghastly and gorgeous; for now, at least, it was home.

FOUR

THE LIGHT RAIN THAT had been falling since before she awoke trailed off as the sun made its first, tentative appearance of the day. Dayna turned off the wipers, reached for her sunglasses and squirmed in her seat. Having had her fill of cross-country travel lately—and having felt a twinge of resistance to leaving the Badlands, however briefly—she'd been hesitant to hit the highway. She took solace, though, in the knowledge that she'd only be driving for about forty-five minutes each way.

The stud-tongued boy at the Stone's Throw had known of two general practitioners in the area. As he had put it, "There's one I been to over in Wall; he's pretty decent. Then there's one in Cactus Flat, which is just up the road…but he ain't all that good." And so, directions to the "pretty decent" one's office in hand, Dayna had returned to Interstate 90, which again stretched out before her into the western horizon.

Barren tracts of undeveloped grassland sped by on both sides, along with a smattering of cedar, ash and cottonwood trees, the occasional herd of grazing pronghorns or mule deer, and the ubiquitous billboards advertising that Mecca of North American tourist traps, Wall Drug. The signs had been promoting the store and its multitudinous special offers and exhibits—"Animated Chuck Wagon Quartet!" "New 'Live' T-Rex!" "Free coffee and donut for Vietnam Vets!"—for the entirety of I–90;

they now grew more frequent, and their tone more aggressive, as the object of their considerable exertions finally drew near.

But to Dayna, those exertions were for naught. She was more interested in the wildlife—particularly the large-eared, tiny-tailed mule deer. To her amazement (and amusement), this creature seemed to transport itself largely by hopping, all four hooves hitting the ground simultaneously, as if the deer had been outfitted with a tetrad of pogo sticks.

The prairie, too, sparked her imagination. It was something like Lake Michigan back home: a flat expanse spread far and wide, its outlying edge pressed snugly against the sky. Thanks to the wind—and, perhaps, nature's other, hidden currents—the prairie, like the lake, was in perpetual motion. This vast dominion was more than a place; it appeared to be organic, alive. Dayna found it overwhelming and, in its capacity to overwhelm, strangely reassuring.

And then there were the trees. Here as in the Badlands, the ash and the cottonwoods were just beginning their fall transformation. Despite Dayna's recent resolution to focus on the present, she again found the colors pulling her back…not to the autumns of her childhood, but to a slightly more recent time: to the September, specifically, of nine years ago.

Arriving on campus for her first year of college, Dayna had felt far from home and completely on her own…and she'd loved it. One by one, the spindly structures of old assumptions were toppled, razed and swept away—by her professors, by other students, by Dayna herself—and she had gloried in the sense of deliverance their departure afforded. It was then that she'd composed the first few of her songs that had been worth playing, the first handful of lyrics that said anything worth saying. Midway through winter term, she'd put together her first band.

After a long summer spent waitressing at HoJo's—and navigating the drinking binges and hair-trigger mood swings of her needy, fast-declining mother—fall meant freedom again. "Back to school," such a loaded phrase throughout childhood, now took on an unreservedly positive meaning. She returned to her friends, her studies and her band; met Erin, her first love; and developed a new guitar sound, one that translated her heart's stirrings into dizzying, dissonant chords that turned heads, curtailed conversations, made people stop, look and listen.

"They" took notice, all right—among them a label rep who succeeded, over the course of a single coffeehouse conversation, in convincing the precocious sophomore that only her academic program stood between Dayna and a brilliant career. Maybe it was the double-cappuccinos talking, but every word the man said had made sense. She should strike while the iron was hot; a day waited was a day wasted. Liberating though college had been, it no longer meant deliverance, but detainment. It was time to…

"Exit—my exit!" Hitting the brake, Dayna veered sharply onto the ramp. She shook her head. What was with all the flashbacks; why had she grown so incessantly nostalgic? This time of year always made her a bit wistful, but this was ridiculous. Dayna sighed. As far as preoccupation with the past was concerned, that English paleontologist had nothing on her.

Arriving in Wall—a town of pleasantly modest dimensions, yet a bustling metropolis compared to Interior—she located the clinic, parked in front and, pulling her sports cap down low, headed up the walk.

The middle-aged nurse/receptionist looked up from a book of Word Jumble puzzles. "May I help you?"

"I have an eleven-o'clock appointment. Lenore Dayton."

"You…know that you're an hour early, right?"

"I…don't think so." She checked her watch. "I've got ten-fifty-five."

The woman looked her over. "You from around here, Ms. Dayton?"

"No, I'm from…"

"…another time zone?"

Of course: two days earlier, she'd crossed into Mountain Time. There must have been a sign on the highway, but she'd been too out-of-it to notice. "How'd you know?"

The woman raised her puzzle book. "I've got a mind for such things."

"Just as well," Dayna said, re-setting her watch. "I have some shopping to do."

One of the countless Wall Drug billboards had promised "Everything Under the Sun," a claim that had seemed grandiose but proved accurate. Every item on her list—canteen and compass, Band-Aids and binoculars, mosquito spray, maps and more—turned up somewhere within the multi-structure store's maze of shelves. She even found, in

Housewares, a hose-and-nozzle tub attachment guaranteed to "turn your bath into a soothing shower."

Arriving at one of the innumerable checkouts, Dayna grabbed from the point-of-purchase display a pair of softcover books—an overview of Badlands Park and a detailed survey of the region's wildlife—and tossed them onto her pile. The man at the register gestured toward the assembled items. "If you're goin' hiking, or if you're plannin' to camp out, we sell a fine guidebook…"

"I'm all set." Dayna felt herself changed, and changing, in many ways, but at least one old trait remained: she couldn't abide following other people's directions. What worked for them, she'd repeatedly learned, wouldn't necessarily work for her…and besides, her intuition was doing pretty well out here so far.

After charging her purchases, she picked up her bag and headed for the door—then paused at the exit as a familiar sight caught her eye. There, on the Wall Drug wall, was another copy of the flyer she'd seen in the service station the night she'd arrived: the picture of Tess with her baby and the entreaty from her family to "Please come home."

Dayna stared at the flyer, remembering how it had devastated her two nights before. The situation was still sad…but this time, Dayna's was a sorrow she felt able to manage. She placed a fingertip to the grainy, gray image— *Hope you find happiness*—then turned away.

When "Ms. Dayton" returned to the clinic, the receptionist had her fill out an insurance form, then led her into the examination room. "Shoes and jacket off, please," the woman said, directing her onto a scale. She recorded Dayna's height and weight in a folder, asked her to sit on the table and left the room with a perfunctory "He'll be right with you."

Not half a minute had passed before a husky, broad-shouldered man with enormous hands and soft, hazel eyes walked through the door. Dayna had pictured him as both older—he looked to be thirty-five— and less imposing. "Ms. Dayton," the doctor said, plunging toward his patient four gargantuan fingers and a colossal thumb.

"Doctor," she replied, watching her own right hand disappear entirely within his. The man's grip was as gentle as his eyes; still, Dayna was relieved to see her hand emerge from the encounter intact. "I appreciate your seeing me on such short notice."

"Not a problem." He glanced inside her folder. "You're under-weight."

"I…haven't been that hungry lately."

The doctor put the folder down. "How long has your voice sound-ed like that?"

"Three or four days."

"Any soreness?"

"Not really."

He reached for his flashlight. "How about when you swallow?"

"No."

He examined the back of Dayna's throat, then placed a mammoth hand under her jaw and pressed against her lymph nodes. "Does this hurt?"

"No."

"No swelling." His immense fingers shifted back slightly. "Rotate your head."

She complied, first to the left and then to the right.

"Range of motion's fine." He looked perplexed. "Have you had any-thing unusual to drink lately? Or been exposed to any fumes or chem-icals?"

Dayna hesitated. "Fumes, yeah." She paused. "Carbon monoxide."

He moved his fingers lower. "In what form?"

"Uh…car exhaust."

The doctor released her. "How'd that happen?"

She shrugged. "Just did."

He stared at Dayna for a moment, then sat down opposite her. "How's your health been lately, Ms. Dayton—in general?"

"Fine."

"How about your mood?"

Dayna eyed him uncertainly. "Up and down."

"More up, or more down?"

"Well, today I'm…"

"No," he cut in, "over, say, the past month. More up, or…?"

"Down, I guess. Nothing new about that." She attempted a laugh. "You'd have to know me."

"Lots of negative thoughts?"

"Sure. Can I ask what this has to do with my throat?"

nails. Got caught in a dust storm; I grabbed the steering wheel a little too tight. That's it."

"And the second story?"

She lowered her hand. "That *was* the second story. The first one…" Dayna hesitated. "Ancient history," she muttered, and walked out the door.

<center>➤·◄</center>

Driving back, Dayna found herself regretting the way her chat with the doctor had played out. Sure, his recommendations had been off base — her mood was fine now, and as for her voice, it was probably just strained from the tour — but his intentions were good. Why had she responded so defensively? She would phone him later with an apology. Better yet, she'd call after hours and leave it in voice mail.

It felt like no time at all before Dayna was back in the Badlands. She took a nameless dirt road into an isolated area, pulled off and parked; then, after slipping her new compass and mini-binoculars into her jacket pocket, she hiked to the nearest range. Standing at the base of a mid-sized formation, she gazed up with anticipation. "You're mine," she murmured, then stepped onto a firm-looking knob two feet above the ground.

The knob held…but her boot did not, slipping clean off the surface. Stumbling, Dayna landed on her knee — the same one she'd bruised in her garage. Ignoring the pain, she scrambled to her feet.

She inspected the sole of her boot and found a streak of wet clay smeared across, and into, its tread. She examined the formation: it looked dry…yet there, where she'd stepped, was a small, moist gash. Dayna recalled the rainfall earlier that day. True, the sky had since cleared and the sun had shone, was shining still. But as yet, only the topmost layer of dirt had dried out; just beneath the formation's dusty surface lay a forbiddingly slick foundation.

It *looked* safe…but that safety was skin deep. To make an attempt now would be pointless, even foolhardy, like trying to scale a huge, wet bar of soap. This, Dayna thought, might have been the most crucial lesson about climbing she'd learned so far: when not to.

A scuffing noise, high above and to the left: footsteps? It sounded as if someone, somehow, was climbing a neighboring formation. Dayna

looked up, then across, finding—and now hearing—nothing. *Wait*, she told herself. *Watch for movement.* She breathed slowly, her body immobile but for the scanning motion of her eyes, the occasional blink, the fluttering of her hair in the wind.

Twenty seconds passed, then twenty more. She was about to chalk it up to her imagination when, abruptly, the rounded ridge at which she was gazing separated from the formation's side and walked—*walked!*—right up the slope beside it. Stopping, the figure lowered its head and began feeding on a sparse patch of brush.

Dayna reached into her jacket pocket; her fingertips found and extracted their quarry. Moving as slowly as she could bear to do, she raised the binoculars and looked through them. What she saw was a stolid body covered with gray-brown fur; four straight and sturdy legs; a dense neck and majestic head; dark, distended nostrils; a tawny muzzle; and two rows of flat, broad teeth tearing out great clumps of grass by the root. The crowning touch, literally, was a pair of massive, ridged horns that curled back from above the beast's amber eyes, soaring upward, then sweeping down and around to form, at last, a complete circle.

It was a bighorn sheep—an adult male, a lone, large ram—and it was glorious.

Dayna gasped at the sight, and in response the wedge-shaped head turned toward her. She lowered her binoculars, and the beast's eyes locked with hers. The bighorn stood as still as some exquisite bas-relief sculpture carved high into the bluff above; then, with quick, economical steps, it veered right, scaled a sheer, almost vertical cliff and leapt onto a steep and narrow shelf. The ram made it look so easy—slippery slopes notwithstanding.

Dayna recalled the bouncy, pouncy mule deer and the pronghorn with its clumsy, hinged gait. The bighorn was nothing like these. It lacked the deer's frenetic desperation, and in the spare athleticism of its steps it was, she thought, more anti-lope than antelope. Never had Dayna witnessed such stealthy self-assurance, such pure, physical grace. Her heart awash with envious admiration, she raised the binoculars back to her eyes and watched as the ram reached the summit, paused to glance her way and then—with a toss of its head and a final, bounding vault—vanished over the top.

Dayna closed her eyes, committing the image to memory. It was just

as well that she couldn't go climbing today; no experience that might await her up there was likely to top this. Eyes open, she turned and hiked back across the prairie to her waiting car. She got in, started the engine and drove back to the motel, smiling all the way.

A perfect day for laundry, Dayna thought, throwing her dirty clothes onto the bed and wrapping them in a Tip Top Inn bath towel, thus creating a hobo-esque bundle that soon occupied her car's front passenger seat. Arriving at the unimaginatively named Interior Laundromat, she followed her usual minimalist protocol, tossing everything—whites, colors and darks—into one machine, hitting "warm" and letting them fight it out for themselves.

"It's lucky for you," Chloe had said, "that ya look so smashing in gray."

Dayna inserted the quarters and pressed START . It had been August. A steamy night soon after they'd met, just over a year ago. Hurling socks and underwear at one another like hand grenades, they'd spent far longer than necessary "folding" Dayna's laundry. Their work (such as it was) accomplished, they'd carried the basket upstairs, then headed downtown. Next had come a highlight of that summer: on an impromptu, mutual dare, the two of them had kicked off their sneakers and jumped the rail to go "swimming" in Buckingham Fountain.

Chasing each other through the blissfully cold, thigh-high water, the women, illumined from below, had cast conspicuous shadows high into the misty spray above. When the officer showed up, Dayna had watched in astonishment as her wet-T-shirted companion thrust out her chest and—with some sweet talk, a toss of her copper tresses and a beaming smile—half-charmed, half-flirted the two Criminal Trespass tickets out of existence.

As they'd headed for the bus stop, Dayna had asked, "Didn't you find that a little…demeaning?"

"Demeaning," Chloe had repeated, considering. "You know, I guess you're right. Yeah, it would've been much more dignified to get cuffed, thrown in a squad car, dragged down to the station, fingerprinted, strip-searched, tossed in a cell…"

Grinning, Dayna had slung an arm around her waist. "I see your point."

"Seriously, hon', if that's what it takes to…to maintain our

integrity, let's go back and try it again. Only topless. Maybe then…"

"I see your point!" Dayna had repeated, and by now she was laughing: at her girlfriend's deadpan drollery, at her own p.c. myopia and, most of all, out of the sheer joy of being in Chloe's company.

She'd laughed a lot in those days. Now, staring down at the rumbling green washing machine in the Interior Laundromat, Dayna wondered if she would ever laugh like that again.

A *distraction—I need a distraction.* She'd neglected to bring either of her Badlands books, and the only reading material lying around was a trio of *Watchtowers*, so she ducked out the door and headed to the grocery store two doors down to pick up some supplies.

Dayna had no hot-pot in which to boil water and warm up soup as she'd done back in college—a situation she told herself to rectify if she returned to Wall Drug—and so tended toward items requiring little or no preparation: Pop Tarts (which were OK untoasted), cereal, bread, peanut butter and so forth. She likewise had no fridge but picked up soda, salami, milk, pears, carrots and orange juice, figuring that her car trunk would suffice…unless the weather warmed up considerably. In a pinch, she could fill the tub with cold water.

Stashing her purchases in the car, Dayna returned to the laundromat and transferred her wash into the nearest dryer. With more time to kill, she sat down on the floor and did twenty minutes' worth of stretches and leg lifts, followed by a hundred sit-ups; she then turned over, determined to execute as many push-ups as she could. She pictured herself as a soldier in training: not for war, but for ascent. *I am this body,* she told herself, arms taut, elbows trembling, *and the stronger this body becomes, the better I'll climb.*

Perhaps it was the bighorn sighting that had so inspired her, or maybe the doctor had given her something to prove to herself. Regardless, while fatigue had been a frequent problem, it wasn't today: as the dryer's buzzer sounded, a sweaty, grimacing Dayna muttered "Forty-five!" and dropped to her stomach in victorious collapse.

Her shirt was now soaked; a shame, she thought while rising, that she'd just finished her laundry. When she opened the dryer, though, she discovered that its contents were themselves still quite damp. Rankled, Dayna reconstituted her clothing bundle—now clean and wet rather than dirty and dry—and returned to the grocery store, for a sign

on the laundromat door had indicated that the establishments were under joint operation.

"I just used one of your so-called dryers," Dayna informed the woman behind the counter, "and…it didn't." She held out a dripping sock as a visual aid.

"Was it the one over against the back wall?"

"Sure was."

"Oh, *that* one doesn't dry; just tosses your clothes around. It's broken."

Dayna stared at the woman.

The woman stared back. "You want a refund?"

"Well, sure, but…"

She opened her register and handed over a pair of quarters.

"…don't you think some kind of sign might be a good idea?"

She closed the drawer. "Everyone knows about that dryer."

"I didn't."

The woman shrugged. "Do now."

That sort of logic was hard to dispute. *Must not get many visitors this time of year*, Dayna thought, heading for the door. Which was, of course, welcome news indeed.

Back in her room, Dayna hung her clothes out to dry over various pieces of furniture. Her jeans, which were the dampest of all, went over the heater, and her white—well, light gray—T-shirt fit perfectly over the front of the TV. She turned the set on, albeit with the volume all the way down, on the theory that its warmth might expedite the drying process.

While unpacking her groceries, Dayna decided that none of them constituted that night's dinner. So after reading for an hour or so, she got into her car and headed back to the Stone's Throw…only to find it closed for the night without apology or explanation. The locals, she told herself, could use a lesson in service-industry basics.

Feeling adventurous, Dayna drove up the road to the Rusty Spur, a small bar not far from the grocery store. The handful of patrons paused to note her arrival but then resumed their respective conversations, most of which concerned hunting. The surrounding land, Dayna knew, was a protected area—and the bighorn, she'd been relieved to read, a protected breed to boot; thus, the locals' stories and stratagems concerned other targets on other turf.

A woman was describing an elk she'd bagged in North Dakota the year before; two men to the right were discussing an anticipated outing "down Wanblee way" for pronghorn bucks. Dayna was in the process of imagining the reaction of these folks to her squirrel-saving tale when the silver-haired bartender approached. "What can I getcha?"

She sat. "Small cheese pizza and a root beer."

Her gravelly voice turned a few heads, but they promptly turned back as vague rumors of "poachers in the Park" were shared and compared. While the bartender poured Dayna's drink, a balding, slightly dumpy, middle-aged man in a tan cowboy hat emerged from the men's room and began heading for the corner table; noticing Dayna, he instead veered toward her. "Hey there," he said, sitting down beside her. "You're new, ain'tcha?"

You're old, ain'tcha? she thought, but instead mumbled "Yeah" and turned away.

"Seen ya in the laundromat, doin' your little workout."

She'd been watched? *This* was disquieting—but she mustn't let it show. "'Little?'" Dayna looked at him. "Excuse me. *You* want to try sixty push-ups?"

"That depends. Where would *you* be?"

"Oh, charming." Dayna reached for her root beer. "Why don't you make like a tumbleweed, and blow?"

The man chuckled approvingly. "Got the fire inside, don'tcha? And the voice to match. Works for me." He motioned to the bartender. "Another one for the lady."

"No," Dayna said, quietly but firmly.

With a shrug, the bartender retreated.

The man stuck out his hand. "Name's Lindstrom—Walter Lindstrom. You can call me Walt."

Dayna stared at the hand; she shook it in the most cursory fashion possible and promptly let go. "You're barking up the wrong tree, Walt."

"I don't see a ring. Well"—he pointed at her eyebrow—"'cept for that one."

"Let's just say you're not my type."

"No?" He adjusted his silver and turquoise bolo tie. "Then who is?"

No need for candor, she decided, with this one; just paint a picture he can't begin to approach. "I like 'em tall, Walt. Six-five or

thereabouts…with a nice, thick head of hair. And a beard. Distinguished. European, ideally. Oh, and a little bit…effeminate. Kind of swishy, y'know? Yeah, Walt, that's what I'm lookin' for: a tall, elegant, bearded, bushy-haired Old World dandy." She sipped her soda. "With a cane. Know any?"

He smiled enigmatically. "'Fraid not."

Dayna gestured toward his table. "I think they're calling you, Walt."

He stood, shaking his head. "Fire inside," he repeated and, with a tip of his Stetson, walked away.

The pizza arrived. Not having eaten, again, in a day, Dayna wolfed down her meal. Then she paid her tab and headed for the door, casting a sideways glance toward the corner table, where Walt was seated with two friends. "I don't know which is worse," one of them rather loudly cogitated, "the fact that this beer tastes like mule piss, or the fact that I'm drinkin' it anyway." *Note to self,* Dayna reflected on the way out: *Steer clear of bars with names like "the Rusty Spur."*

Dayna never wore any of the merchandise with her name or likeness on it and certainly hadn't packed any for her trip. She thus was shocked, upon opening her motel room door, to spot a Dayna Clay concert T-shirt hanging from the front of the TV. It took her a few seconds to realize that the image of her face originated not on the worn, off-white fabric but on the screen behind it, showing—blurred but recognizable—right through. She rushed over, yanked off the shirt and turned up the volume.

"…since the final night of her seven-month tour. So far, the response from Clay's representatives has been 'no comment.'" The still photo of Dayna's face was replaced by a video image of several sullen youths seated, candles lit and boom boxes playing, in the front yard of her Bucktown home. The female voice-over continued: "A ragtag assemblage of fans continues to keep an uneasy vigil outside Clay's Chicago townhouse, playing her music, waiting for word that they may not be prepared to hear…and hoping for the best."

"Jesus," Dayna whispered.

The correspondent, a young black woman in a Chanel suit, walked into frame in the foreground. "While the intercepted cell-phone transmission appears authentic, the question remains: was it a suicide note, or just a cry of 'retreat' from the public eye? Until that question

is answered, we are left only with Clay's own parting words…"

Three sentences of text were superimposed over some concert footage of Dayna playing guitar, accompanied by a fuzzy recording of her voice: "I can't go through that again. I wish there was some other way; I…I wish it didn't have to come to this. But wishes…well, I don't believe in wishes anymore."

The image froze, and the correspondent's voice returned: "This is Fanta Foxx for 'Entertainment Tonight.'"

"Thank you, Fanta. In movie news, the long-rumored sequel to…"

Dayna turned off the TV and stared at the blank screen for a solid minute. She removed her eyebrow ring, opened her knapsack and dropped it inside. Then she took her Swiss Army knife out of the side compartment, stepped over to the bathroom mirror and went to work. Dayna's chestnut locks fell into the sink in clumps as she hacked her hair down to a standard two-inch length. She scooped out the trimmings—five fistfuls' worth—and shoved them into the wastebasket.

Dayna left the bathroom, took off her boots and sat down in the middle of the bed, her head bowed, her feet tucked beneath her. Clearly, she'd have to contact someone—Jayce, the label, *someone*—and tell them…what? That, yes, she was alive…but her career wasn't. That there would be no more interviews, no more concerts or CDs. That the kids—*oh, God*—the poor, silly kids should go home and find themselves a new idol. And that she was…

"Sorry," she said, to no one and everyone, her shoulders beginning to sag. "I'm sorry." She burrowed herself, fully dressed, beneath the covers, then reached for the bedside lamp and turned it off, plunging the room, the bed and the body within into the same dense, all-encompassing darkness that already had risen, silent and swift, like a high tide in her heart.

An hour passed. Then another. Then another, and another, each more agonizing than the last. Lying on her side, eyes shut tight, Dayna longed for sleep as for another person, a soul mate: the more persistently she wished, the more painful was her failure to obtain. When at last she fell, just before daybreak, into sleep, it was an uneasy one populated by dreams of insomnia; when she awoke two and a half hours later, it was without having rested at all.

The next day was a field trip to hell. Isolated with her sorrows and self-doubts, her memories, mistakes and fears, Dayna lay staring at the clock radio's mocking digital read-out and cringed at the sliver of sunshine that had forced its way between the curtains and into her stale, brown cell of a room. She yearned to get up—just for a moment—so she could pull the curtains closed and blot out the lone ray of intrusive light…but she was afraid to move.

Toward mid-afternoon she found herself rolled onto her stomach and transported back in time to re-live, pain for pain and shame for shame, the worst nineteen minutes of her life. "No," Dayna pleaded hoarsely into her tear- and spit-stained pillow, "Oh—God, oh—*please*, just—no." Her head swam; she was drunk, again, on the peppermint Schnapps *he* had given her, the first knuckle of her left fist clenched between her teeth, her pelvis pressed into the mattress as he battered his way into the body she ached to flee.

Afterward she lay on her back, mouth open, shoulders shaking, furious: with God, with Fate, with her mother, with her mother's despicable excuse for a boyfriend…and with herself. Was *this* to be her reward for facing her demons, for her defiant unwillingness to sugarcoat, her lifelong refusal to self-censor or suppress? How she wished she could be like those with "repressed memories" who'd been granted, at least within the conscious realm, a sanctuary from the past. She was jealous of the ignorant, the clueless, the oblivious; she envied the cataleptic, the comatose, the dead. And then—

—instantly, at 3:03, as if by the flip of some tiny toggle in the center of her head…it ended.

Dayna sat up in bed, rubbing the tears and mucus from her nose and cheeks. She stood, padded over to the sink and splashed cool water onto her face; she poured herself a glass and drank it down. She used the toilet, stood, flushed. She stared at the strange, short-haired woman in the mirror: not particularly attractive, but maybe that was just as well. Returning to her bed, she sat on the edge and put on her hiking boots, tying them up good and tight. She stood once more, grabbed her jacket and room key and walked out the door, slamming it shut on the room and—at least for the moment—all that had transpired within.

>·<

Silent and intent, Dayna worked her way up the base of the same formation she'd tried to scale the afternoon before. Having spent the interim drying out, it now felt completely different to the touch, stubbled rather than slippery; accordingly, it now supported Dayna's weight and, for the most part, respected her efforts.

Not that it offered her a free ride; rather, this particular formation contrived to undermine its climber's every expectation. What appeared from below to be a straightforward stretch turned out to harbor a yawning chasm. She could jump it—well, probably—but how stable was the other side? There was no way to know, and Dayna wasn't feeling particularly lucky. She therefore retreated and began ascending a steep ridge to the left.

Halfway to the top, she noticed a series of natural steps trailing up to the right: stony, square-edged crests six to ten inches tall, aligned one on top of another. Dayna placed a foot gingerly atop the first, testing: it held. Without delay, she darted forward in deft ascent. One, two, three, four…so far, so good…seven, eight, nine, ten…they were a kind of gift…thirteen, fourteen, fifteen, *fuck!*: the sixteenth step collapsed on contact. Dayna jerked, teetered, arms outstretched, then bent her knees and hunched forward, regaining her balance.

Hands gripping the mountainside, she gazed at the dozen steps that were left…and at the flat, secure-looking plane beyond. "Easy," she whispered, "slow and easy." Placing her boot on the next step, she shifted her weight gradually: A-OK. She ascended the remaining steps one at a time, pre-testing each in turn; when the third-to-last shifted at her boot's touch, she skipped over it.

The "staircase" had brought Dayna to a narrow ledge that spiraled up to the summit: a promising route, *if* she could keep her balance. Facing the formation, she sidestepped her way up, her hands borrowing what security they could from the crests and crags along the way. The rocky nodules of which the paleontologist had spoken proved the first to go, snapping off under the slightest pressure. It made sense: denser than the surrounding dirt, the nodules would readily separate from their fragile foundation—if given the opportunity.

Dayna sent one fist-sized lump plummeting toward the earth below; seconds passed between her toss and the sound of impact. Craning her neck, she peered down: she had climbed higher than she'd thought.

Keep going, she told herself. *Almost there.*

Working her way ever higher, she noticed the narrow ledge beneath her feet becoming narrower still; soon, she saw, it would taper out of existence. She was stuck...unless that vertical crack along the formation's side, the one she'd just passed, offered not only a foothold but an alternate means of ascent. Dayna backtracked, then stood gazing into the crevice.

The topography section of her Badlands book had distinguished between regular fissures and what it called "clastic dikes"—a term that, when she'd read it, had raised a smile. *If that's a cross between classy and plastic*, she'd mused, *I think I've dated one.* In actuality, the term referred to fissures partially filled by ancient volcanic ash. Dayna worked her hands forward, around the edges, and lowered one foot into the rocky gash.

The dike proved an effective route to the top, a means of dipping downward in order to continue up. Ascending in an essentially quadrupedal manner, she kept three of her four contact points—two feet and a hand, or two hands and a foot—planted at all times, moving one limb forward into a stable position before permitting the next to follow. This system made for slow going. A far cry from brisk bighorn behavior...but it worked.

She was now almost as high as the ram had been; today, though, she'd heard no distant scuffing, nor had she seen any sign of that creature or its kind. Not that she'd expected to; she'd read that bighorns weren't territorial, instead wandering far and wide, like nomads or gypsies or...or Dayna herself. No sooner had this notion occurred to her than she stumbled, landing elbow-first on the fissure floor. *Too bad*, she thought while picking herself up, *the resemblance ends there.*

Still, her climbing was improving, if slowly. As with the guitar a dozen years earlier, she now learned through trial and error: by doing what came naturally; by screwing up two-thirds, then half, then a third of the time; by remembering her failures but revisiting her successes and willing herself to prevail.

Finally, Dayna reached a flat stretch that sloped up toward a gently concave cliff, a tier of cumulonimbus clouds hovering beyond. Advancing with ease, she found herself more in awe with every step, for she could see no slopes, peaks or horizon beyond the edge...could see, in

fact, nothing but sky. She had lost track, again, of how high she'd managed to climb, and it now appeared as if she'd arrived at the edge of the world.

Not until she'd reached the very brink could Dayna make out a hazy line of ghost-like formations many miles away. She looked down: a few hundred feet below, the White River snaked serenely through a lush valley dotted with flaxen-leafed cottonwoods and ash. There, far to the west, cattle — or possibly bison — grazed; there, to the north, two horses nuzzled in a sunny pasture; and there, in between, a vacant dirt road wended its way to nowhere.

Dayna sat down on the lip, legs dangling, and placed her palms on the ground…her left hand cupping what felt like a plant. Sure enough: sticking out of the earth, there at the edge of infinity, was a smattering of wildflowers with green leaves and slim, yellow petals. On impulse, Dayna picked one. Drawing the blossom up in front of her, she felt an urge to eat it, though she had no idea why. Instead she wore it, tucking the stem behind her ear.

Returning her attention to the vista before her, Dayna gazed out, down, all around. She watched the clouds crawl by, left to right, near to far; she watched their shadows creep slowly over the grassland, the prairie, the faraway formations. It was a staggering view, a breathtaking sight. And it would make a breathtaking place to breathe one's last.

It was tempting. Because it would be so easy, so freeing, so right: to jump and drop down, down, swiftly reversing her laborious ascent, finally meeting the ground from which she'd started and letting it erase, in an instant, all of her pain. Maybe that's why she'd seen the jagged line back home and why nature, in the form of a squirrel, had intervened: so that she could die not in a dank, dark urban garage, but out here in the air, on the land, in the light.

Dayna stood.

She had hoped, longed, all but prayed for deliverance. And it had seemed for a while that her wish had been granted; it had felt as if the land itself were the answer, and all she had to do was stay there and take it in. That, she could do…could even embrace.

But medication? To start on that would mean she was seriously ill, in it for the long haul, and Dayna doubted she had the stamina. Besides, she loathed the thought of altering her mind. That was what *he*

had done to her: used booze to cloud her brain so that he could more easily seize her body. She hadn't had a drink since, let alone anything stronger, despite her otherwise-typical rock 'n' roll lifestyle. It was self-defense: she kept her head pure lest her body again be contaminated; she kept her mind clean because it was all she had left. But...

But where is it now?

Dayna closed her eyes. She heard the wind whistling in her ears, felt it swirling, curling, currents and cross-currents buffeting her from all directions: separately, in tandem, all at once.

A single step is all it would take...

Gusts from her left, her right, then both, squeezing; from the front, the right, the back and left at once.

...one step that would save me so many others...

Wind from behind, then behind and right; from the left, left still, then from the front.

...one step that would...cure me, solve everything...

Gusts from her left, then from the front; still the front, the front *only*, harder, harder still, pushing and prodding, urging her backward, away from the edge. Digging her heels into the clay, Dayna stood her ground, equally afraid to step forward or back—to die or live—and vowed to wait the wind out and choose her own answer.

Then it occurred to her that the wind itself might *be* an answer.

She opened her eyes and backtracked one, two, three paces, the cold gust in her face subsiding a bit with every step. Was the wind dying down because she was lower now, less exposed...or because, crazy as it sounded, she had done as the wind had asked?

Or were those explanations one and the same?

Dayna turned, stuck her hands in her pockets and continued walking away from the edge. She would climb down, find her way to her car, drive back to the motel and call the doctor. She would reconsider his recommendations...well, up to a point. No psychotherapy; she had neither the faith nor the patience for that. And the drugs? She'd rather not...but maybe; maybe. She would go back to his office with an open mind, and she'd hear him out. She would place her trust in his ample hands and hope for the best.

Another question—the one that had tormented her so in the Chinese restaurant four nights before—now returned. The question was

still tinged with fear, but this time her tone was one more of wonder than of despair. "Who am I?" Dayna asked softly. "Who on earth am I?"

She stopped walking and stood, but no reply was forthcoming. No surprise there; it was a tougher question, really more of a riddle. "Should I live or die?" was a comparative no-brainer, a simple yes-or-no that nature, arguably, had answered on her behalf. But this other question, this far more open-ended one…?

Dayna licked her chapped lips and resumed her descent. *This one, I may have to tackle on my own.*

FIVE

"YOU LIKE FURNITURE?"

"Well, I…" Dayna paused; the doctor's query was hardly the anticipated response to her request for a second appointment. "Excuse me?"

"Chairs, desks, end tables…"

"They serve their purpose, I suppose."

He was silent. Then: "How about riding?"

"Riding…furniture?"

The doctor laughed. "Horses."

"Oh; sure. Yeah, I ride." Was this some strange, free-association exercise…or was he asking her out? She tried imagining those massive hands in a carnal context, then tried not to. "It's been a while, but I rode every year at summer camp."

"Got a pen?"

She found one. "Yeah."

"The name's Drake. He runs a small stable a dozen miles west of Interior. Also hand-crafts the most magnificent furniture you'd ever hope to find." He gave her directions to the man's home.

"Got it." She paused. "What…about him?"

"Go talk to Drake. *Then* come see me."

"What is he, a shrink?"

"He's a stunt man. Take care, Ms. Dayton." And with that, the doctor hung up.

Dayna did the same. She rose, stepped distractedly past the open bathroom door—and flinched, startled by her own reflection. She'd only been blonde for an hour and so momentarily mistook the mirror for a window into the neighboring bathroom. Dayna flipped on the light and scrutinized her new look: the cheap dye from the grocery store had stung her scalp, but it had done the job. Even her most ardent fans would be hard-pressed to peg the bearer of those short-cropped, peroxide locks as Dayna Clay.

She moved closer. Her new persona was somewhat androgynous; perhaps she should take it a step further, stroll across the gender line and go completely undercover. Her breasts were nearly small enough, her hips slim and her facial features harsh enough. Then again, she was a bit slight for a man. A runaway teenage boy, maybe…but in terms of lowering her profile, what good would *that* do? Besides, with her luck, she'd succeed in establishing a credible male persona only to end up meeting the man of her dreams.

Or worse, she thought while grabbing her jacket, *the woman.*

The trip to Drake's began pleasantly enough, for simply having the Badlands in view stabilized and soothed her. She'd been there less than four days and had never seen the area prior to that week; still, driving through, she felt a profound sense of belonging. It was enough to give the notion of "past lives" a smattering of credibility.

Her brow furrowed. *Chloe.*

Dayna's ex had been a big believer in past-life regression—a fact that Dayna, at first, had chosen to find charming. That had proven a challenge, though, for the topic had arisen with surprising frequency. It even came up during their final conversation, during the sound check at that ratty old Pittsburgh arena. She could still see Chloe standing below the stage in the VIP section, arms folded, eyes ablaze, her face a mask of imminent mourning. *She knows,* Dayna had thought. *She sees it coming.*

"Is that why you flew me out to this godforsaken place, Dayna—to break up with me?"

Dayna forced a little laugh, then glanced back toward her drummer; he avoided her gaze. Face reddening, she returned her attention to her

guitar. "You're being ridiculous," she said, eyes down. "Y'know, Chlo, I have a concert to get…"

"I shouldn't be surprised. I mean, it's par for the course."

The A string sounded off. "What is?" Dayna asked, tuning.

"Time and again, I keep falling for people who turn around and pull the rug right out from under me. And not…not only in *this* life…"

"That again?" She tried a chord: not quite, not yet.

"Yes, that again," Chloe said, her voice cracking. "It's part of who I am."

Or was it the D string? Worth a try. "Seems to me there's plenty on your plate in the here and now. Instead of channeling the past, maybe you should…"

"Maybe *you* should answer the question. Did you bring me here to break up with me?"

"No." She tried the chord again: perfect. "No, I didn't. It just…" She looked over at Chloe. Their eyes locked; Dayna's voice dropped. "It just worked out that way."

Only now, weeks later, did Dayna begin facing up to how unfair she'd been—to Chloe, of course, but also to herself. Her mood slipping, she dared not call to mind the rest of that conversation: the soft-spoken yet scathing farewell that Chloe had delivered just before leaving the VIP section, the theater, Dayna's life. Gazing out again at the grassy plain and the dusky formations beyond, Dayna longed for the reassurance this same land had given her not two minutes before. That gift, it seemed, had been but a loan.

From a distance, Drake's house, work shed and stable appeared normal: a trio of humble gray structures erected beside a sizable stand of prairie cottonwoods. As Dayna drove closer, though, she noticed that the house's stone chimney was only half there, that the shed door hung from its hinges at a precarious angle and that the small corral's wooden rails were splintered in as many places as they were smooth. Moreover, the exteriors of all three buildings were seriously worn and torn. *Look up "weather-beaten,"* Dayna told herself while parking, *and there's the illustration.*

That same thought tarried as the property's owner emerged from the work shed and made his way toward her. His tall frame bent to average height, he walked with a moderate limp, a catch in his gait, his left

shoulder curling forward with every other step. Closing her car door, Dayna wondered if the process were as painful as it looked, a likelihood only enhanced by the squinty, gritted-teeth grin stretched over the man's cross-hatched road map of a face. He could have been forty, seventy or, most likely, somewhere in between. But however many years he had lived, it was clear they'd been long ones.

Coming to a stop, he stuck a thumb into his hip pocket; his gray Stetson tilted up. "Help ya?"

"Mr. Drake?"

"All except the 'Mister.'"

A horse whinnied. Dayna glanced toward the corral, where an exquisite Appaloosa was shaking its speckled head at a chestnut mare. Dayna's eyes lingered on the animals. "I'd…like to do some riding."

Drake turned and headed down the dirt path to the stable. Because he hadn't motioned her to follow, Dayna wavered, uncertain; apparently sensing her hesitation, Drake, without slowing, offered, "Horses are down here."

Feeling foolish, Dayna hurried to catch up, then eased into a more casual stride a pace behind him. "That's a beautiful Appaloosa," she said, eager to show the man that she knew what an Appaloosa was — that she was not, in fact, a complete moron.

"That's Blizzard. Just turned four. Wanna ride him?"

"Sure."

Drake opened the creaky gate, and they stepped inside the corral. "Whatcha say, Bliz? Gonna be civil for the young lady today?" He turned back to Dayna. "A little moody, this one. Bit of an attitude."

"Oh. Well, I…"

"It'll be good for him — if you're up to it."

Dayna stared at Drake, wondering just how many of his numerous stunt injuries had occurred on horseback…or, more to the point, falling off. Then again, as she'd discovered while climbing, being intermittently suicidal lends one a fairly casual disposition toward danger. "Yeah," she said, thumbs in her pockets. "I'm up to it."

Drake took her into the stable, collected his fee — $30 for two hours — and handed her a clipboard and pen. "That form's a state requirement," he said, turning to scan the saddle rack. "Need your Jane Hancock at the bottom. All it means is you ain't gonna sue me" — he

hefted a black leather saddle off the top rail—"if Blizzard wraps you 'round a cottonwood or tosses you into a cactus. Or a canyon."

Dayna had no feel for how to read this man. Was he joking? Probably. The horse would behave, and she would be fine. After all, she told herself while putting pen to paper, she was there on her doctor's referral.

As Drake saddled up her horse, Dayna stroked its forehead, scratched behind its ear. "Good horse," she said. "Good Blizzard." She gave the animal's right-rear flank a couple of sturdy pats; with each, a small cloud of Badlands dust rose from its smooth, hairy hide. Dayna wondered whether a solid slap to her own ass might induce, nowadays, the same result.

"Good to go," Drake said. "Hop on up, and we'll check the stirrups."

Dayna pulled her cap low, then placed her foot in the left stirrup, hoisted her body up and swung her right leg over Blizzard's back, all in one assured motion. Taking the reins, she peered down at Drake and glimpsed what may have been an approving look; it wasn't there long enough to tell. She glanced farther down, at her dangling feet. "A little low."

"Couple notches," he concurred, and made an adjustment to her left stirrup.

Dayna slipped her boot inside. "Perfect."

Crossing in front, Drake advised, "He'll want to run, but be careful. Bunch of badger holes under the grass, layin' there like traps, and they're hard to see till you're in 'em." He fixed Dayna's right stirrup. "So make sure you're out of the brush and on a good, solid straightaway before you let him kick it up." Drake gave the horse's neck a single, firm pat and turned away.

"You're not coming along?"

"Wasn't plannin' to. You know what you're doin', right?"

"Yeah, but..." *But I was sent here to talk to you.* "...maybe you could get me started? Take me part way out and point me in the right direction?"

He stared up at her. "Get my saddle," he mumbled, and headed back to the stable.

Drake saddled up the chestnut mare in short order, then heaved himself up on top of her. The moment he did so, his back became somewhat straighter, his shoulders broadened and his crooked legs, lib-

erated from the land, conformed perfectly to the contours of his mount. It was as if he'd been visiting an alien planet with a hostile environment, an atmosphere that damaged and distorted him, and now had come home. "H'yah," he grunted, and the mare trotted out of the corral, Blizzard falling into step close behind.

As they worked their way across the stretch of prairie just to the east, Dayna brought Blizzard up alongside the mare. "I understand you're a stunt man."

"Retired."

"Sounds exciting."

He laughed. "That's one word for it." Drake steered clear of a good-sized grouping of prickly-pear. "Made decent money; I'll give it that."

"Yeah?"

He nodded. "On the westerns, they'd throw in an extra thousand a week to bring my own horse." He looked down at the mare. "That was fine if I was takin' a fall, but if they wanted *her* to drop, I told 'em no. Could've made her. But in the end, your horse's trust is worth more than money."

"How old is she?"

"Oh, not Casey here; she's only seven. This was years ago. I been out of the business a while. Mostly spend my time buildin' furniture."

"Makin' instead of breakin', huh?" Dayna winced, wondering if her remark had sounded as insipid to him as it had to her.

He looked over—"Never thought of it that way"—and kind of smiled.

Dayna kind-of-smiled back. "Did you ever get a speaking part?"

"Cries of pain." He chuckled. "And that wasn't acting! Carlotta—my horse at the time—she rears up, on cue, and 'throws' me through a window. I'm layin' there in a pile of splintered wood and so-called safety glass—which is still plenty sharp, believe me—director says, 'Not bad. But on the next take, pretend you're in real agony.' 'Pretend?' I say. 'Actually, sir, it hurts like a motherfucker!'" He glanced at her sideways. "Beg pardon."

"Not a problem."

As they approached a narrow stream, Drake instructed, "Don't let him drink; that white water'd make him sick. It's too muddy. Got Badlands in it, like everything else out here."

Dayna tightened her hold on the reins as Blizzard stepped across.

Drake guided Casey up a gentle incline. "Don't believe I caught your name."

Dayna leaned forward as Blizzard followed. "Lenore."

"You got a sore throat, Lenore?"

"Sounds worse than it is."

"What kinda work you in?"

"I'm a writer," Dayna said. "I'm doing a book, a travel guide to the Great Plains. Forgotten treasures in the heart of the heartland; America's rediscovered frontier…that kind of thing." *Jesus*, she thought, *where'd all* that *come from?*

"Seen anything worth writin' about?"

"Plenty. The Badlands, to begin with; the formations." A line of deer tracks trailed off to the right. "And the wildlife. The bighorns! I was kind of surprised they're still here."

"They're not; they're back. Got wiped out of these parts by settlers. The feds brought some replacements in from the Rockies, must've been thirty years back—'bout the time you were born, I imagine."

"About. How're they doing?"

"So-so. No serious predators left, but disease takes its toll." He peered over at her. "Sheep made an impression on ya, did they?"

"See," Dayna began with feeling, "I don't even think of them as sheep. To me, sheep are the…the fluffy, docile, *bleating* things that Mary had a little one of. But *these*…"

He chuckled. "You may have a point. Group of bighorns ain't a 'flock'; it's a 'herd.'"

"I rest my case." The incline was getting steeper; Dayna leaned farther forward. "Kind of wish I could get a look at one up close."

"Keep wishin'. They see, smell and hear ten times better than you and me. And on top of that…well, you seen 'em climb, right? They're nature's escape artists."

"Then how'd they get wiped out in the first place?"

"Scramblin' up the side of a steep cliff works fine against cougars and wolves: they can still see ya, but they can't get at ya. Don't work so good against a gun."

Dayna visualized the scenario. "Oh."

"Can't shoot 'em now, of course—not around here. They're protect-

ed. But like I was saying, you'll never sneak close enough for a good look. Only way you're ever gonna see one at close range is…"

"…in a zoo?"

"Hell, no. Every time they've tried to stick a bighorn in captivity, it's died. Pretty quick, too; we're talking days."

"What from?"

"Starvation, exhaustion, whichever comes first. See, the sheep— 'scuse me, the bighorn—refuses food. Just charges back and forth in its pen till its heart gives out. Almost like…" He left the sentence incomplete, guiding his mount clear of a small fissure and up the final, sharp slope leading to the top of the ridge. Dayna leaned still farther forward, her legs pressed against Blizzard's sides as he scampered up to stand beside the mare.

She gazed into the distance: a line of pale, gray Badlands stretched out wide from north to south. Dayna marveled at how formations that appeared so horizontal here and now could look so very vertical close-up.

Drake shifted in his saddle. "Storm comin'."

"How can you tell?"

He aimed a finger at the distant range. "When they bleach out like that, means rain's on the way." Drake looked higher, into the sky. "Couple, maybe three hours. Still time to ride." He turned to Dayna. "Whatcha say, Lenore? Ready to head out on your own?"

She shrugged. "Why not?"

"This is all good ridin' on top. Then you can work your way down the other side, along that basin and 'round to the east. Take your time, don't be afraid to show Blizzard who's boss…" He steered Casey back toward the trail they'd taken up. "…and good luck."

Dayna turned in her saddle, watching her guide descend out of sight. Blizzard watched, too, seemingly surprised by this turn of events, then raised his head and let out a loud if ambiguous whinny. The sound sliced through the crisp mountain air, and Dayna found herself envying the animal its hale and hardy vocal cords.

She nudged Blizzard back into motion, directing him eastward along the top of the ridge. It didn't take long before the horse, acting on his own authority, kicked up into a trot. "Whoa," Dayna intoned, tugging at the reins and slowing him back to a walk. Moments later,

Blizzard again accelerated; this time Dayna shouted, pulling back even harder to bring her horse first to a walk and then—whinnying insistently, his great head bobbing in protest—to a stop.

She perused her mount, who was hoofing the ground impatiently. Drake had said Blizzard was four years old; Dayna multiplied by four for the human equivalent, and suddenly the antsy Appaloosa's behavior made sense. "Listen," she said. "I've got nothing against speed. But it's gotta be on my say-so." Reaching out, she tousled his forelock. "Deal?"

Dayna looked out at the flat expanse just ahead: no grass—nothing tall, anyway—so even if there were badger holes way up here, she'd see them in time. Eyes narrowing, Dayna dug her heels into the horse's sides and, with a spirited "Hee-*yah!*", sent the two of them lurching forward in a trot that escalated at once into a barreling, breakneck run.

One thing was immediately clear: she'd never ridden a horse this fast at summer camp. Blizzard's drum-rolling hooves pummeled the prairie, Dayna bending low over his outstretched neck as the dusty ground shot by below. She kept her legs locked as tightly as she could but relaxed a bit from the hips up, allowing the rhythm of her body to approach, align and merge with that of the great beast beneath.

Amid flashes of terror and elation, Dayna found herself speculating that this sense of oneness—of becoming part of the horse, and the horse part of her—must have been the inspiration for whichever ancient mythologist contrived the centaur. For there was, finally, no perceivable difference, no barrier between rider and mount. *Almost as good as sex,* she thought. *And with fewer complications.*

The ridge's western edge was visible ahead and drew closer with each gallop; beyond it lay a substantial drop. Would Blizzard know to stop in time…or even be able to without help? *Let's not find out.* "Whoa!" she exclaimed, yanking on the reins. "Whoa, boy! *Whoa!*"

Blizzard fell into an obliging trot—obliterating, Dayna noted with regret, their rhythmic unity—then swerved left a few yards shy of the edge and executed a cocky, high-stepping prance before settling into a walk. Again, he whinnied mightily, perhaps in celebration of the run, perhaps because he could. "You said it," Dayna said, envious no more —thankful, even, for the animal's ability to express on her behalf what they both were feeling.

Dayna rode for another hour and a half, guiding Blizzard down the opposite side of the ridge, across an expanse of borderline-desert to the edge of a small canyon and then east through some mixed-prairie grassland where she spotted a number of the foretold badger holes. Directing her still-lively mount to start cooling down, she headed south around the crest, back across the stream and, ultimately, into the corral.

Drake heard her—or, more accurately, her ever-expressive horse—coming and emerged from the work shed to greet her. "Looks like you two got along fine."

Dayna slung herself off the saddle—"Bosom buddies"—picked up a thick guide rope and tied Blizzard off beside the water trough. She slipped the bit out of his mouth; the horse lowered his head and drank with vigor.

Drake walked over to inspect her work. He picked up the rope, dropped it. "Sometime, I'll have to show you how to tie a real knot."

Dayna stuck her hands in her jeans pockets. Caught between his statement's two implications—the dig, which she slightly resented, and the suggestion that he'd like her to come back, which she appreciated— she said nothing.

"Some thirst on that horse," Drake observed. "How 'bout yourself?"

"What've you got?"

He headed toward the house. "Come in and see."

Oddly, the inside of Drake's home was as well-tended as the outside was bruised and battered. The spacious, high-ceilinged living room housed a stone fireplace, a wall-mounted, eighteen-point elk rack, a state-of-the-art entertainment center—and the loveliest wooden tables and chairs Dayna had ever seen. Functional, yes, but magnificent, just as the doctor had said. Even at a glance, it was clear that the craftsman—the *artist*—responsible for their creation had addressed the task with spirit as well as skill. "Did you make all this?"

"That I did," Drake said from the kitchen. "Got beer, iced tea, lemonade…"

"Lemonade sounds good."

"Well…truth be told, it's a 'lemon-flavored drink mix.'"

She shrugged. "Bring on the chemicals." Turning toward the entertainment center—itself constructed of beautiful, rounded oak—she

spotted an 8" x 10" photo standing atop the TV in a slim, cedar frame. The smiling, raven-haired girl in the picture was several years younger than Dayna. "Your daughter?"

Drake walked out to join her. "Yeah," he said, handing over a glass. "That's Kayla."

"Pretty name."

"Family name."

"Pretty girl."

He nodded. "You're looking at me, wonderin' 'How the hell'd *that* happen?'"

Dayna laughed.

Drake gazed at the picture proudly. "You may have seen her on TV."

"Really?"

He nodded. "Has her own show; she's on every week."

Dayna's TV viewing had tapered off during her tour; the commercials had become progressively shrill and the program content increasingly bleak, aiding and abetting her downward spiral, till finally, two months ago, she'd gone cold turkey. Sipping her lemonless lemonade, she looked at the photo again: the girl's face, though open and inviting, held no associations.

Drake turned on the TV, pulled a videotape from its stack, stuck it in the VCR and hit PLAY. "Take a look," he said, heading for the front door. "Be back in a minute."

She watched him leave, then turned her attention to the screen. There, in profile, languorously lounging atop the rounded, gray edge of some largely off-screen object, was the young woman from the photo...but dramatically transformed. She was attired in black — a high-necked dress adorned with a short cape — and her thick, ebony hair had been teased into a disordered head-top mass. The darkness of her eye shadow, lipstick and hair lent her complexion a distinctly anemic hue. Kayla's cute, slightly upturned nose was the only incongruous element of the elegantly macabre persona she'd concocted.

As grim organ music played, her black-gloved hand raised a wine glass into frame and swished the blood-red liquid within round and round; she turned her head, looked directly into the camera and, in darkly dulcet tones, spoke:

"According to Webster—who is, of course, *deceased*—'horror' is a

painful and intense feeling of fear and abhorrence, a shuddering sense of loathing and dread." Kayla savored each syllable as if reading from a gourmet menu—or a potent piece of erotica. "If that sounds like your cup of…" She looked into the glass. "…fluid, then you've come to the right place. For I promise, you shall have the 'pleasure' of experiencing each of these sensations…*tonight.*"

Smitten, Dayna stepped closer to the screen.

Fog rolled into frame, and the camera zoomed out to reveal the object on which Kayla was perched: a headstone. "Welcome to 'Shock Theatre.' I am your hostess, Ivana Viktimm." As her character's pun-derived name appeared in ghoulish yellow letters at the bottom of the screen, she uncrossed her black-stockinged legs slowly, provocatively, and stood. Gesturing toward the grave marker, she continued, "My late husband couldn't make it this evening. A shame, for tonight's film was one of his favorites: *Frankenstein Meets the Wolf Man*"—here, in response to an off-screen howl, she glanced over her shoulder—"starring Lon Chaney, Jr. and Bela Lugosi."

"Ivana" began strolling, the camera panning to follow her across a rather cheesy in-studio graveyard set. "The film's title seems a bit…understated, don't you think? *Frankenstein* Meets *the Wolf Man.* 'Meets'—as if the two hooked up for a mocha latté, or perhaps nine holes and a Cuban down at the club. As you shall see, their actual encounter turns out to be far less…cordial. So stay tuned…" Her aquamarine eyes widened suddenly, startlingly, and her supple voice took on an accusatory edge. "…*won't* you?"

"Whatcha think?"

Dayna turned quickly. "Not bad," she said, downplaying her reaction. "Nice, uh, sense of character. Is that a local show, or…?"

Drake walked past her to the VCR—"Channel 19 out of Rapid City; Kayla goes to school in Spearfish, a few miles north"—and turned it off. "Theater major."

Dayna nodded.

"Writes her own lines."

"Does she?" Sipping her drink, Dayna suddenly noticed a rich, autumnal odor creeping into the living room. "Something smells good."

He shrugged. "Nothin' in the stove."

She moved over to the open window. Gazing out toward the work

shed, she noticed a wisp of smoke flitting around it at ground level. "I…think you may have a fire."

"What?" Drake rushed to join her, his hand gripping the sill as the smoke began to billow. "The lamp—kerosene…" He ran to the door. "My furniture!"

Dayna followed him out. "What can I do?"

He jabbed a finger behind her. "The hose—other side of the house—get it!"

She dashed around the corner, in the process stumbling over a rake half-covered by leaves. Righting herself, she jumped a storm drain and rounded the house's far corner. She located the hose, opened the valve, grabbed the nozzle and ran back, water gushing in a horizontal trail to her side. Just shy of her starting point, an unseen force jerked her backward and nearly off her feet. Looking behind her, she saw the problem: she'd run out of hose.

Pulling it taut, she aimed the hose toward the shed; its stream fell twenty feet short of the mark. Dayna pressed her thumb over the tip, concentrating the jet: a few droplets landed right in front of the door— closer, but still no contact. "It won't reach!" she shouted. "Hey, where are you?" Her eyes scanned the area as the smoke and the smell continued to swell and her ears filled with the sound of blistering wood. "Drake! What do we do now?"

The water issuing from her obsolete hose slowed, then stopped. Dayna stared at the nozzle, then turned to see Drake walking into view— taking his time, ambling—from around the back of the house. "You tell me."

She shook her head, uncomprehending. "The fire…"

"Leaves," he said. "Behind the shed, a safe distance away. I set it while you were in there watchin' the tube." He stopped and stood serenely beside her.

She wanted to punch him—and would have if she'd seen a spot that wasn't already scarred over. "I nearly split my skull tripping over your goddamn rake. Why the *fuck* would you…?"

"Let's take a walk."

Hesitantly, she followed Drake out past the work shed to a clearing where a good-sized pile of leaves was, in fact, burning. "All right. What's this about?"

"Ted Eaton called me while you were out ridin'."

"Ted who?"

"Dr. Eaton in Wall. He said it was him sent you over; said you reminded him of me. I knew that meant you needed some convincin' about your meds, 'cause Lord knows I did."

Dayna crossed her arms; seething, she said nothing.

"They don't mess with your brain; it's the sickness does that. The meds change it back. The meds make you yourself again." He looked down into the fire, watching the leaves crackle and curl, and his eyes darkened. "Believe me, I've been where you are. Wife died five and a half years back. Heart failure, out of the blue. I started grievin', of course—only somehow, the grievin' never stopped."

"Go on," she said flatly.

"I know about those hours that feel like days, the days that feel like nights, the nights that…that never end. I'd lay there with my .45 under the pillow, takin' comfort in the feel of it beneath my head, tryin' to get up the nerve to use it." He looked over at Dayna. "Spent two years in that hell before I got off my ass and got some help."

Dayna said nothing. His story had engaged but hadn't placated her.

"It's funny. I guess I've broken fifty, sixty bones, some more'n once— not to mention collecting all manner of burns, sprains and lacerations—and look: I'm still walkin'. Even been known to dance now and again. The human body's awfully resilient. But the *mind*…" He tapped a fingertip against his temple. "Like fine china. You've got to take care."

"Right, right," she said impatiently. "What about the fire?"

"I needed to burn these leaves anyway, before the rain; figured I'd use 'em to make a point, try and show you the…urgency of the situation. C'mon." Drake started walking again, then stopped when he realized that Dayna wasn't following. He took a single step back in her direction. "It's not your fault, Lenore, but right now, your mind's not workin' right. There's connections in there that ain't gettin' made; signals goin' out, but no receiver."

"I see," Dayna said testily. "So these 'meds' are going to…to add an 'extension' to my mental 'hose' and put out the 'fire.' Is that right?"

"Did for me." Dayna began to cut in, but Drake interrupted her interruption: "Good thing, too. If they hadn't, Kayla'd have become an orphan." His face dropped. "Not that *I* was much use to her…during

the worst time of her life." He looked at Dayna again. "But I came back. I got better. And so can you." Hands behind his back, he turned and headed out of the clearing and back toward the house.

She followed in silence, several steps behind, then broke off toward her car. As Drake climbed the three steps to his front door, Dayna called out: "Hey."

He turned.

She took out her keys. "For what it's worth, I'm semi-convinced."

He smiled faintly.

"But next time, for Christ's sake…just *tell* me."

Drake—caught, Dayna thought, between her dig and the suggestion that she'd be back—said nothing. Instead he nodded almost imperceptibly, then opened the screen door and returned, silent and alone, into the oak and cedar sanctum beyond.

The next morning, just as Dayna was leaving her room, old Outskirts arrived to change the towels and bed sheets. The woman eyed her boarder even more suspiciously now than before. *The hair,* Dayna thought, holding the door for the linen-laden proprietor. "Yeah, it's still me," she offered. "I just figured, if the leaves get to change color, why can't I?"

Stepping inside, the woman said nothing.

Walking out the door, Dayna considered shouting some question to which the probable reply would be "outskirts"—another query about Interior, or a request for advice on how best to gussy up a lackluster prom dress. Instead, she got into her car and headed for Wall.

It was the last time she ever intended to drive the Mystique, for on her way to the doctor she planned to stop at a used car dealership and make a trade. The stud-tongued boy at the Stone's Throw the night before had known of two dealers in the area. One of them, Shmerler & Son, was "pretty decent," while the other, he'd said, "ain't all that good. That'd be Lindstrom's, and word is…"

"Lindstrom?" *That grinning twit at the Rusty Spur. "Walter* Lindstrom?"

"You know him?"

"A used car salesman. Why am I not surprised?"

And so, armed with the boy's handwritten directions to the "pretty decent" dealership, Dayna now sped again down Interstate 90. It was a lovely morning, sunny and cool under a pale, blue sky. The previous afternoon's storm clouds had lingered overnight but hadn't burst, finally dissipating around dawn. Drake had predicted rain, but he'd been mistaken…*not* an omen, she presumed, regarding the validity of his other counsel.

Glancing at her reflection in the rear view mirror, Dayna liked what she saw. She was wearing, again, the tiny flower she'd picked atop the overlook a day and a half earlier. It had spent the interim in a glass of water on her bedside table; before leaving this morning, she'd spotted it and, on a whim, slipped it back behind her ear. The color of the petals perfectly matched that of her new hair—almost seemed, in retrospect, to have foreshadowed it.

She located Shmerler & Son without incident and, after a brief test drive and a briefer negotiation, traded in her Mystique for an emerald-green Probe. Though manufactured the same year as her old car, the Probe had logged nearly twice as many miles; still, it drove well, everything looked good under the hood, and the price was right. What's more, she'd selected it herself; the vehicle had no connection whatsoever to a record label and a career Dayna now considered moot. She filled out the forms, handed over the title (her name, it was clear, meant nothing to the sixtyish salesman), obtained information about ordering state plates, took her new keys and headed for Wall, feeling less conspicuous already.

Also reassuring was that morning's edition of the Rapid City *Times-Monitor*, which Dayna, arriving at the clinic a few minutes early, took a moment to scan. There wasn't a single reference to her in People, Spotlight or any other section. In addition, the lead headline—"21 S.D. Watersheds Get Poor Rating"—suggested to her that the locals' interests tended, conveniently, toward the parochial.

There was, however, an item of interest in the entertainment listings. Despite her aversion to TV, Dayna made a mental note to tune in to Channel 19 at 10:30 that night for "Shock Theatre."

"Ms. Dayton?"

She looked up. The nurse/receptionist, crossword book in one hand, stood holding the door open with the other. "He'll see you now."

This time, Dr. Eaton was already seated in the examination room, reading a file, when Dayna stepped inside. The nurse closed the door on the two of them as the physician glanced up. "A new look, Ms. Clay?"

Dayna froze. "How did you…?"

"Actually, it was Barbara that figured it out. She's quite good with puzzles." The doctor folded his great hands on his lap. "That, and she saw you on 'Entertainment Tonight.'" He smiled. "Then, too, there was the name 'Dayna Clay' on your insurance card."

"Christ! What was I thinking?" She shook her head. "I wasn't."

"Not to worry. Your 'secret identity' falls safely within the realm of doctor/patient confidentiality."

Lawyers too, Dayna recalled, are held to that contract, that commitment. *That* was a thought. She made a second mental note: *Call Susan.*

He placed the file aside. "Incidentally, I picked up your CD. It's quite…strong."

"Thanks." She felt as if she were taking credit for someone else's work. "But about my, uh, problem…"

"How did things go with Drake?"

She provided a brief synopsis, concluding with: "Before making any more referrals, kindly explain to him the concept of tact."

"I'm sorry that happened. Although…"

"You told me he was a stunt man, but I had no clue he'd pull a stunt like that! Still in all…I'm here."

"And I'm glad." He pointed at the flower behind her ear. "What's that?"

She removed it. "Just something I found growing in the Badlands, way, way up on the edge of a…" Dayna hesitated to use the word "cliff," given the doctor's all-too-well-founded suspicions about her condition. "…a ridge."

"May I see it?"

She handed him the bloom, her own curiosity piqued by his.

He studied the flower. "Many of my Lakota patients use herbal remedies as a complement to my own." He shrugged. "Or maybe vice versa. This one, I've seen." Dr. Eaton rubbed one leaf between his thumb and index finger, then showed her his hand: the tips of both digits were

tinged with red. "There's the active ingredient. What you have here is a little something called hypericum."

"All I know is, I had this weird urge to…to eat it!"

"It's also known as Saint John's wort. Dayna, it's used to treat…"

"Depression." The doctor returned the flower to Dayna, who stared down at its pale petals and frail leaves before tucking it back behind her ear. "Wow."

"The body sometimes knows exactly what it needs. Either that, or…someone's trying to tell you something."

This was getting dangerously close to therapy. "Whatever. Let's talk treatment."

They spent several minutes discussing Dayna's symptoms, health history and overall physical condition. Dr. Eaton was intrigued to learn that his patient hadn't had a period in almost three months. "You're certain you're not pregnant?"

Dayna laughed. "Not unless there's some way of getting knocked up that I don't know about. I haven't been with a man in nearly a year."

"Well, you're quite underweight; that could be the reason. Not—not for…" His face flushed. "For the lack of periods, I mean. And the depression could be a factor as well." He gestured toward the flower in her hair. "Funny thing is, hypericum's supposed to smooth out menstrual irregularities, too."

"Can I just take *that*—hypericum?"

"I wouldn't advise it. For mild depression, sure, but not for someone in crisis. I can prescribe something just as safe that'll do a much more thorough job. Faster, too."

"OK," Dayna said with a shrug. Then, wryly, an inside joke to herself: "Bring on the chemicals."

There was, Dayna found, something a bit disconcerting about walking past a roaring, teeth-gnashing, life-size Tyrannosaurus Rex on the way to pick up one's psychopharmaceuticals…but such was the nature of obtaining meds at Wall Drug.

Standing in line at the prescription counter, she glanced down at the trio of Rx slips in her hand. Dr. Eaton's handwriting was unusual-

ly legible and his lettering, as she'd expected, quite large. Reviewing the names of the drugs—two of which she was to take daily, the third as needed—Dayna improvised a snippet of campy sci-fi dialogue in her head: *People of Earth. I am Zoloft, ruler of the planet Xanax. Submit to our Trazadone beam, or die!*

"Help ya, blondie?"

Dayna glanced behind her, preparing to tell the pharmacist that *she* was next in line.

"Miss?"

"Oh," she said, turning back to face him, and handed over the slips. She considered making a joke out of it—"Lost track of who I was"— but decided not to, in view of the type of drugs she was procuring.

After paying for the pills, Dayna left Wall Drug and, in short order, Wall as well, hitting the highway in her new used car and heading back to the Tip Top. It was still sunny, and she longed to get back out on the land, to feel the formations under her feet, to savor the sensation of their rough hide pressed against her fingers and palms. Returning to her room, though, she paused to knock off two quick chores: she took her first Zoloft, and she picked up the phone and dialed.

A bored female voice: "Fleckman, Dwyer and Lowe."

"Ms. Lowe, please."

"Whom may I say is calling?"

She sat down on her bed. "A client."

"A current client, or…?"

"Yes."

"And your name?"

"An *impatient* client, on a confidential matter."

"One moment." Several seconds passed; then, "This is Susan Lowe."

"This is Dayna Clay."

"Yeah, right. The last one at least *sounded* like…"

"Girl Bar," Dayna cut in, "on Halsted. The day after Valentine's— a Saturday. You were wearing a brown bomber jacket. You took the seat next to mine and said…"

"My God. It's you!"

"No; more like, 'Buy you another?'" Dayna stretched her legs. "No sparks, sadly…but it did turn out to be the beginning of a beautiful attorney-client relationship."

"Dayna, are you all right? Where are you? I have about a million questions…"

"The answers to which would be kept, I take it, in the strictest…?"

"Absolutely."

She gazed out the window and into the distance, where the looming formations awaited. "Good. But I've only got a minute. Just know that I'm alive…"

"And well?"

Dayna reached toward the bedside table and stacked up the three pill containers, one atop another in a teetering tower. "Getting there."

"Can you give me your number and address?" Sensing her client's hesitancy, Susan added: "Emergencies only, and I won't share it with a soul. Not even Jayce."

"*Especially* not Jayce." Dayna sighed. She'd always trusted Susan—more, oddly, than she'd actually liked her—and so supplied the information, adding, "I'm registered as Lenore Dayton."

"Not Washington?"—Dayna's touring pseudonym, derived from her initials.

"Nope. No more tours; Ms. Washington is deceased. Put out a statement, would you, Susan? You know: I appreciate my fans' concern, but I'm doing fine; I'll be gone for a while, and I need to be left alone."

"What should I say you're doing? Why should I say you…ran away?"

Suddenly recalling what Drake had told her out on the trail, she felt as exposed as a cliffside bighorn caught in the cross-hairs. "Say whatever you like. Or whatever Jayce likes. Talk it over; you two decide. But please, Susan…do it today."

Dayna headed out on foot and climbed till sunset, working her way up, down and across numerous peaks, valleys and canyons, trusting her compass—and, if necessary, her flashlight—to guide her safely back. And indeed, those items would have to suffice, for the Badlands offered few reliable landmarks. The distant summit that had resembled a house's roof sharpened, as she drew nearer, into an upturned arrowhead; the formation that had tapered into a hand-like shape smoothed out, as she rounded its base, into amorphous anonymity. Nothing here was constant—not to the eye.

It proved an eventful climb. Stepping too quickly across a seemingly stable outcropping 100-plus feet up, Dayna felt the foundation shatter underfoot and found herself in free-fall. She plummeted straight down and landed on her feet, without a scrape or sprain, atop the sturdy ledge seven feet below. There was a sore spot on the side of her tongue; apparently, she'd bitten it. Not very hard, though, for there was no blood.

It had happened so fast. What was that fleeting fragment of thought, that sub-verbal shard that had shot through her mind while airborne? Was it a prayer? If so, it was her first in ages. Steadying herself, Dayna struggled to translate the thought into words. *Let me live*—that was close. Or, simply, *Live*.

As if in callous counterpoint she then spotted, encrusted in silt and jutting down from the underside of the half-collapsed ledge above, what looked like a human skull. On closer inspection, it turned out to be one of several mud nests built and later abandoned by the local cliff swallows. The typical nest resembled a misshapen jar—with a single, round aperture interrupting its oddly cranial curvature—yet this one had three openings: two seeming "eye holes" and, below and between, one for a "nose."

Dayna stared up at the nest; its mouthless face stared back. She stood on tiptoes and tapped a knuckle against the object's side. The sound that emerged was predictably dull and hollow: the sound, she thought with a chill, of death.

It was exactly one week since her suicide attempt...*and yet*, she reminded herself, *I live*. "I live," Dayna repeated aloud. "This body lives." Stepping past the mud nests, she scrambled up the next ridge as the sun began setting behind her and a near-half-moon came into view.

Reaching the top, she noticed the vast shadow—eighty, maybe ninety feet tall—that she now cast onto the facing formation. It reminded Dayna of her spotlight shadow, the one that, at some point in every concert, loomed high on the rear wall of whatever hall she was playing. Though initially the sight had inspired her, in time it had made her feel small and insignificant beyond words. This current shadow had a similar effect...but the smallness she felt now was tinged less with inadequacy than with awe.

Am I casting a shadow on the earth, or is the earth casting me?

A scuffing sound drew her attention to the peak just to the east. As

she located the noise's source, it took all of the self-control Dayna could muster not to gasp as before, for there on the formation's sheer, brush-bespecked face stood a whole herd of bighorns: rams, ewes and lambs alike, sixteen in all, grazing indifferently sixty yards away.

Slowly, Dayna edged to the side and ducked behind a short crest. Eyes riveted on the cluster of bighorns, she lowered herself into a seated position...and directly onto a prickly-pear cactus. Squelching her cry, she leaned forward and knelt; reaching behind her, she located by touch and pulled out the needles—mercifully, only four—that had penetrated the dusty denim to lodge themselves in the tender flesh of her butt.

In spite of this mishap, the cover she'd sought had done its job: the herd had yet to notice her. A light wind blew into Dayna's face; if it were to switch directions, the animals would smell her and beat a hasty retreat. Instead, the bighorns—seven stolid rams with massive, curling headsets; five ewes whose short, slender horns resembled misplaced tusks; and four lively lambs—carried on with their feeding in utter nonchalance.

Dayna remained perfectly still, an act with which she had some facility. Before her career took off, she'd picked up a few bucks modeling for art classes and had learned, of necessity, how to maintain positions of varying comfort levels for extended periods. The long poses worked best when she screened out her surroundings, slowed her breathing and entered a state verging on the meditative. Now, though, she remained alert, for her environs and their inhabitants were not a distraction; they were her reason for crouching here in the first place.

Dayna recalled Drake's lesson in not-so-natural history: how these bighorns, or at least their forebears, had been displaced from their native habitat and brought to the Badlands by forces beyond their control...just as had she herself. Watching the creatures navigate with ease the steep slope before them, she hoped she would prove even half as adaptive as they.

Standing guard above the rest was a large, implacable-looking ram, possibly the same one Dayna had encountered before. He stepped forward and began ascending a nearly sheer wall—the type of surface that, in Dayna's experience, could be scaled only by insects, lizards and comic-book superheroes. Heroes? That wasn't far off. For the more she

watched the ram and his cohorts, the more aware Dayna became of harboring an acute inter-species crush. *As if,* she mused, *my bisexuality didn't complicate matters enough.*

One of the taller ewes, a hardy-looking adult, turned away from the patch of brush she'd been patiently decimating and began deftly ascending the ridge above her, heading for the spot upon which the herd leader stood. Absent the ram's great, bi-coiled crown, she came across as less ostentatious than he; still, her hoofwork was as nimble and her steps every bit as assured. Maybe she was his mate, or perhaps she was declaring her interest in such a prospect. At any rate, she stepped up beside the ram, tucked her snout behind his jaw and as the *rifle blast echoed in Dayna's ears*

> fell
> sliding
> past the rest
> to land in a splayed
> heap at the formation's base.

Dayna bolted to her feet. "No!" she shrieked, her torn voice fraying further. The ram leapt over the summit and out of sight as two more shots rang out, neither finding its mark. The rest of the herd, in soaring bounds, likewise dashed upward—hooves crashing, bodies careening, an avalanche in reverse—and disappeared over the top.

Heedless to the danger, Dayna half-ran, half-slid down the adverse face of her lookout peak, charging through the twilit canyon toward the fallen ewe. "Oh—God, oh—*please,* just—no." Her head swam as she reached the heaving body. Falling to her knees, she cradled the ewe's head in her arms, the side of one smooth horn pressed between Dayna's ribs. Liquid heat gushed from the animal's muscular neck; stroking its trembling torso with her right hand, Dayna clamped her left palm over the wound in a pointless attempt to stanch the flow.

Something Drake had said came back to her: a string of words, a statement she hadn't let him finish: "Only way you're ever gonna see one at close range is…"

…is dead?

In desperation she stroked faster, cooing and baaing in soft, guttural tones, the syllables of a language Dayna herself didn't know. As if in response, one amber eye rolled up toward her, locking briefly with her

own. The ewe raised its haunches, twisting its trunk weakly, then dropped back to the ground. Its trembling slowed, subsided…ceased.

Dayna tightened her embrace around the creature's head and began to sob, her tears and saliva staining its hide. She looked all around her, searching for the poacher she knew to be out there still, but the tears and the ever-darkening sky left all a dim blur. Raising her head, she suppressed the sobs to shout out as loudly as she could: "Mother-*fuck*er!" Her fists gripped the ewe's coarse fur, pulling its body into her own. "Missed your target, didn't you? Missed your ram. Now you've gotta get rid of the evidence. Except we're not going anywhere!"

From out of the darkness, an agitated male voice: "Turn around."

She screamed at him—an appalling banshee cry that dissolved, finally, into another sob—then regained control, her rage simmering. "I see you," Dayna lied. "I…I'm lookin' right at you. Coward! *You* turn around. 'Cause I won't look away—not this time. And I *won't* do what you say!"

She waited, eyes flitting from side to side. Then, through the teary haze, she was able to make out—barely—a solitary shape retreating over a jagged crest to the left.

It could have been a trick; he might have moved only a short distance away. Dayna thus remained kneeling in static silence, drawing in deep, calming breaths, keeping her patient vigil over the dead till nightfall was complete.

As the moon shone out of a starry sky, Dayna again grew cognizant of being watched. This time, though, she sensed not one pair of eyes but many—glowing, yellow, slightly slanted—situated at what was, in her present position, her own eye level. The skulking figures filed silently toward her from two directions at once and fell into a rough semicircle around her, hemming her in against the formation's side.

It wasn't she, Dayna half-hoped, half-guessed, that they wanted; to them, she was a fellow predator—not quarry, but competitor. Heart pounding, she released the ewe and rose slowly to her feet; she removed her bloodied jeans jacket and dropped it beside the carcass. Then, at a deliberate pace, Dayna began sidestepping left. The pair of eyes closest to her receded, edging to the right, and allowed her free passage out of the pack.

Shivering in the late-September chill, Dayna hurried away from the

feasting coyotes and back across the canyon. She unpocketed her flashlight and compass, activated the former, aimed it at the latter and determined the direction home: west by northwest, 290 degrees.

The trip from this unnamed canyon back to the Tip Top would be arduous—would take, under current conditions, twice as long as had the journey there. But Dayna was more than up to the challenge, was filled, at least for the moment, with a sense of invulnerability. Because although the poacher might still be waiting out there in the darkness, Dayna somehow discerned that he wasn't...that he had, in fact, fled.

In her heart, she simply knew it: this time, she had won.

SIX

THE NEXT MORNING, Dayna shuffled bleary-eyed into the ranger station to report what she'd witnessed. The officer on duty was a subdued, fortyish man whose initial detachment vanished upon hearing the word "poacher." Grabbing a pen, he scribbled succinct notes while listening to Dayna with interest and intent. When she was through, he posed a few pointed questions—What time had the incident occurred? What kind of gun did she think the man had used? Was his voice at all familiar?—questions that Dayna, having already disclosed everything she knew, answered to the best of her ability, which is to say not well at all.

"I'm sorry," she said, "but it happened so quickly. I think the shock of it—my...agitation, my fear—kept me from noticing more."

"I don't know," the ranger replied, his tone one of grudging admiration. "You sound pretty fearless to me. Bordering on reckless. Seriously"—he checked his notes—"Ms., uh, Dayton, if I could offer a word of advice...?"

"Sure."

"In the future, if you wind up in the vicinity of an illegal kill, don't situate yourself between killer and quarry. Your typical poacher doesn't have much of a conscience. And, of course, it's in his interest not to leave evidence. Or witnesses."

What he said made sense…yet wasn't there another question in play, a larger issue at stake? For if staying alive meant backing down in the face of evil—if survival entailed surrender—then what was the point of living? It seemed a rather metaphysical question to ask of such a no-nonsense man, so she muttered "Gotcha" and kept her qualms to herself.

Dayna offered to escort him to the place where the shooting had occurred, or anyway to try, but the ranger responded, "From your description, I think I know the spot. Besides, once I get close, the buzzards'll take me the rest of the way."

"I'm guessing those coyotes didn't leave much."

"Even so…" He smiled tentatively. "I'm a pretty good tracker. What I'm saying is, you don't have to lead me out there, because you already have."

"Oh." The notion intrigued her. Dayna eyed the ranger's broad face with its sharp planes and prominent cheekbones; he might, she thought, be part Sioux.

"Say you're staying at the Tip Top?"

"Room 4. If you end up needing my help…"

"I'll be in touch." He reached to shake her hand. "Thank you."

Dayna headed out the door and, under an overcast sky, across the lot to her waiting car. She felt gratified by the respect the ranger had shown her…hardly a given, historically, in her interactions with male authority figures or, for that matter, men in general. He had addressed her not as a little girl, a sex object or—worse—some sick combination of the two; rather, like Dr. Eaton back in Wall, he'd treated her as an equal. It therefore annoyed her all the more to glance up and find herself walking straight into a second encounter with the approaching Walter Lindstrom.

Though his eyes and attention had been trained on her from the instant she'd entered his sight—his entire nervous system, Dayna theorized, was geared toward the detection and pursuit of women half his age—it took Walt a while to identify her as the former brunette he'd met at the bar. Once he did so, his face positively shone at the revelation. Slipping his hands into his pockets, he dropped into a saunter; peering out from under his Stetson, he appraised Dayna as he might a shiny yellow sports car just brought into his lot. "Tell me. Do blondes really have more fun?"

Averting her eyes, Dayna kept walking.

"'Cause I could help ya find out."

"Would I buy a used pickup line from this man?" Removing her keys, she stepped past him. "Not on a bet."

"It suits you," Walt continued, pivoting to let his gaze follow her. "Not that you didn't look fine before. But those 'goldilocks' oughta be good bait for that Euro-sissy you're hopin' to snag. Still, I'm guessin' the Dakota Badlands ain't the likeliest place to find him."

Dayna got into her car.

"You may be waitin' a while."

She closed the door, then replied through the open window, "I've got time."

"Me, too. Care to kill some together?"

"Listen," she said, turning the key, "yesterday I sat on a cactus, so…"

"So you don't need another pain in the ass." Walt grinned, pleased with himself. "Right?"

"No," she said, gunning the engine and jerking the car into gear. "So I've had my share of irritating little pricks for a while."

He chuckled, then spoke the words—"Fire inside"—that Dayna knew he would even before the squeal of her tires blotted them out entirely.

"It's all taken care of," Susan said, her calm voice reassuring across the many miles. "I called Jayce, and she got your statement out right away. She added a line about 'exhaustion following the tour'; she said people would need an explanation. Anyway, it's in all the papers, and I heard it on the radio this morning. You're alive."

Dayna nodded, her fingers twisting the cord. "Good. And the kids…the ones outside my house…?"

"I heard about that. Quite a tribute."

"Listen, Susan…" She sat down on the bed. "Could you do me a big favor? Could you drive over and see if any of 'em are still around? Tell them you've talked to me; thank them, and tell 'em to…to please go home." To her surprise, Dayna found herself choking up; she cleared her throat. "Tell them to get on with their lives. Could you…?"

"Will do. Listen, I have a couple of messages from Jayce."

Dayna grimaced, pulling her bare feet up underneath her. "Go ahead."

"Some computer-game company approached her about using 'Virtual Virtue' in a TV commercial."

"Good God." She laughed, incredulous. "Do they even know what the song's about? Have they listened to the lyrics?"

"Well, they were interested in *changing*…"

"And Jayce told them…"

"…to call back…"

"*What?!*"

"…when the Pope does a spot for Trojans."

Dayna smiled. "Nice." She reached for her brand-new jeans jacket, purchased earlier that day at the local general store. "And the other message?"

"It's about 'Letterman.' This Friday."

Dayna opened her pocket knife and cut off the tag. "As you may have guessed, I won't be making it."

"Jayce has come to terms with that. But she doesn't want to disappoint Dave, or CBS, so she…" Susan's tone was equivocal. "…she's approached Justin Gould about filling in."

Dayna closed the knife. "Who?"

"The kid you gave your guitar to. He got some good press out of that whole episode, especially in the wake of your disappearance. Anyway, the idea is for him to go on with your Strat, talk to Dave about how he got it and, uh, play one of your songs."

"Oh, *that* would certainly quell the media circus."

"Jayce strongly recommends you OK this. Letterman likes the idea, the boy's parents are cool with it and apparently Justin himself is nearly speechless with excitement."

"No doubt. Well, as far as I'm concerned, Jayce can tell the kid…" Dayna paused, looking across the room and out the window. The morning sun had broken through the clouds and was casting vast shadows across the distant formations. She stared for a moment, then shook her head. "Tell him to get over it."

"Get over…?"

"The speechlessness. He doesn't want to make a fool of himself on network TV."

That second week, Dayna fell into a daily pattern that most outsiders would have found odd but that for her felt absolutely right. She woke up early, did half an hour of sit-ups, push-ups and stretches, rewarded her efforts with a Pop Tart and a piece of a fruit, then filled her canteen and packed for the day. She drove to a new location every morning—not difficult, given the area's 244,000 acres—stopping wherever whim or intuition instructed. Looking out, she located the highest, steepest or most distant peak visible from her vantage point…or, ideally, one that met all three criteria. Reaching the summit was her goal for the day, though she reserved the right, once there, to look still farther out and select another.

Understandably, Dayna's climbing ability improved by leaps and bounds, the first such bound occurring right off the bat. Making her way up a looming badland wall the day after the bighorn ewe's death, Dayna marveled at her own sure-footedness, the ease with which she was able to navigate this loose, inconstant terrain and scale a stretch as sheer as it was shaky. Darting over the top of the formation and onto a narrow ledge, she found herself entertaining an odd notion: that perhaps, out of gratitude for whatever comfort Dayna had managed to offer it, the ewe had given her something back.

She sat down and worked her heels into the clay, the notion tugging at her imagination. Could it be that in the instant the creature had looked up and locked eyes with her, its head nestled in her arms, her left hand—yes, her left *palm*—clamped over its surging wound, what had washed over her was not only its lifeblood but its life force? The ewe had left its mark on Dayna's surface. But had something else gone deeper, seeped into her, become a part of her?

How very New Age, Dayna thought, getting to her feet. *Chloe would be proud.*

Whether or not some supernatural element had played a role, it was clear that all of Dayna's practice was paying off. As with the guitar back in college, she'd turned some unseen corner, had reached a level where discoveries were constant and errors ever more rare. Her steps became steadier, her bearing more balanced and her gait more graceful each day.

Having achieved near-mastery of ascent, she turned her attention to its problematic opposite. From the start, descending the formations had proven more challenging for Dayna than making her way up them. But now, rather than continuing to fight her downhill momentum, she discovered how to use it.

She taught herself to steer each steep descent toward a waiting straightaway or slight incline and channel her downward impetus into fleet, forward progress. These breakneck blasts down precipitous slopes required total focus, exceptional balance, split-second decision-making (*left of ridge then right of gap then jump over boulder but land clear of chasm*) and acute foot-eye coordination. Such maneuvers weren't easy, but the adrenaline rush they provided reminded Dayna of her elation while barreling over the prairie on Blizzard's back. In both cases there was, embedded within the heart-pounding apprehension, a giddy sense of being especially alive.

In places where swift descent wasn't possible, a small voice — of her body, or of the land? — came forward with alternatives. Working her way down a clastic dike, hands and feet pressed out to the sides, Dayna recalled climbing the narrow elevator walls in the apartment building where she and her mother had lived seventeen years ago. She'd crawled, spider-like, up past the floor buttons to the ceiling, staying there till the door opened and then dropping to her feet, impassive and nonchalant, beside some startled incoming tenant. Here as there, it was a matter of pressure and counter-pressure, of pushing off in three or four directions at once. One's limbs had to work in concert, and one's body in accord with one's mind.

Indeed, climbing the formations both demanded and engendered mind/body coordination such as she'd never known. To doubt herself even briefly, she found on a few knee- or elbow-skinning occasions, was to break some internal contract...and invite the consequences. So it was that she who had struggled to remain faithful in romance learned that most basic of bonds: fidelity to herself.

Dayna timed her return climbs to coincide with sunset: "magic hour," when the formations were at their most breathtaking, glowing as if from within. As night fell, she drove back to the Tip Top for a much-needed shower, crumbs of gray Badlands clay tumbling out of her clothes while she stripped and, as the water met its mark, off her body

as well. Trading dirty jeans for clean, she headed to the Stone's Throw for dinner, then returned to her room and spent an hour reading before falling into an early and, increasingly, unbroken night's sleep.

Only on Friday did her depression return, and then at half-strength. She awoke at sunrise from a hazy yet unsettling dream about her childhood friend, Rozzie Bailey. Dayna could remember no details about the dream, but its sense of dread lingered.

She spent the morning in bed, plagued by the notion that although she'd managed to avoid ending her life, she now was engaged in pissing it away…that clambering up and down Badlands formations was a pointless, even pathetic way to live. What did it get her? Where was the reward? "Climbing," she murmured into her pillow, "is its own reward. Reaching…succeeding…" She trailed off, unable to complete the thought, let alone believe it.

Still, she managed to peel and eat an orange, to pick up a book and skim a few origin myths of the Oglala Sioux, to tolerate the sun shining through her window and—most mercifully—to avoid reliving any episodes of childhood abuse. Her past, for now, felt safely contained, and the world at large provoked less fear than fatigue. This was still depression, but without the teeth, more Lower Purgatory than living hell.

Just before noon, she slid out of bed and got dressed. Steering her feet into her boots, she reminded herself that she'd only been on the meds for a week; they weren't supposed to reach full potency for another three. "The serotonin level in your brain needs to build back to normal," Dr. Eaton had explained, "and that's a cumulative process." But she was off to a good start. "Two steps forward, one step back" still constituted progress—it was just hard to appreciate during the step back.

"So go forward," Dayna mumbled, then grabbed her jacket and walked out the door.

She started her car and, glancing at the gas gauge, drove straight to the nearby Vet's service station ("Your Whoa 'n' Go Fuel Stop"). She filled the tank, squeegeed the bugs off her windshield, paid in cash— and, on the way out, paused to peruse the latest incarnation of a now-familiar sight: the flyer imploring, "Come Home, Tess."

This one was different, an update. The family had used a color copier; the picture of their missing matriarch now looked less like a mug shot than like the Sears or Wal-Mart studio print it undoubtedly was.

Somehow, the baby in her arms appeared younger: smaller, pinker, more vulnerable. And the text had changed as well. To "Please come home" had been added the word "NOW," and "All is forgiven" had been replaced by the somewhat less gracious "Your family needs you."

Tough love, Dayna thought. *I know the type.* She pushed the door open and returned to her car. *Take your time, girl. Make him sweat.*

Still spooked by the anti-climbing jag to which her sickness had subjected her that morning, Dayna gave the formations the day off and headed down the westbound road to Drake's. Maybe a Blizzard-back tear across the prairie would knock some more of the funk out of her. Besides, it'd been, what, eight days? It was about time to show Drake that she didn't intend to hold his well-intentioned misstep against him forever.

Yet when Dayna arrived and knocked on the teetering front door, it wasn't he that answered but a young, black-haired woman with mischievous blue-green eyes and features as smooth as Drake's were craggy. She was barefoot, and though she was taller than Dayna, her gray BHSU sweatshirt—borrowed, evidently, from someone taller still—came down to her bare knees. She held a spiral-bound notebook in one hand and a half-eaten caramel apple in the other. This was no seductive spider-woman, no vampiress-vixen; this was the girl next door.

She idly rotated the apple clockwise, then back again on its stick. "Help ya?"

The same first words Drake himself had spoken. "You must be...Kayla?"

"Yeah." A glimmer of recognition. "And you..."

Please don't let her be a fan. "My name's Lenore."

Kayla nodded slowly. "My Dad told me. You rode Blizzard, right?"

"That's right. Beautiful animal."

"Bliz must think the same of you. Plays favorites like nobody's business; always has." She lifted the caramel apple, took another bite and spoke with her mouth full. "Dad says you really won him over."

Blizzard? Or Drake? She hesitated. "So it would seem."

Kayla studied her for a moment. "Sore throat?"

"It sounds worse than it is."

"You looking to ride today?"

"Well...yeah, I thought I might. Guess I should've called ahead..."

"Dad's in Kadoka, picking up specs for some chairs or something. He took my car. Won't be back for a while." She paused. "But I could take you out."

"That'd be great!" *Jesus! Could I be any more transparent?*

"Unless you'd rather just take Blizzard and go."

"Well, I…don't mind the company. If you're up for it." *Better.*

"Be out in a sec."

Dayna sat down on the stoop, her forearms on her knees. She gazed off toward the corral, where Blizzard, Casey and a third horse—its hide a chalky gray, the color of the Badlands before a storm—stood watching her. Blizzard took a few steps in Dayna's general direction, then lowered his head. He rubbed the top of his muzzle back and forth across a fence post, scratching.

Dayna looked at the ground between her feet. She didn't even *know* Kayla—had seen her once on TV, then spoken to her just now for a minute—yet never had she felt so immediate an attraction. Why was she falling for Drake's daughter? Was this an infatuation, or a premonition of something more? Dayna dug one boot heel into the dirt, pried out a bottle cap—Bud Light—and kicked it away. *Cool it. She probably has a boyfriend—the owner of that gigantic sweatshirt, no doubt—and if not, she's working on it. The odds that she'd be interested in* you…

"Good to go." Dayna turned to see Kayla closing the door behind her. The girl had thrown on blue jeans and beat-up black cowboy boots with slim, silver boot-backs. Evidently, she'd also exchanged her sweatshirt for something less bulky, for she now was wearing a black motorcycle jacket that fit her long, slender trunk to a "t." She was still the girl next door…but in form-fitting denim and leather.

Dayna stood. If God or destiny or whatever called the cosmic shots wasn't going to give *her* a shot with Kayla, then this was a hell of a way to help her come to terms with it.

They walked down to the corral and saddled up Blizzard and the gray—Kayla's own horse, it turned out, a young male named Mojo. Kayla did most of the work, but Dayna assisted where she could and watched every step in hopes of handling her own saddle next time around. Their task accomplished, the women hoisted themselves onto their mounts and, side by side, headed east across the prairie and into a light, early-October breeze.

"Dad says you're a writer."

"Uh, yeah. Travel guides, mostly." Dayna wondered precisely how much of her interaction with Drake he'd seen fit to share.

"So you must get to see a lot of the world."

"In the research phase, yeah…but I go home for the actual writing." A small, brown-gray shape bounded across a stretch of grassland to the right, zigzagging away at an amazing speed. Dayna's head spun to follow it, but already the shape had vanished. "Jackrabbit?"

"Yup." She smiled slyly. "'Course, when the foreign tourists spot one, I tell 'em it's a jackalope. Then they ask, 'Where are the antlers?' I say, 'Oh, that's a female.'" Kayla looked over at her. "And they all grab their cameras!"

Dayna laughed. "You're awful," she said—loath to express her true opinion.

"Makes 'em happy."

"Speaking of tourists, I've hardly seen any since I got here. Must be off-season."

Kayla nodded. "You came at a good time. The families have all gone home; kids are back in school…"

"You're in college, right?"

"Blacks Hills State, up in Spearfish. I make it back here one or two weekends a month; it's only an hour's drive." Then, an afterthought: "I'm a sophomore."

"With a pretty interesting job on the side."

Kayla rolled her eyes. "God. He didn't make you watch that tape of his, did he?"

"You put Elvira to shame."

"Well…thanks. That's basically what the station asked me to do. Um…let's go left here." They veered past a gnarled old cottonwood; nearly half of its leaves had fallen off but, thanks to those that remained, so too remained the sound of rain. "We'll head down the ridge, then south to the sod tables."

Blizzard whinnied expressively, as if in response; Dayna eyed him briefly, then returned her attention to her companion. "How'd you get the gig?"

"What—Ivana? There was a notice on the Theater Department bulletin board."

"Must have been an interesting audition."

"You know it," she said, her tone light, kidding. "Just me, the general manager and a couch."

"Don't you mean a coffin?"

Kayla laughed. "Right! The old casting coffin. Actually, it was just the opposite. See, Channel 19 is owned by this wealthy fundamentalist Christian. And his son, the station manager—he's cut from the same cloth. So from day one, it was, 'Be sensual but not sexual. Be alluring but not smutty.' Oh, and 'No bare flesh below the neck.' I'm like, where are we…Iran? Once, the boss had a hissy fit because I'd changed my hair style, and he thought it looked like I'd grown horns! You get the idea: lot's of 'don'ts,' 'can'ts' and 'nevers.'"

They began heading downhill; Dayna leaned back in her saddle. "I guess that explains their choice of films, too. That stuff from the '40s is pretty tame by today's standards."

"They did consider some slasher movies. The owner didn't care for the gore, but he didn't mind seeing all those Godless, sex-crazed kids getting their just desserts. So as an experiment he took, like, *Friday the 13th* or something, and he had someone edit out all the swearing, nudity, sex and violence. And it was…"

"…about fifteen minutes long."

"You got it!"

"So, in other words—" Blizzard stumbled, jolted, lurched ahead and to the right. As if by instinct, Dayna—yanked forward, her left foot ripped from its stirrup—threw all of her weight back and to the left, and her whinnying horse righted himself. She glanced at Kayla, who was standing in her stirrups and appeared concerned. "Shit," Dayna said, heart racing.

"You did good." Kayla sat down and tucked a stray black lock behind her ear. "So did Bliz." She cupped a hand over her mouth. "Nice job, Bliz!"

"Badger hole?"

Kayla shook her head. "Looked like a root. You OK?"

"Fine"—well, she would be, momentarily. "Thanks." They continued down the hill. "We were talking about, uh, your show."

"Right. It's a pretty good part-time job, as part-time jobs go. Lots of exposure, decent pay. What's challenging about it, and about the char-

acter—Ivana—is making her 'work' in spite of the restrictions. You know: how do I come across as mysterious, desirable and enticing, all with a 'G' rating?"

"With hand gestures," Dayna said, "and tone of voice, and subtle bits of body language, and the words you choose to emphasize, and that thing you do with your eyes."

Kayla looked over at her. "Jeez. Thanks for noticing."

Dayna, starting to blush, glanced away. "No problem."

By now they had reached the bottom of the hill and were heading across a sparsely vegetated plain. "Pretty flat turf," Kayla said. "If you want, we can run 'em through here on the way back."

"Sounds good." *Why not now?* Dayna wondered hopefully. *Because you're enjoying our conversation...?* "Your show—it's on Fridays, right? Do you have to go back and do it tonight?"

"We tape 'em in advance." She looked at Dayna. "How many have you seen?"

"Just the clip your Dad showed me. *Frankenstein Meets the Wolfman.*" Dayna grinned. "You came up with some nice lines, some funny asides."

"They cut a bunch of 'em; they always do. Usually the more, y'know, cerebral ones. Heaven forbid one of my dumb jokes goes over someone's head. Brad—that's the director—he always tells me, 'This isn't academia, Kay. It's not a term paper; it's a monster-movie show.' I'm like, 'Oh, *I* see. Thanks for the tip. That'd explain some of the mail I've been getting.'" She pointed up ahead. "There they are."

Dayna looked out: in the distance stood several dozen miniature mesas. Ranging in height from seven to perhaps seventeen feet, they jutted out of the ground like the stumps from some gargantuan forest now long gone. The dull aridity of their exposed sides made them look dead and infertile, yet along the flat top of each grew a lush carpet of grass.

"Ever seen sod tables before?"

"Sure haven't."

"Weird-looking, huh?"

Dayna nodded. "Like some...huge, petrified board game. The chess set of the gods."

Kayla laughed. "Never heard that one before."

"How'd they get here?"

"Oh, they've been here for eons; it's the ground around 'em that's eroded away. C'mon." She kicked her horse into a trot and headed for the haphazard network of bantam buttes, Dayna following close behind. As they reached the shadow of the nearest sod table, they slowed to a walk. "I used to love coming here when I was little," Kayla said. "I'd climb up and pretend I was on stage. This is where I used to rehearse my lines for the school plays!"

Gazing up, Dayna pictured a pre-teen Kayla standing atop the table, feet planted in the sod, head held high and arms in motion, dramatically delivering a passionate soliloquy to no one. She smiled, lost in the image; an emphatic whinny from Blizzard brought her back. "So you've been into acting your whole life?"

"Yeah. Got the bug from my Mom. She did a lot of stage work out east when she was young. Then she met Dad on a movie project—she had a small role, and he was doing stunts—they fell in love, got married, and she moved out here. She still kept a hand in with, like, community theater: Black Hills Passion Play, that kind of stuff." Prodding her horse forward, Kayla disappeared behind the first table—"I've always *liked* acting, but after she died, I started taking it more seriously"—then emerged on the other side—"I guess as a way of carrying on. When I perform now, it's like I'm doing it for both of us." She looked at Dayna. "Y'know?"

"I think so. I lost my own mother a few years back. We didn't get along so well, but I still...I think about her sometimes. And I wonder what she'd think of me."

"Do you miss her?"

"Miss her..." Dayna grimaced, struggling to provide an honest answer. "Miss my mother. Yeah; sure. In spite of it all, I guess I do."

"I miss mine, too. But I'm thankful I still have Dad." Turning her horse, Kayla headed deeper into the sod-table maze. "You met him—Drake. What'd you think?"

Dayna followed. "That's a tough one."

"No need to be diplomatic."

"Oh; I'm sorry."

"No; I'm serious. He's not the easiest person to get along with. I mean, I love and respect him and all, but he's not my role model. I'm his daughter, not his...disciple."

"Gotcha," Dayna said…but hesitated. She wanted to tell Kayla what had happened with Drake, but doing so would entail disclosing her own psychological state. All things being equal, she'd just as soon Kayla view her as strong and capable, not weak and unwell.

Then again, wasn't acknowledging her illness to others—telling the truth, however unpleasant—itself a sign of strength?

And so, as they guided their horses in between and around the grass-topped mounds, catching glimpses of one another along the way, Dayna summarized her get-together with Kayla's father, up to and including the water-hose incident and the rationale behind it. "It pissed me off," Dayna concluded. "That kind of thing always does." She looked down. "Let's just say I have issues with…older men manipulating me into doing what they want."

"Did you take his advice?"

"Yeah; I got the meds."

"And…?"

"And they…seem to be helping. I mean, I know what he did was for my own good. But that doesn't mean I have to like it."

Kayla nodded. "He means well, and he usually turns out to be right, too. It's the part in between that'll drive you crazy."

"Well," Dayna replied, "the whole episode kind of got my guard up. In the words of a song I never particularly liked, by a band I never cared for: I won't get fooled again."

Kayla turned her horse toward Dayna's and offered an enigmatic smile. "Is that a challenge, Lenore?"

Dayna smiled back. "Why not?"

"Why not?" Kayla repeated obliquely, then steered Mojo away, weaving back through the buttes toward the trail by which they had arrived.

Confused by this latest line of discourse, Dayna turned Blizzard and, prodding him to follow, changed the subject. "Tell me more about these…sod tables."

"They're the remnants of the original plain; that's how high the land here *used* to be back in, like, woolly mammoth days. The sod on top protects the table underneath from the elements, absorbing the rain and the snow-melt and, you know, preventing further erosion. Thanks to that, they'll be here for ages—probably longer than the Badlands themselves."

Dayna pointed at her. "Know who you sound like?"

Kayla shook her head.

"The morning I got here, I bumped into this fossil scientist, a woman—British, I think—and her kind of cowpoky assistant."

Kayla stopped her horse and turned her head back toward Dayna, eyes wide. Her voice, when she spoke, was hushed. "Did he call her…?"

"Doc. And he had some kind of…fish name. I haven't seen them since."

"Doc and Pike…" Kayla appeared shaken; she shifted one tremulous hand to her saddle horn and gripped it tightly as if for support.

"What is it?" Dayna asked, moving Blizzard closer. "Are you all right? Kayla, what…what's wrong?"

"I knew them," she began, her voice little more than a whisper. "When I was a girl. They were friends of my parents. We'd visit them out at their dig. Sometimes they'd even let me help out a little, have me hold the flashlight or…or brush off a bone. But then…" Her voice dropped lower still. "…ten years ago, a terrible storm came through, and this whole area had a flash flood. An underground site they were digging in collapsed, and…"

Dayna shivered in anticipation. "And…they died?"

Kayla swallowed, shuddered…and broke into a disarming grin. "Naw, they were right near the top; they got out fine. I still run into 'em all the time. Nice folks." Leaning forward, she poked Dayna in the arm—"Won't get fooled again?"—and then steered her mount away from the sod tables, kicking Mojo into a run and tearing back across the prairie at full tilt.

Flabbergasted, Dayna stared after her, then barked out a sharp "Hee-yah!" and followed. Blizzard caught up quickly, and soon the two horses were running neck and neck. Unsure whether to be impressed by Kayla's performance or mortified by her own gullibility, Dayna settled on lobbing a mild insult her companion's way. "The word 'sophomore,'" she hollered over the eight thundering hooves, "is Latin for 'wise idiot'…"

"You looked like a ghost!"

"…though 'smart-ass' might be a better translation."

Bent low over her charging mount, Kayla glanced sideways at Dayna, aquamarine eyes aglimmer. "An *anemic* ghost." She clicked her

tongue loudly at Mojo, who dutifully picked up his pace. "Race ya back to the ridge. H'*yah!*"

Chasing after Kayla, whose own black mane danced and darted behind her neck with her horse's every gallop, Dayna again felt the naked adrenaline rush of unfettered forward momentum—in more ways, now, than one. Gray clouds were converging in front of the sun, and a mud-spattered horse's ass was front-and-center all the way back, yet she couldn't imagine a better view.

<center>➤·◄</center>

Clearly, they had hit it off—whatever that did or didn't mean about the direction their friendship would take—and so while paying Kayla for the ride, Dayna suggested they exchange phone numbers. The younger woman eagerly assented, adding, "I was going to ask *you.*" As Dayna drove away, those six simple words ran through her head, a prized affirmation that her interest in Kayla was reciprocal.

Back in Room 4, she sat down on her bed, staring at the sheet of ripped-out notebook paper on which her new acquaintance had written her name and, beneath, both Drake's number and her own at some dorm in Spearfish. Somehow, having these two phone numbers in hand gave Dayna the composure—and the courage—to pick up the receiver and dial a third.

A woman answered: "Hello?"

Dayna cleared her throat. "Chloe, it's…"

"This isn't Chloe. Just a minute." A pause; then, "Hiya."

"Chloe, it's Dayna."

Another pause, longer than the first. "Where are you?"

"I…can't really…"

"Are you all right?"

"I'm fine. Thanks for asking. I…suppose you've been reading about me. About my kind of, uh, dropping out for a while."

"I can't say it shocked me, given the way you dropped out on me."

"I know." Dayna lay back on the bed. "That's why I'm…"

"I've moved on." Chloe's tone was matter-of-fact. "I've met someone else. I believe you just spoke with…"

"Yeah. That's great." In spite of everything, this news stung. Dayna tightened her grip on the receiver. "I'm…I didn't call to try and…to get

you to take me back. That'd be a mistake. For both of us. Especially…" She rolled onto her side; she looked over at the half-open curtains. "Especially for you."

"Then why *did* you call?"

"To say I'm sorry. That's all. I fucked up. I didn't treat you very well. I was only…I was thinking of myself. And by the end, I…" She gripped the side of the bed. "The way I acted was pretty unforgivable. I guess I don't blame…"

"Dayna," Chloe cut in, her voice low, her tone even, "I forgive you."

Blinking, she smiled weakly. "Yeah?"

"Yeah. It was just…" Chloe stopped, then, revising her reply—editing, it seemed, in her head. "It was good of you to call. Take care of yourself."

"Working on it," Dayna answered, and the line went dead. She placed a finger to her cheek and gingerly lifted from it a solitary teardrop: the period at the end of their sad run-on sentence of a romance. Lips closing around her fingertip, Dayna touched the tear with her tongue, tasted her own salt…and, from 900 miles away, kissed her lover good-bye.

It was the sort of event that could have plunged her back into depression…could have, but didn't. Instead, permeating her grief was a sense of balance, a feeling of peace. That being the case, perhaps she should seize the moment and dial a few other numbers. Apologies were owed to Lynette, to Evan, to Erin—certainly to Erin—to Tina, Patrick and Kirk. Well, not Kirk, the lying prick; if anything, she should apologize to *herself* for that one. But to the others—and to Rozzie, too, for different reasons—she ought to make amends.

Dayna sat back up and, staring at the phone, gave the idea more thought. For whom would she be placing those calls? For the sake of the injured parties…or her own? Assuaging her conscience didn't merit re-opening old wounds, some of which were probably just beginning to heal. They'd gotten on with their lives; better for her to do the same.

And so she threw on her jeans jacket, drove through a light rain to the Stone's Throw, gave the stud-tongued boy her supper order, sat down by the window and raised a lemonade to her reflection in the glass. Locking eyes with her own image, Dayna silently toasted the sixty-odd years that she now not only assumed but actually hoped lay ahead.

Dayna's young friend brought out her meal with customary geniality but then hurried back into the kitchen, which sounded noisier than usual. Did he have company? On closer inspection, she saw that he was, as always, working alone, but was simultaneously monitoring two different football games: one on an old portable TV, the other on radio. "Good games?" she asked, leaning up against the counter.

"One of 'em's pretty decent," he said, indicating the radio. "Local high school grudge match. But the other one...well, it ain't all that good." He shook his head. "Hell, it's awful. We're gettin' reamed."

"Then why watch?"

He shrugged. "They're my team. Gotta stick with 'em through thick and thin. That's what bein' a fan's all about."

Dayna recalled the motley crew of teens that had assembled outside her Chicago townhouse. "I suppose," she said. "Just...don't get your heart broken."

"Oh, they'll put it together," he said, staring at the screen. "They always do. Maybe not tonight; maybe not this season. But they'll be back."

Such faith, Dayna thought, then returned to her table and dug into her meal. While enjoying her taco, she felt a twinge of pain in her mouth, far back on the right: a sore molar, or maybe the space in between two of them. She moved her mouthful to the left side and resumed chewing. Her brushing had dropped off during her illness; now, in the midst of recovery, it seemed she might have to pay the piper. Dayna vowed to buy some floss and begin taking better care of *that* part of herself as well.

Back in her room an hour later, her curiosity got the better of her, and she turned on the TV for the first time since her inadvertent exposure to "Entertainment Tonight." It was much as she had expected: Letterman had a big map of North America on which were posted numerous graphic emblems, some depicting Dayna. Like the TV weatherman he used to be, Dave stood beside the map, gesturing and explaining: "Dayna Clay sightings continue to be heavy throughout the Eastern Seaboard, as well as across the Rockies and up into the Pacific northwest. As you can see, in terms of sheer numbers, she has displaced Sasquatch and is closing in quickly on Elvis."

Dayna had to laugh. She'd never imagined herself in such company; what's more, the emblem representing her—a cut-out photo in

which she stood on one leg, guitar upraised, head thrown back, shriek-ing—was a kick. At one point Dave peeled one off the map and showed it to the band, commenting, "It'd look nice on the ol' Christmas tree, wouldn't it?" before flinging it, Frisbee-like, into the audience.

The only aspect of the gag that gave her pause was the placement of one of the Dayna-sighting symbols smack-dab in Cedar Rapids, Iowa, the town where she'd dropped off Shelly. It *had* to be a coincidence—and anyway, not a single emblem appeared in all of South Dakota—but it unsettled her nonetheless.

Then Justin came on, sporting black sneakers, torn jeans, the same Dayna Clay T-shirt he'd worn at the concert and, hanging over one shoulder, the guitar she'd given him. He looked even younger than before; Letterman being tall, Justin seemed tiny beside him. Still the boy, though fidgety, acquitted himself well, fielding questions about the concert, the instrument and his impromptu performance with good humor and, for a not-quite-fourteen-year-old, relative aplomb. He also deftly deflected Dave's solitary jibe; asked if "this whole disappearance thing" might be a publicity stunt engineered to boost record sales, Jus-tin shook his head and replied, "Listen to the CD. That's not what Dayna's about."

"Justin, I understand you're going to go over there with Paul and the band, 'plug in' and favor us with a number."

"Yeah," he answered, anxiously sweeping his fingernails back and forth across his strings. "I'm gonna play something off Dayna's *first* re-lease, which most people don't have, but should. It's called 'Karma Bomb.'"

Dayna gasped. In typical teenage fashion, Justin had chosen to per-form the most confrontational, least commercial song she'd ever record-ed. The first verse briefly lauds the teachings of Jesus, then points out their inadequacy in a world where most people don't abide: "Till that tarnished Golden Rule is practiced far and wide / I propose a way for us to stay uncrucified." The verses that follow describe the brutal jus-tice meted out by the title weapon: over the course of the song, the Karma Bomb subjects wife-beaters, gay-bashers, clinic-bombers, and the like to the self-same terror and abuse with which they have victim-ized others.

Justin sang the song well, played it even better. Indeed, watching

him perform, Dayna gained new respect for a composition she lately had viewed as a mild embarrassment. The words were still preachy and naive—still had the ideological depth, she chided herself, of a bottle cap—but as an honest expression of youthful indignation, a frank, cathartic blast of lefty-humanist angst...it worked. And it worked all the better with a strident thirteen-year-old leading the charge, ripping through every stanza as if his life were on the line.

When Justin left amidst well-earned applause, Dayna switched over to Channel 19. The UHF signal from Rapid City was weak; thus, Ivana appeared on Dayna's screen as, appropriately, a mere apparition. Still, Dayna watched "Shock Theatre" straight through to its hostess' parting declaration: "Next week: *The Bride of Frankenstein*. The Monster finds a mate! Find one yourself, and tune in...together."

Staring back into the piercing eyes of her eerily transformed riding buddy, Dayna silently promised to do just that.

The rain ended sometime overnight, but enough had fallen to downgrade Dayna's Saturday climb to a hike. Heading out across intermittently muddy prairie, she gazed up at the formations with an edgy awe, for they'd never looked as they did today. Their bases were cloaked in a thick bank of mist, yet their peaks were still visible and thus seemed to be floating—severed, disconnected—high above the plain. The effect was surreal. It was as if the Badlands were receding, foundation first, into the bygone era from which they'd emerged.

Herself now moving into the mist, Dayna shivered. Buttoning her jacket, she glanced down and saw a solitary line of bighorn tracks trailing off to the right. They were large—the tracks, perhaps, of the alpha ram?—and were spread far apart, as if the animal had been moving at a good clip. Kneeling, Dayna placed her fingers inside the semi-circular indentation and scooped out a handful of wet, gray clay. It was smooth and pliant, oozing rather satisfyingly between her clenched fingers.

Dayna found a reasonably dry patch of ground and sat down. Back in her modeling days, she'd listened with some interest as a sculpting instructor—who thereafter became her lover—had advised his students on how best to capture her pose: by breaking her body down into its component planes. Perhaps she, now, could use this approach to mold

a bighorn figurine, a kind of do-it-yourself fetish, out of clay from the animal's own hoof print.

As she worked the slippery material in her hands, calling to mind the ram's shape and stature, Dayna realized that she hadn't spotted a bighorn all week. True, the area was vast, and there weren't many herds to begin with…but they'd shown up for her with regularity before. She hoped the incident with the poacher wouldn't turn out to mark the end of her contact with a species she'd grown to revere, then envy, then finally love.

Still, with the fog so dense and pervasive, Dayna knew the bighorn-spotting odds would be slim today. Nor was anything resembling one of the beasts emerging from the moist mass in her hands. The clay was malleable, all right—to a fault; it refused to hold shape, adhering to her skin as readily as to itself. She stood up and shook her hands, flinging off as much as she could, then wiped the rest on her jeans. As she gazed out at the sturdy peaks all around her, it struck Dayna that what she'd found impossible was second nature for nature.

A keening cry from above: she looked up to see a lone eagle circling the highest spire in sight, the tips of its broad, brown wings nearly tickling the formation's top with each pass. Dayna stood watching the bird circumnavigate the same stretch of sky again and again, periodically piercing the autumn chill with its shrill call. For whom was it calling; for what was it searching? Was it hunting prey, looking for water or guarding its young? Challenging a rival, beckoning a mate…or just passing time?

There was no way to tell. But whatever its motivation, the great bird persisted, massive wings slicing the cold air, endlessly re-tracing its elliptical route, determinedly traveling nowhere.

There were times for eschewing the company of others to commune with nature, but every sign seemed to be telling Dayna that this wasn't one of them. Formations without foundation; clay she couldn't mold; an eagle stuck in a holding pattern…the land was speaking to her, all right. Only this time it was saying, "Not today."

Dayna turned and, re-tracing her own footprints, began the hike back, intent upon phoning her new acquaintance. For *that* was the type of communion she currently craved: simple human fellowship. It was only Saturday; the weekend was young. And so, after all, were they.

She side-stepped a mud flat and picked up her pace. Dayna had no idea why, out of all the women and men in the world, she'd been led to this stunt man's daughter, this mischief-making mystery girl, this horror hostess for the hoe-down set. Nor did she have a clue whether Kayla would turn out to be her friend, her lover or—that elusive ideal—both. She'd make a fine friend, and a fine friend was something Dayna certainly could use. Yes; Dayna would settle for friendship. But she would hope, perhaps even pray, for more.

As it turned out, she had little time to do either, for when she arrived back at the Tip Top, a dark-haired, leather-jacketed figure was standing in front of the door to Room 4, affixing an envelope above the knob. Dayna stepped up behind her. "Mornin'."

Kayla spun around, squelching a scream. "Jeez!"

Dayna cleared her throat and, hoarseness notwithstanding, managed a passable impression. "I didn't mean to...*frighten* you," she intoned, eyes widening.

Kayla laughed. "Is that how I look?"

"I caught you last night. Nice job." Dayna pointed at the envelope. "What's...?"

"For you," Kayla said, pulling it off the door and handing it to her. "Your money from yesterday's ride. Dad said that one was on the house."

"Oh." Dayna turned the envelope over in her hands. "Tell him 'thanks.'"

"There's a note in there, too."

"From Drake?"

"From me," Kayla said, rocking on her boot heels. "I'm heading back to Rapid City. The station called, and they need me to tape a promo that's supposed to air tomorrow. It's a re-do; apparently the station manager's daughter knocked, like, a quart of apple juice onto one of the consoles, and the tape got fried...along with a $4,000 deck." She shook her head. "The trials of UHF stardom."

"So...you'll be back..."

"In a month."

"Oh," Dayna said, then wondered how far into the parking lot her face had fallen.

"But Rapid City's only an hour away. Why don't you come to the

studio Wednesday afternoon and watch us tape the show? Then afterward, maybe we can grab dinner. I mean…if you're interested."

"Very," Dayna replied at once. "I'd love to."

"Fan*tas*tic! Well…I'd better hit the road. Call me for directions. Or else, I…"

"I'll call you, Kayla. I will."

Kayla stood for a moment, nodding, then reached out and gave her a slightly awkward hug. Dayna responded in kind, eyes closed, chin raised, gently pulling Kayla's chest toward her own, smelling her hair, her skin and the musky leather of her jacket collar, drinking in the feeling of being held by someone she truly liked who appeared to like her as well. Someone who saw her as neither remote rock idol nor profitable commodity; someone drawn to her not for her celebrity, but simply for the person—the woman—she was.

Just as Kayla had seemed hesitant to initiate the embrace, so did Dayna now hesitate to end it. Fighting to contain the rush of emotion within, she gave her new friend a final squeeze and whispered into her ear the words that, trite though they may have sounded, expressed precisely how she felt.

"Thanks," Dayna said, "for everything."

SEVEN

PERHAPS SOME NOW-OBSCURE childhood memory was eluding her, but Dayna could not recall ever having been so delighted to hear the sound of urination.

Her Sunday and Monday climbs, though challenging and worthwhile, had been conspicuously bighorn-free. She'd seen tracks but had caught not a glimpse of the creature itself...until this instant. Catching her breath atop the day's second "target peak," she had heard a faint noise coming from beneath her and off to the right. Peering into the canyon below, she'd spotted a solitary bighorn—a young ram, its horns curled halfway back—impassively contributing to a puddle of its own making. As the ram finished and stepped forward, there arose from the pool a trace of steam.

How they climbed as quietly as they did was beyond her understanding. It was a kind of magic. But it was a kind confined, apparently, to the animals' hooves: "escape artist" or no, the sound of piss hitting dirt still carried. And for this, Dayna—who'd been on the verge of leaving— was grateful.

The wind was blowing straight toward her, a sharp slap in the face, but a blessing, too, for the scent-masking it would provide. Slowly, Dayna lowered herself to her knees and, checking behind her, sat; the series of incremental adjustments took her a full two minutes. Through-

out, her eyes never strayed from the lone bighorn below…until a second, third and fourth emerged from behind a crest to join it. The young ram and three ewes ambled across a twisting gully, converged upon a thatch of prairie grass and began to graze.

Dayna reached into her jacket pocket for her mini-binoculars, then positioned herself to utilize them: legs folded, elbows propped on her knees, one hand clenched firmly around each of the instrument's barrels. She slowed down her breathing, reverting again to "modeling mode," and cast her eyes on the herd below.

The bighorn quartet had doubled; moments later a ninth—the third ram—arrived from the opposite direction. The group, Dayna noted, stayed in fairly tight formation. Strength in numbers; wasn't that what the herding instinct was all about? Whatever predator or threat they met, they wouldn't meet it alone. For a nomadic breed—for born wanderers like the bighorns or, yes, Dayna herself—perhaps the simple sharing of space, the being among one's own, was what constituted "home."

Among one's own…but who, Dayna wondered, were hers? She'd never felt all that comfortable in any group larger than a rock band—and, depending on the personnel, sometimes *that* was pushing it. She'd always been the antithesis of a joiner, yet she did seem to be developing a kinship with the creatures now trudging through the sparse brush below. Little wonder; they were, after all, her "partners in climb," spending the bulk of their waking hours just as Dayna now spent hers. Besides, a bond had been established that night two weeks before—a bond sealed in blood.

But to what end?

Earlier that day, while passing under a prairie cottonwood, Dayna had seen a flash of crimson fluttering down from above; reaching up, she'd surprised herself by catching the leaf in mid-fall. Studying her prize, she had fallen into a reverie, pondering at length the symmetry of nature. The leaf's intricate network of veins mirrored, in miniature, the branches from which it had dropped—not to mention the other, unseen tributaries anchoring the trunk to the earth below. The realization had made her gasp, and it had moved her in a way she couldn't quite fathom. The veins were the branches were the roots; from high in the air to deep underground, the tree emphatically assert-

ed its "treeness" throughout.

To hell, she'd thought, *with the Bible; here's the divine plan.*

And now, crouched atop a mid-sized formation with a nasty north wind in her face, Dayna took this line of thought further. She'd seen it dozens of times in dozens of ways: the land sustained not just flora but fauna as well. And in so doing, it embraced male and female in equal measure, engaging and sustaining both sexes with an unerring — and unerringly even-handed — devotion. And what, finally, was "God" if not the seed-sowing, life-growing spirit flowing *through* that land: through bison and bighorn, pine tree and prairie grass, mountain and canyon and...and Dayna as well?

My own nature, she understood with a start, *mirrors nature.*

Throughout her adult life, there had been those who'd told her how wrong her feelings were, from the ex-boyfriend who'd labeled her attraction to women "a phase," to the leader of a lesbian support group who'd provided anything but, accusing Dayna of "coming halfway out" and deriding her professed feelings for men as a cover. At times, under the weight of such criticism, Dayna had wondered whether her detractors might be right. Yet the land itself seemed to suggest otherwise — and to do so by example.

Looking up, she saw the vista before her as if for the first time. She'd just begun, tentatively, to believe in a higher power, but already she understood what it meant for her, a bisexual woman, to have been made in that higher power's image. Any lingering trace of guilt connected to who she was and whom she'd loved vanished the moment Dayna understood that her Creator felt the very same way.

Gazing down at the bighorns, she wondered whether her "place in the plan" might have something to do with theirs. A ewe had died by the hand of Man mere days after Dayna had arrived. One climber was gone, but a new one, Dayna herself, had appeared. Was this, too, part of nature's far-sweeping symmetry? Was she here to atone for that loss...to replace the life that had been taken?

CRACK! Not a rifle blast; not this time — nearly as loud yet more elemental, as harsh and abrupt as the Badlands themselves. It was the sound not of explosion but of collision, impact. A few of the bighorns lifted their heads and gazed toward the formation behind them. *CRACK!* Their curiosity piqued and the grass pretty much grazed out

anyway, all nine animals turned toward the steep cliff wall and, with deft steps, began to ascend.

CRACK! The booming reports kept coming at ten- to fifteen-second intervals, the sound of a billiards contest amplified to thunderous dimensions, as Dayna watched the animals navigate the steep slope with ease. Even at 20x magnification she saw not a pebble or mud ball fall as the seventh, eighth and then ninth bighorn trotted up the side, over the summit and—*CRACK!*—out of sight.

Springing to her feet, she zigzagged her way into the shallow canyon. She had an idea what the source of the sounds might be—a contest, yes, but one notably devoid of cushions—and very much wanted to witness and share in this quintessential bighorn experience.

CRACK!—the loudest yet. Dayna darted across the canyon floor and began to scale the facing formation. She ascended as quickly as the hindrance of her humanity allowed, reaching the top in twice the time it had taken her hoofed predecessors, only to find them gone. They had left no tracks in the dry, hard ground; worse still, spread out before her was a labyrinth of cliffs, crests, peaks and valleys, any of which could be hiding the herd as easily as any other.

Panting and sweaty, her chest heaving, Dayna stamped her boot in frustration; a small concretion rolled down into the next canyon as if daring her to follow. She considered the challenge but declined. The cracking sounds had stopped; the match was over. Some anonymous ram out there had proven, through sheer hard-headedness, his dominance over another and had won, perhaps, a mate in the process…but it was no concern of hers. If they *were* fighting over one of the local females, one thing was clear: it wasn't Dayna.

Turning, she made her way back down to the patch of largely decimated brush on which the herd had been grazing. Dayna yanked out a fistful of bristly grass and lifted it to her nose: no scent at all. She placed a blade between her teeth, bit down and tore; then, shifting the stiff, abrasive shaft back between her molars—but avoiding the area of her toothache—she gamely attempted to chew. The taste was vaguely unpleasant; worse, the "blade" was just that, its edges sharper than anything she'd tried eating before.

Dayna spat the grass back into the harsh terrain from which it had come. Hands in her jacket pockets, she began heading back, disappoint-

ed but not discouraged. It was still possible that the bighorns were, in some sense, her own—that somewhere down the line she could, however briefly, replace the ewe and join its herd. But if so, she intended to pack a lunch.

<center>➜·←</center>

Her phone conversation with Kayla that night, the second in three days, lasted close to an hour. They covered plenty of ground: in addition to obtaining directions for the next day's visit, Dayna learned what courses Kayla was taking and how they were going; traded world's-worst-roommate tales; determined that Kayla, whatever her orientation, was currently unattached; and established that "Lenore" was herself "single but looking."

"Well," Kayla remarked, "finding somebody worthwhile shouldn't be hard. Not for someone like you."

"Thanks," Dayna said. "Right back at ya." She considered coming out to Kayla then and there, but experience had taught her that such disclosures were best made in person. She was adept at reading intimations and gauging responses, but the phone was a handicap. Better to wait...though her new friend, intentionally or not, seemed dead-set on making that ever more difficult:

"Listen, if I don't finish this stupid Anthro paper now, I'm gonna have to work on it tomorrow night. And there are things I'd much rather be doing then, y'know?"

"Yeah," Dayna said, "I know"—but she didn't. Was that a compliment...or a come-on? Was Kayla alluding to dinner and dialogue, or to something more? Reminding herself that either outcome would be welcome, she replied, "Let me hang up and, uh, help you make that happen." She wished Kayla luck and, as they said their good-byes, wished herself a little, too.

Kayla's directions were letter-perfect and precise; the afternoon drive to Rapid City was easy, and Dayna reached the Channel 19 parking lot in good time. Getting out of her car, she glanced off to the west. From where she stood, she could make out a distant swath of the pine-laden Black Hills, which were really more of a chocolate brown. Pretty hills, pretty land...but not *her* land; not Badlands. She shut the car door and headed into the station.

The reception area was empty and unmanned. As Dayna surveyed her surroundings, her eyes were drawn to the two framed adornments gracing the otherwise pristine walls: the station's FCC license and, beside it, a medium-sized print of an ethereal Jesus stooping, staff in hand, to feed his flock. *Yup*, she thought, heading past the front desk. *This is the place.*

When she stepped into the chilly Studio A, the crew paid little notice, but Kayla spotted her at once. Emerging from a somewhat shabby-looking casket, the sleek and elegant specter stood and approached, her lacy black shroud trailing behind, then reached out with dagger-nailed hands, hypnotic eyes and a surreptitious smile. As Dayna accepted "Ivana's" embrace, it occurred to her that if death had appeared half this enticing during the depths of her depression, she would not be standing here—or anywhere—today.

"Good to see you," Dayna said as they disengaged. "Look at you!"

"I would," Kayla said, "but for some reason, I don't seem to be casting a reflection in the mirror. Weird, huh?"

"Downright spooky." She gestured toward the coffin. "New accommodations?"

"That old thing? They drag it out once a month; I bargained 'em down from weekly. It's just about as comfy as it looks. Plus, every time I get in, I'd swear it's gonna collapse."

"What, did they buy it *used*?"

Kayla smirked. "That'd explain the smell."

"You should have your Dad build you a new one. Something more solid."

She nodded. "He was gonna make me one for Christmas…"

Dayna laughed. "Now *there's* a scene Norman Rockwell neglected."

"He never got any further than taking measurements. It was creeping him out. Understandable, I guess, in view of…family circumstances."

"Oh; right."

Kayla glanced back toward the casket. "But the main problem is, I'm claustrophobic. Always have been." She shrugged. "Maybe it comes from growing up with, y'know, the prairie as my front yard and the Badlands as my back. I like open spaces; I can't stand being…constrained." She smiled crookedly. "My 'ex' could tell you something about that."

A stocky, slightly anxious-looking man in his early forties stepped up alongside them, wooden clipboard in one hand, steaming Styrofoam cup in the other. He cleared his throat—"Ready to roll, Kay"—then glanced at Dayna.

"Our trusty director," Kayla said. "Brad, this is Lenore. She's gonna watch us tape."

He nodded. "That's fine. There's coffee over in that big red cooler, and there's a soda machine down the hall. But the area beyond this line"—he indicated a semi-circular strip of gaffer's tape spanning the studio floor—"is a beverage-free zone."

"Oh," Dayna said, "right. I heard about the mishap."

"Brad," Kayla said, arms folded, "wouldn't it make more sense to establish a *toddler*-free zone?"

"Tell it to Eugene"—then, to Dayna—"Station manager." Brad shook his head. "You should've seen the mess, Kay. And Eugene just keeps going on about how it wasn't his daughter's fault, it 'could've happened to anyone.' Yeah: anyone under the age of *three*."

"At least this time," Kayla said, "he didn't blame it on secular humanism."

"I saw it happen," Brad said crossly. "I'd swear she knocked it over on purpose."

"Maybe," Dayna offered, "it was demonic possession."

Kayla burst out laughing. "Fan*tas*tic! I have *got* to work that into the script."

Brad's brow furrowed—"The devil you will"—then turned and headed for the control room. "Let's do it, people. Sound...cameras ready, please...Ms. Drake?"

Kayla flashed her friend a grin—"Glad you're here"—then returned to the set and, grudgingly, the casket. Dayna poured a cup of coffee, pulled a folding chair up to a spot just outside the beverage-free zone and sat down to watch.

Brad, wearing headphones and seated behind glass, held up one hand and called for quiet. Soon pre-recorded organ music started to play: a minor-key rendition of "Here Comes the Bride." Slowly but steadily, the coffin lid began to rise. Ivana sat up and, flipping her hair behind one shoulder, turned to face Camera 2. "Good evening," she purred, "and welcome to 'Shock Theatre.'" She gestured toward

herself—"Ivana Viktimm"—then toward the camera—"and I believe I see a few choice prospects already. But all in good time."

She emerged from the casket and strolled toward a small pew, its side festooned with a black-ribboned garland of wilted flowers. "Dearly beloved, we are gathered here to celebrate the union of man and woman in…unholy matrimony. What the good Dr. Frankenstein has joined together—limbs to torsos, heads to necks and so forth—let *no* one put asunder." She sat, crossed her legs, folded her hands on her knees and gazed off-camera. "Hmmm. The groom looks a bit…stiff, don't you think?" Ivana turned back to the camera. "Then again, that should come in handy"—her eyes widened abruptly—"on the wedding night."

Brad burst out of the control room. "Cut!" he shouted over Dayna's and the cameramen's laughter. "Stop tape."

Kayla grinned. "I couldn't resist."

"Clearly." Brad glowered. "So much for 'One-Take Drake.' From the top, people. Oh, and Kayla, while you're at it, lose the reference to 'unholy matrimony.'"

"For crying out loud," she said, skulking back to her casket. She lifted the lid—"This born-again aesthetic will be the death of me"—and got back in.

Watching Kayla and company tape a second take of their *Bride of Frankenstein* intro (G-rated and fundamentalist-friendly, but entertaining nonetheless), Dayna tried to recall the last time she'd derived as much pleasure from performing as her friend was now. It was in Portland, during the third or fourth month of her tour. For one night, her inner darkness had receded entirely; she'd felt fully invested in every song, every verse, every word. And her enthusiasm had proven contagious: the adoring audience had demanded *five* encores.

But that was back in, what…April? Half a year ago. Her urge to take the stage had been absent for months and showed no signs of returning. Thus, when Brad approached to ask whether she'd like to do a walk-on—handing Ivana, now back in her parlor, an antique telephone—Dayna declined. She had no desire to perform; more to the point, flashing her features over even local UHF airwaves would be ill advised. "Thanks, but no thanks."

"Come on," Kayla pleaded. "It'll be a kick!"

"Sorry. I'm just not up for it today. Plus, my hair's…"

"Wear a mask. Brad, give her the devil; we'll do a 'phone call from hell' gag."

He shook his head. "No can do. Boss got rid of all the devil gear. Said he wasn't about to give 'the Adversary' free air-time."

"Oh, for God's sake…"

"Precisely."

Kayla appeared exasperated. "The Cyclops, then. Or, no: the ape."

Brad brought Dayna a somewhat moth-eaten, full-head orangutan mask, a kind of down-on-his-luck Dr. Zaius; she stared into its vacant eye holes. Kayla seemed dead-set on including her in this silly skit. Dayna didn't want to disappoint…and besides, as long as her identity was hidden, what was the harm? She slipped the mask over her head and, on cue, shambled onto the set, vintage telephone in hand.

"For me?" Ivana asked grandly, taking the prop from the jeans-jacketed anthropoid. "Thank you, Eronel."

Dayna bowed low.

Ivana hesitated, eyeing the receiver; she leaned in close to her simian servant, her voice dropping to a fearful hush. "It isn't"—her eyes widened—"*telemarketing*, is it?"

Dayna shook her shaggy head "no." Then, improvising, she reached out, picked from her mistress' tresses an imaginary tick…and ate it.

"Eronel!" Ivana admonished. "I told you: we shall be dining *after* the show!"

Dayna shrugged, turned and shuffled off the set. Peeling the mask from her head, she glanced at Brad, who gave her a thumbs-up. Dayna returned to her chair. She was glad she'd done it—gratified that the director had approved of her shtick, and pleased to have pleased Kayla—yet it was all so…remote. She'd felt utterly detached throughout. Perhaps it would have been different had she sung or played guitar; perhaps, but she suspected otherwise. She'd lost the yearning, the drive; she was a performer no more.

Dayna shifted in her chair. *It's OK*, she reminded herself. *I'm someone else now.*

Once the taping had concluded, she congratulated her friend on a job well done, then sauntered around the studio as Kayla headed for the dressing room to "exorcise Ivana." As the crew withdrew the

cameras and began dismantling the set, Dayna found herself drawn to-
ward Kayla's nemesis: the semi-dilapidated casket. She wandered up
beside it and, peering in at the red velvet overlay, called to Brad, "Mind
if I give it a whirl?"

"Knock yourself out."

Dayna stepped in, sat down, lay back and pulled the lid shut; her
world became black, still, serene. No claustrophobe she, Dayna relaxed
instantly. She closed her eyes, folded her arms atop her chest and ex-
haled slowly, purging her lungs. The setting was neither cramped nor
confining, but pleasant. Peaceful.

Then again, after a minute or so it was also a bit…dull. Particularly
in comparison to the prospect of a dinner-date with her heart's desire.
All things considered, Dayna decided, she was glad to be alive.

Three knocks sounded; Dayna opened her eyes. "Come in," she
said.

The lid lifted to reveal Kayla, make-up gone and now wearing her
usual boots, jeans and leather jacket. "All set. Unless I'm…taking you
away from anything?"

Dayna sat up. "In a way, I think you are."

Outside, the shadows were lengthening and the temperature begin-
ning to drop; still, Kayla, antsy from an afternoon sequestered in-stu-
dio, suggested they proceed to the restaurant on foot. "It's a bit of a trek,"
she said. "Maybe a mile."

"Works for me."

"Oh, right. You're quite the hiker, aren't you?" They left the lot and
began heading south. "Getting good material for that book?"

"That's…how it started. But it's turned into something more." Day-
na paused. She longed to share her recent life with someone—partic-
ularly with Kayla. But to what extent?

Her companion looked over, clearly intrigued, but said nothing.

Dayna stared at the sidewalk. "I've been sick. You know about…"

"The depression."

"Yeah." She kicked a stray pine cone onto someone's front yard. "I'm
getting better. It's been bumpy, but the general direction is up. And while
I'm sure the meds are helping, it honestly feels like…like the land is do-
ing most of the work. Calming me with its calm; silencing my doubts
with its silence. Grounding me; healing me. Does that make any sense?"

Kayla spoke at once, nearly interrupting the question: "All the sense in the world."

Dayna smiled faintly, and they crossed the street. "I'm learning things, too. About the land, the plants, the animals. About nature and…my place in it."

Kayla nodded. "And," she ventured, "you feel changed."

"And changing still. Which is a little scary, to tell you the truth. Not recognizing yourself; 'meeting' yourself as you would another person. I suppose it's trite to ask, 'Who am I?' But, see, until recently…" She looked away. "I always thought I knew."

Kayla slid an arm around her back, gave her a sturdy sideways hug— "We'll get to know you together"—and released her. "Deal?"

Dayna's smile returned, broader than before. "Deal."

They crossed another street. "If the land's doing all that for you, then how're you feeling now? I mean, granted, Rapid City's no metropolis, but it's not the Badlands, either. And if the Badlands are sort of your life-line…"

"I'm doing fine," Dayna said, her gaze meeting Kayla's. "Better than fine." *And you're the reason why.*

Picking up their pace, they reached the restaurant shortly thereafter. Dinner itself was nothing to brag about—by her second bite of chicken-fried steak, Dayna had inwardly converted to vegetarianism—and the dining process itself was a bit painful, thanks to her resurgent toothache…but the company couldn't have been better. The two women had a fair amount in common, along with enough key differences to keep things interesting.

What's more, Kayla's stories—particularly those concerning her TV persona—never failed to entertain. "Oh, I've got a solid fan base, all right," she divulged over a forkful of cole slaw. "A friend who's doing a Psych rotation at the state pen told me that every Friday night, the place gets real quiet as the TVs click on, all tuned to Channel 19. When I heard that, it made my skin crawl. Plus, there's a few that send me these pretty graphic drawings of me and them…together." Kayla shuddered. "I used to wish my real name appeared in the credits. I've come around on that one."

"Pseudonyms," Dayna concurred, "have their uses. Or so I've heard."

"You ever write with a pen name?"

"No. Hey, where'd you get that name you called me on the show?"

Kayla stared at her. "Jeez. Didn't you ever spell your own name backwards?"

"Oh," Dayna said, a bit flustered, "right: Eronel. Has a nice ring, doesn't it?"

"*I thought so. I mean, isn't* ero *Latin for 'love'? As in 'erotic,' right?*"

Were these hints, Dayna asked herself, or just coincidences? There resounded within her a scream: *Enough already!* "Actually, this kind of brings up something I wanted to…something I thought I should mention."

Kayla waited, her expression attentive. "Shoot."

Dayna looked down at her place mat: depictions of area landmarks—the Badlands, Mount Rushmore, Crazy Horse, Devil's Tower—printed in khaki-colored ink. She looked back up at Kayla. "I'm bisexual. I've had male and female lovers; I'm attracted to women and men. Always have been. It's…" Glancing down again, she ran her thumb across the Badlands. "It's who I am."

"I see," Kayla said evenly. She paused, considering. "I…guess we don't have quite as much in common as I'd thought."

"No?"

"No offense, Lenore, but personally, I can't imagine being involved with a man."

It occurred to Dayna that if her life were a situation comedy, she'd have misunderstood, would have made an antithetical assumption about what her friend had said. Instead she heard Kayla correctly and grasped her meaning at once. She mustered her nerve and leaned forward. "From where I'm sitting now, *I* can't imagine it, either."

Kayla slid her hand across the tabletop—four inches was all it took—and placed the tips of two fingers on Dayna's right wrist. The approaching waitress stopped in mid-step, hesitated, busied herself at another table…but Kayla didn't notice. "If you're saying," she began, "that you have feelings for…for the woman you're with…"

"I am."

"…then that much, we do have in common."

Outside, the sun was setting; Dayna could see it through the window. For an instant, her mind's eye returned to the Badlands. It was

magic hour, and the formations were changing color: orange bleeding into pink, red into rust into gold, radiating a defiant warmth high into the still, chilly sky. It would have made a far better setting for the present moment than the drab interior of this all-too-greasy spoon. And yet, had they been standing beside the most exquisitely tapered pinnacle or atop the highest, most luminous peak, the touch of Kayla's hand, the sound of her voice and the light in her eyes couldn't have been more glorious.

<div align="center">➔·←</div>

From the restaurant, it was off to one of Kayla's hang-outs, the local pool hall, where they discovered more common ground: equal proficiency at eight-ball. The women traded victories for an hour and a half, finally turning in their cues on a four-four tie. As they headed for the exit, Dayna asked, "What next?"

Kayla grabbed her arm, stopping her just shy of the door. "You decide. Left or right?"

"Uh…left."

"Pick a number between one and ten."

"Nine."

They stepped out onto the sidewalk, turned left and walked past a series of storefronts, Kayla counting off each one in turn. Several of the establishments were closed for the night—a grocery store, a realtor, a savings and loan—but the ninth was wide open. They halted in front of it and gazed up at the garish, electric-blue awning. "'The Tattoo Zone,'" Dayna read aloud. "'Our Design or Yours. No Appointment Needed.'" She laughed, pointing. "Oh, here's a bonus: 'New Needle for Each Client!'"

"How reassuring." Kayla's spontaneity was sliding into circumspection. She pointed farther up the sidewalk. "If only you'd said 'ten,' we'd be trying on bowling shoes right now."

"But I didn't." An image was forming in her mind.

"Y'know, we don't *have* to…"

She grabbed Kayla's sleeve—"I *do*"—pulled her inside and marched her up to the counter. The fellow seated behind it—a brawny, bearded, heavily decorated specimen whose name, Dayna thought, just had to be Gus—looked up slowly from an oft-read off-brand porno mag.

"Hi," Dayna began. "I believe my friend here is wimping out…"

"That's correct," said Kayla quickly.

"…but *I* would like a tattoo."

Gus scratched his bicep (and with it the hooded head of a Harley-riding Reaper), put down his copy of *Spanktacular* and rose to his feet…and his full six-and-a-half-foot height. His voice was a subterranean rumble: all woofer, no tweeter. "You're in the right place."

"Can you give me a bighorn?"

"Sheep? Sure."

"A female."

Gus appeared perplexed. "You don't want…"

"Can you do it?"

"Piece of cake. But no point doin' a bighorn without the…big horns."

Dayna unbuttoned her jacket. "There's a point," she said, "for me."

Afterward, they walked back to Dayna's car and drove the few miles north to Spearfish. By midnight they were seated on a pair of swings in the playground of an unlit community park across the street from Kayla's campus. Traffic at this hour was nonexistent; the women's own voices and the chirping of crickets were the only sounds to be heard. Kayla rotated her nylon seat, twisting her chains into a tight metal braid. "At the risk of sounding sadistic, I must admit, watching you get that tattoo was pretty hot."

"Really?" Dayna realized how pleased she sounded, but that was permissible now. "Continue. In…great detail."

"Every time you flinched or gritted your teeth or caught your breath, I felt kinda, well…*you* know." Kayla raised her feet, allowing the chains to unwind themselves, and her, back to the starting position. She spoke while spinning, a blur in the dark: "By the end, I was having trouble sitting still! Not because you were in pain, but because it was so…so…"

"So immediate," Dayna said, "and so intimate. I felt it, too. We were both right there in the moment, watching the needle…and watching my body respond."

"Right," Kayla said, then sighed.

Dayna smiled. "If only we could've gotten rid of Gus. Like, 'Can you leave us alone back here for a while?'"

"Did a nice job, though, didn't he?" Kayla gazed up at the stars. "Someday, you'll have to tell me about you and bighorns."

"Someday, I will."

The sound of jubilant voices carried through the cool autumn air from across the street. Kayla glanced toward campus. "I'd ask you over, but my roomie…"

"Gotcha." Dayna pushed off with her feet, swinging briefly backward, then forward into the darkness. She would have declined the invitation anyway; showing her face in a college dorm was too risky, even out here. Swinging back again, she scowled. This double life had served its purpose, but it was getting old; she was tempted to take back her name, if only with her new companion. She'd made two major disclosures to Kayla already—last week's, about her depression, and then tonight's—both of which had been well received. Perhaps she should go for the hat trick and "come out" to her as Dayna Clay.

Then again, why rush to reclaim Dayna when things were going so well for…

"Lenore." Kayla had swiveled to face her, and though her face was largely hidden in darkness, her earnest demeanor was apparent. "What I said before, in the studio, about not wanting to be…constrained…"

Dayna slowed her swing. "Something about…an ex-girlfriend?"

She nodded. "I'm not about to hold her mistakes against you. I don't do that. But to be honest, you *are* catching me at a less-than-perfect time."

"What do you need, Kayla? What do you need from me?"

She thought it over, then answered, "Patience."

Dayna smiled to herself. Patience was a virtue she long had struggled to obtain…but had been learning, lately, of necessity. "Done."

"Thanks." Kayla got off her swing, walked over and stood just behind Dayna's; she gave her back a gentle push. "And what do *you* need?"

"Are you kidding?" Feet thrust out in front of her, Dayna glided smoothly forward and back, forward and back—"You're doing everything right"—returning again and again to Kayla's capable hands. She closed her eyes and caught an inkling of some alternate reality, imagined a childhood quite different from the one she'd survived. "The fact

that you're willing to even *think* about getting involved, considering…"

"Considering what?"

"My condition. My depression. My fucking Achilles brain."

"My Dad recovered; you will, too. Jeez, you're halfway there!"

"But I feel so shaky, so uncertain. I'm living by guesswork, hour to hour. I'm improvising everything, making it up as I go: my life… my*self*." She shook her head. "I finally meet someone really amazing, and I'm not even *me* anymore!"

Kayla stopped pushing; Dayna's swing began to slow. "Maybe," Kayla said, walking to the front, "you're someone better."

Dayna dragged her heels, bringing the swing to a stop. She stood and stepped forward into the night; before she knew it, her face and Kayla's were inches apart. "Maybe I am."

Kayla placed her hands on Dayna's hips. "In which case…lucky me!"

"In which case," Dayna corrected, "lucky us."

Kayla nodded, her eyes at once gentle and intent, illumined by the moon.

Dayna raised her chin, and her lips found Kayla's, their mouths opening together. Kayla shifted her feet and, as the edge of Dayna's tongue slid alongside her own, released a low moan. Then Dayna found herself pulled up on tiptoes as Kayla's arms wrapped snugly around her back, drawing her closer, higher, stomach to stomach, chest to chest. The words came to Dayna in a flash: *my kind*. Not because Kayla was a woman—she didn't have to be—but because she was this woman. Because she was Kayla Drake in all her quirky, incongruous, sweet-souled glory. *My kind. My kin. My own.*

Dayna tightened her embrace, holding on as firmly as hands, arms and will would allow.

I'm home.

The next few days found Dayna returning to her Badlands exploration with a renewed sense of purpose. Perhaps it was because she now had someone with whom to share her every discovery and epiphany; during their nightly phone conversations, Kayla proved an eager listener. Or perhaps it was because everything Dayna encountered "out there"

appeared, increasingly, to be connected, even the most disparate elements snapping together like puzzle pieces once she'd turned them over in her mind.

Or perhaps it was the change of seasons. For it was now mid-October; the days were growing colder and the air drier, stiffening the formations and rendering them ever more brittle and inconstant. As they grew harder, they grew harder to navigate, in spite of Dayna's own hard-won expertise. Not that she minded; this development merely constituted a new challenge, and one that she took pride in facing head-on. And so, wearing a sweatshirt or two under her jacket, she continued setting out for the most formidable peaks. Her climbs took longer now, and she skinned her knees more often than she would have liked. But one way or another, she always made it to the top—and back—by sunset.

Occasionally, Dayna glimpsed a lone ram or a pair of ewes regarding her from a neighboring peak. In reply, she reached under her shirts, placed a finger between her breasts and traced the still-sensitive outline of her tattoo. It had been, she realized, a bit out of character: marching into that ratty little joint, entrusting herself to the likes of Gus and ordering up a customized scar. She was surprised with herself, but not displeased. For while Dayna now knew that the breed depicted was not "her own," the bighorn remained a kind of spiritual touchstone in the unfolding drama of this, her new life. She felt privileged to wear its likeness atop her heart…though the region within belonged, increasingly, to someone else.

After pausing to offer her secret salute, Dayna returned to the task at hand with increased determination. Eyes narrowing, she took hold of the fragile wall before her and hoisted herself ever higher as her comrades watched in characteristic silence. They hadn't stopped climbing, and neither would she.

Dayna felt stronger than she'd dared hope only days before—and it was a strength that lingered after the climb was over. Driving back to the Tip Top, taking a shower, heading over to the Stone's Throw, shooting the breeze with its sole employee, shoveling down her dinner and returning to her room, she continued to feel sound, stable and self-assured. Dr. Eaton, during their weekly check-in calls, was most impressed with his patient's progress. And who could blame him? One by one, her symptoms were fading clean out of sight.

Was it the meds? she wondered one night, closing her book and reaching to turn off the bedside lamp. Or was it the act of climbing, or the land itself, or Kayla's presence in her life that had boosted her into this uncommon level of tranquillity and health?

"All of the above," she murmured, head hitting her pillow. She had hoped to reign in the depression, had longed to subdue it, dreamt of slaying it. And now here she was, dancing on its grave.

<center>⇥·⇤</center>

Hours later, it clawed its way out and devoured her.

She awoke just past 3 A.M. dazed and disoriented, shoulders quaking, sheets damp with sweat. She felt tiny, not a woman but a girl, as helpless and isolated as if set adrift in outer space. *Not again*, she thought, rolling over and over, *please, please*, please *not again*.

Looking out the window, she caught a glimpse of the formations. It was at night, half-lit by moonlight, that they seemed most ominous— barely visible, black against near-black, looming and silent and vast— but now they were monstrous. Had she really been up there? Had she truly stood, walked, leapt across those precipitous peaks and ridges hundreds of feet above ground? Her mind swerved, careened; she lay on her back, limbs flailing, thoughts faltering and spirit failing and…she fell.

And fell, and fell—five yards for every one she'd ever climbed. She fell for miles, for hours: back into the abyss, into the darkness…into the past. Again, she felt his hand between her shoulder blades, pushing her, as always, flat on her stomach; again, she felt his other hand, aided by his knees, prying her own legs open and pinning her there as if for dissection, all too aware, too conscious, too alive. The liquor wore off too soon, and Dayna came back to herself: desperate, incensed, she shook her head, squirmed under his weight, struggled to break free. But by then he was a pillar of hurt so dense and thick that with each lunge, she was certain the next would tear her in two. At that point the thrashing around just made it worse, so she clenched her left fist and lay as still as possible and waited for him to finish…little knowing that fifteen years later, she would be waiting, still, for it all finally to end.

At sunrise, Dayna pulled the covers over her head and wept. Why was this happening again? What had she done to deserve it? She felt

like a character from one of the movies on Kayla's show: Dr. Jekyll, or the Wolfman. For Dayna, too, found herself periodically transformed into an appalling creature she could neither comprehend nor control. She, too, had no choice but to wait it out, withstand its ravages until the curse had run its course and worked its way—for now, only for now—back into the recesses of her brain.

Poking a hand out from under the covers, she located the night stand, opened the drawer and fumbled around for her Xanax, the tranquilizer she was to take on an as-needed basis. She drew the bottle under the covers, popped it open, poured the pills onto the mattress and counted: twenty-four left. She had two options: take one now, and see if it does any good…or take them all and render the question moot.

After a moment's deliberation, she popped a single pill into her mouth, choked it down with saliva—the ten-foot distance from bed to sink being insurmountable—and shoved the rest back into the container. As she put the bottle back, her hand glanced against another object: a book. The Gideons' Bible. She'd spotted it there in the drawer weeks ago, had pushed it to the rear. Now, turning onto her side, she took hold of it and drew it near.

Dayna licked her chapped lips and ran her fingers across the textured cover. She'd known people—those of simple, straightforward faith, true believers—who, when faced with a crisis, opened the Bible at random, trusting God to guide them…but in the midst of this resurgent torment, Dayna wasn't sure she even believed in God. What's more, the part of her that did continued to hold a grudge for all she'd endured: the wasted childhood prayers, the lack of response from above. God existed—probably—but had let her down big-time.

Then again, she told herself, everyone deserves a second chance.

"Help me." She opened the book in the middle and jabbed her fingertip against a left-hand page; she wiped her nose with her other wrist, cleared her throat and read aloud:

"I will satisfy the weary, and I will replenish every sorrowful soul."
Thereupon I awoke and beheld, and my sleep was sweet unto me.

Dayna lay still, torn between her urge to find solace in the words—words that, she had to admit, were eerily pertinent—and her

skepticism toward anything that presented itself as "the way." Satisfaction, replenishment, sweet sleep; that all sounded great. But how, where, *when*? God talked a good game, but what had "He" done for her lately?

She closed the book and, re-opening it, tried again:

For the man was not made from the woman, but the woman from the man. Neither was the man created for the sake of the woman, but the woman for the sake of the man.

"Give me a fuckin' break." Dayna slammed the book shut, picked it up...and hesitated. She stared at it—a dark, dense slab, shiny gold letters on brown—then placed it back on the bed and propped herself on one elbow above it. *All right. Best two out of three.*

The phone rang; Dayna eyed it warily. She was feeling slightly better—this scriptural game show had proven a distraction from her gloom—but was still far from herself. *It could be Kayla*, she thought. *Can I talk to her now without falling apart?* A second ring. She'd have preferred that Kayla not find out about this relapse, had no desire for her potential partner to see her as needy or weak.

Then again, maybe hearing Kayla's voice, in and of itself, would help.

She grabbed the receiver. "Hello?"

"Ms. Dayton?" A man.

"Yeah."

"Ranger Swaney of the Park Service. We met a couple weeks back; you came in and reported that poaching incident..."

"Right...right." This was unexpected.

"I just wanted to let you know we've located the offender."

"Great," Dayna mumbled, cognizant that, if not for the muffling effect of her depression, she'd have been genuinely pleased. She picked up the Bible—"Throw the book at 'em, OK?"—and put it away.

"Well, its kind of a...unique situation."

Had she known what was to follow, Dayna would have ended the call then and there. Because by the time she'd finished hearing about the mentally retarded fifteen-year-old down in Sharps Corner—a boy who'd set out to bag a bighorn ram in a disastrous attempt to impress

his stern and distant sportsman father—her heart was breaking anew. "Oh," Dayna said, voice quavering. "God, that's…awful."

"It's no holiday."

She pictured herself trying, in her present state, to testify against such a youth. "You don't…need me for anything…do you?"

"No. He's confessed. I just wanted to let you know."

She thanked him and hung up, then burrowed back under the covers, trembling, cold and alone. The Xanax wasn't helping, not in the wake of this latest intrusion; Dayna found herself plunged as deep into despair as when she'd awoken. For she possessed a kind of sixth sense that, in her bleakest hours, eclipsed the others: an ability—worse, a compulsion—to turn all the heartache she encountered into her own. So it had been from the beginning, was now and ever would be. *Grief without end. Amen.*

Two hours later, the black tarp shifted, then lifted…though not, she suspected, for long. She'd encountered this before: the teasing, mid-episode morsel of relief that made the remainder seem all the more dismal in contrast, even as it left her clinging to a shred of hope. Dayna seized the moment and performed a task she'd contemplated all morning long: she got out of bed, walked across the room and wolfed down an untoasted blueberry Pop-Tart.

Wiping her hand on her T-shirt, she glanced down. There at the closet entrance, beside her boots, something caught her eye… something she hadn't noticed before. A lone weed half the height of her thumb was poking up between two of the floorboards. Dayna got down on her hands and knees to inspect the shoot, a scrawny stem without a leaf to its name. There was nothing distinctive about it—nothing, that is, but its presence within a motel room, its ability to make its way up through a crack in the floor, its stubborn drive to grow and survive.

Dayna stood, walked into the bathroom and filled a glass with water. Returning, she knelt and poured a trickle in between the slats; the rest of the water, she drank. And as she swallowed the last of it, she began to believe that the relief she now felt was not, in fact, fleeting…was not the eye of the storm, but the morning after.

A knock at the door; her head turned. "Who is it?"

No reply.

The silent proprietor, no doubt. Old Outskirts, bringing a much-

needed change of sheets. Dayna grabbed her jeans, pulled them on and opened the door.

He looked instantly familiar. A man in his thirties, nicely attired—crisp jeans, linen jacket—trendy hairstyle, not unattractive...and definitely not from around here. Someone from her semi-recent past, though she couldn't place him. For his part, he was studying her sun-tanned yet bedraggled features as if searching for the face of someone he knew under this spent young woman's bottle-blonde hair. "Dayna?"

She nodded tentatively. "I know you..."

"Hugh McCarter." He stuck out his hand.

She took it, shook it and remembered. He was a senior writer for the nation's leading rock 'n' roll biweekly. She'd always liked his style—had especially admired, during her high school years, his seminal pieces on the then-nascent Seattle sound—but hadn't met him until an "Anti-Grammys" party the previous March. After a few pleasantries, he had conducted a brief, impromptu interview, and she'd promised him a longer one "soon, real soon." But then had come the utter implosion of her world.

She released his hand. "Let me guess: you're here to collect. Right?"

He lowered an eyebrow. "With your consent."

"I..." She hesitated. "How'd you find me?"

"It wasn't easy." He leaned against the doorway. "I'll tell you this, Dayna: it's good to find you alive."

"Does anyone else know I'm here?"

"I seriously doubt it." A hint of pride.

"Did you...?"

"This'll be some interview," he cut in, "if *you* keep asking all the questions."

Folding her arms, she smiled thinly. "You seem awfully sure there's gonna *be* an interview."

Folding his own arms, he returned the smile. "Is there?"

EIGHT

DATELINE: OBLIVION
The Dayna Clay Interview
by Hugh McCarter

THE STORY GOES LIKE THIS: *During contract negotiations with a major-label record company representative, the as-yet-unsigned Dayna Clay responded to the man's initial proposal by excusing herself, standing up and leaving the room. Her mystified agent carried on without her until the singer returned, brown paper bag in hand, having made a purchase at a nearby adult book store. Stepping up alongside the rep, Clay whipped out a large, rubber phallus and slammed it down on the conference table with a resounding* thwack. *"Now that I have one too,"* she suggested, *"perhaps you'd like to make me a serious offer."*

True or not (her agent confirms it), the anecdote meshes neatly with the persona Clay's fans know and love: writer and singer of contentious, confrontational lyrics; guitar-wielding spokeswoman for the used, abused and generally confused; the artist who included, in her debut CD's liner notes, descriptive information about the man who molested her a dozen years earlier "in case the slime's out there hunting new prey." Time magazine hit the mark with the headline of its recent Clay profile: "Voice with a Vendetta." In her work as in her life, Clay has consistently engaged in

no-holds-barred combat with her every foe, real or perceived—up to and including herself.

But on a chilly October afternoon, it's quite another Dayna Clay that answers the door of a motel room somewhere in rural North America. She looks different—having checked in under an assumed name, she has altered her appearance accordingly—and she sounds different, her renowned voice a raspy shadow of its former self. But a still greater contrast lies in how she carries herself. As we converse, Clay pauses to measure her words before speaking, and her overall demeanor is not combative but obliging, her wit less caustic than convivial. Even the rare flash of testiness is tempered by a gentle discretion.

Despite her self-imposed (and much-publicized) exile from the public eye, Clay consents to an interview fairly readily, on two conditions: that her visitor explain, before leaving, precisely how he was able to find her, and that her whereabouts remain concealed.

We begin not in Clay's room but, at her suggestion, outdoors while hiking across the local terrain. And an arresting terrain it is: the area in which the rocker now resides is characterized by wide open spaces, vaguely disturbing topography and an all-consuming quiet. Her new home would be an unorthodox choice for most retreats, but for this one it feels ideal.

In "Give Me Oblivion"—a song that's been inescapable on the radio since your disappearance nearly five weeks ago—you sing, "My mind is scattered and my body's spent and sore / They never seem to play together anymore." Which have you found out here: oblivion—or integration?

I…Jesus. Thanks for lobbing me a softball right off the bat. Whatever happened to "What's your favorite record? Who are your favorite artists?"

Turn-ons, turn-offs, that kind of thing?
[laughs] Yeah, that's me: Playmate of the Month.

Or we could begin at the beginning. You were born and raised…
[interrupts] Honestly, does anyone care? Yet every interview, every profile starts there: my childhood, my parents…

Your father took his own life before you were born, a fact that you discovered in your early teens.

Right. *[pauses]* Is that a question?

There must have been times when you felt awfully alone.

There are worse things than solitude. But let's...focus on the present.

All right. Solitude would seem to be plentiful out here.

It is. So is silence. And silence, I think, is underrated. That may sound ironic coming from me, but it's been a real gift. And a relief.

Do you see yourself heading away from your previous hard-driving sound and into a quieter, more introspective kind of music?

I don't see myself heading anywhere. I do not consider myself a...recording artist, or a performer, at this point in time. I may or may not return to music. Nothing could concern me less.

Yet it's a matter of great concern to your fans.

Yeah, well...I can't fake it. I'm not gonna go through the motions. All that would do is taint whatever minor successes I may have achieved back when I gave a fuck. *[points east]* Let's go this way. *[We head across a flat stretch toward a looming mountain.]* Might as well take a stab at that first question now.

Integration versus oblivion.

Right. *[long pause]* Coming out here has...changed me. Dramatically. In ways I only half-understand. See, I...*[pauses]* When I left that cell-phone message, the one about the "wishing bridge" I visited as a girl and how I don't believe in wishes anymore—the call that got intercepted and, apparently, splashed all over the airwaves—well, at that time I was about as low as a person can get.

Dayna, was that a suicide note?

[long pause] When you're a...public figure, an entertainer, you really have to watch what you do and say because people you don't even know—kids, especially—they take it all very personally. Many teenag-

ers model their lives on people like me. Which is…terrifying. *[deep breath]* Yeah; it was. A suicide note. I did try to kill myself. Runs in the family, right? But where my father succeeded, if you can call it that, I failed.

Are you glad about that now?

Absolutely. I've come to see the attempt as a mistake. I wanted escape, deliverance, release, and I couldn't think of any other way. I wanted oblivion…and ended up out here, very much by accident, still looking for it. As you can see, this land lends itself to those kinds of longings.

It is quite desolate.

[nods] That's what attracted me initially: the isolation, and the privacy it affords. But at the same time, this area's teeming with life. *[She points out some local flora and fauna, describing them with authority.]* Don't put any of that in your article; someone might identify the locale. Anyway, thanks to time spent out on the land—along with some anti-depressive medication—I've been heading out of oblivion and into…cohesion, wholeness, whatever. Integration. My mind, body and spirit aren't always on the same page, but they're in the same chapter. Most days, anyway. And it's my body that's been leading the way.

How so?

I've been doing a lot of climbing. *[gestures toward the mountains]* Up there. Gotten good at it, too. And it's given me a feeling of strength, of empowerment, I guess, that I can't seem to get from anything else. Certainly not from music. Y'know, the depression stole my mind and…stained my soul, but even during the lowest lows, my body was still mine. So I placed my faith in that most basic part of myself, and eventually it kind of…it pulled the rest of me out. Though that's not quite…*[shakes her head]* It's hard to put into words.

Some of the words you have been using—"soul," "faith," "deliverance"—have a distinctly spiritual ring to them.

I guess.

That's somewhat uncharacteristic language for you, isn't it?
[kicks a stone] Your point being…?

*Has your time out here constituted, on some level, a religious experi-
ence?*
Depends on your definition.

I'd be more interested in yours.
Right. *[She grabs my tape recorder and speaks directly into it.]* Rest
easy, Clay fans: if I ever *do* record again, there won't be an embarrass-
ing "born again" phase for you to rationalize and defend. *[hands it back]*
I continue to have serious problems with the Bible, which offers, as far
as I can tell, equal parts comfort and crap. I know there's beauty in
there, and truth. But there's also ignorance, intolerance…and some
really bad advice. "The word of God?" I don't think so.

Do you believe in God?
Not a God so petty and insecure as to care whether I believed in it
or not. And not a God so small you could contain it in a book. Or be-
gin to understand it, let alone describe it.

What do you believe in?
[pauses] The land. The power…the sacred power of nature. *[indi-
cates the mountains]* I've felt it up there, under my feet; I've held it in
my hands. But a supreme being? I don't know. Maybe. If there is one,
I'm pretty sure it doesn't speak in words—"Thou shalt; thou shalt
not"—but in, y'know, the wind and the waves. And in healing. I guess
I've been hearing that voice myself lately…intermittent though it be.

*You haven't by any chance been studying Native American religions,
have you?*
Not really. If I've come up with a…comparable outlook, I'd guess
it's from having done—in my own abbreviated, touristy way—what
they've been doing for ages: listening to the land.

And you sense in that land a divine presence?
Something like that. I don't know. Maybe it's wishful thinking;

maybe I'm out here all alone. For that matter, maybe the Almighty really is a big, angry guy with a beard who shuns queers and fornicators and intends for women to be obedient helpmates. If so, then *[looks up]* send me to hell, God, 'cause I'll fit in much better there! *[to me]* Besides, after depression, fire and brimstone would be a cake walk.

How are you feeling now?
Just had a bad day—a wretched one, actually—but at this point, those are few and far between. The meds are working, and the change of scenery's done me good. Depression is a treatable illness. Your readers should know that. There's really no reason for suicide, though that's hard to see when you're in the thick of it—when despair and fear are all you can feel.

They say a broken bone becomes stronger than ever once it's mended. Could the same be said of a broken mind?
[long pause] I feel stronger and weaker at the same time. I know that sounds like a cop-out, but it's the truth.

Can you elaborate?
I'm…less cynical; I have a lower tolerance for negativity. I'm more aware of my limitations—limitations that may or may not have been there all along. I'm more easily overwhelmed. But on the other hand, I've…I seem to have developed a keen sense of intuition, a gut feeling for what's going to help me and what isn't. A kind of internal truth detector: an ability to identify, well, not Truth with a capital T, but what's true and good for me. And I've also undergone a pretty radical revision of my…priorities in life.

The result being?
Fewer things matter to me, and they matter much more.

What matters now?
Not my career. Not my music. Not a world tour…and not that damned movie everyone's so adamant I make. I don't act! I mean, look at me: I can't even play *myself.*

I didn't ask what doesn't matter; I asked…

Right. *[pauses]* My health. My well-being. A sense of balance, of…stability. A decent meal; a good night's sleep. The occasional warm embrace.

Is there…someone in your life?
[pauses] Yeah.

Is it serious?
It's…early. Let's not jinx it.

This is someone you met out here?
Next question.

What, if anything, can you divulge about…this individual?
"This individual." *[shakes her head]* Go ahead and ask.

Well, when a professed bisexual says she's become involved, one naturally wonders…
But why? Is that the key, defining aspect of a person? News flash, Hugh: I'm not from Venus, and you—to the best of my knowledge, at least—are not from Mars. Male or female, straight, bi or gay, we all come from the same place. There's a lot more that connects us than separates us. That is, if we let it.

I seem to have touched a nerve.
Look, I'm just not wild about the assumptions people make based on gender. I don't know; maybe it's a function of growing up bi. When you've always been attracted to both, it evens out the playing field, and you tend to focus on other areas. Like how much fun someone is to be with, or the quality of their heart. It seems so simple to me, so obvious— but from the reactions of many straights *and* queers I've known, you'd think I was a lunatic. *[throws up her hands]* Whatever; it's who I am.

You've known this about yourself since childhood.
Oh, yeah. And incidentally, it predates the abuse, lest anyone think *that* yanked me out of the hetero camp. It didn't; I was never there to

begin with. Y'know, this is all gonna be pretty redundant for anyone who read my profile in the April issue of *Anything That Moves*.

We have a somewhat larger circulation.
Right; right. Well, I knew how I felt from age eight or so on; I just didn't know what to *do* with those feelings. I kept a lid on 'em through junior high, but halfway through high school I got kind of blatant, openly flirting with boys and girls alike.

How was that received?
[laughs] How do you think? A stridently bisexual goth-girl? My class-mates called me AC/DC—a play on my initials. They meant it as a slur, but I embraced it. My attitude was basically, "Sure am, Suzie; sure am, Steve. Wanna catch a movie; wanna dance with me?"

And did they?
[shakes her head] Some may have wanted to, but if so, they were afraid to act on it. Then again, scaring off potential partners has always been my forté. I fared better in college…though not as well as I could've.

Because of your orientation?
No. Because of my image; because of the signals I was sending. See, back then I was fronting this punky little grunge band…

Salt Lick.
[nods] May it rest in peace. Anyway, one night I got hold of an en-tire roll of police tape—don't ask how—and decided to wrap myself up in it before every gig…

Yes, there's a photo on one of your websites…
No doubt. As you can imagine, covering my body with the words "Do Not Cross" tended to be a bit…off-putting…to any otherwise in-terested classmates, male *or* female.

A psychoanalyst would have a field day with that one.
Too easy. It analyzes *itself*, doesn't it? Clearly, I was still dealing with "abuse issues." *[shrugs]* Still am. It's a tough one to shake.

Was writing, recording and performing "Virtual Virtue" helpful in that regard?

It was. Though I didn't do it as self-therapy. At least, not consciously.

What's your take on the song's runaway success?

Well, there's more exploitation and abuse of kids going on out there than most people would like to believe. But "Virtue" has been embraced by those who've been betrayed in other, less overt ways, too. If you give someone your trust, especially someone older, and if that trust is squandered, it's important to go on record about it: "I know what you did; I see what you are. You've hurt me, but I'm still here...and I'm telling."

That's sort of a kinder, gentler version of the chorus. The song's actual lyrics are quite frank, quite...literal.

[*nodding*] Others have addressed similar experiences through metaphor, which most people find more palatable. But for me, that undermines the severity, the...reality of what happened. No offense intended to my colleagues, but he didn't "pluck my petals" or "steal my pearl." He plied me with booze, held me down and forced his body inside mine. On nine separate occasions. To dress that up would be to downplay it.

I find it impressive that, in spite of that experience, you've been able to maintain such positive feelings about sexuality.

Too positive, some would say. I've gotten interesting feedback from some...how shall I put this?...well-intentioned but clueless parents.

Well, let's face it: a song like "Sex Instead" [in which Clay slams recreational drug use while praising recreation of another kind] was recorded to neither please nor appease the moms and dads of middle America.

No, it wasn't. [*smiles*] But it's got a good beat, and you can dance to it.

The song's tacit endorsement of "drive-by couplings" obviously flies in the face of so-called traditional family values.

Yet I'd argue that those very couplings, responsibly practiced, actu-

ally *strengthen* the family by preventing bad families from forming in the first place. If you're hot for someone, and vice versa, don't marry them; take 'em to bed. Use protection, obviously…but share your bodies, not rings or vows. Save commitment for the one you not only want to sleep with but wake up with, morning after morning, for as long as you can imagine. Save marriage for the love that lasts a lifetime.

Do you believe in such a love?
Sure. I mean, I keep hoping; I suppose it's the ultimate goal. But those drive-by couplings—and, on occasion, triplings—always seemed to me a pretty good way to kill time till "true love" came along.

Add to such statements the fact that nude photos from your days as an art-school model are now all over the Internet, and it's easy to see why…
[cutting in] Y'know what? I'm glad. Granted, I'd have asked for a few more bucks if I'd had any idea how much that stuff would be worth today. But I don't regret posing, not for a second. My body's served me well, especially out here…and has proven, frankly, a hell of a lot more reliable than my mind. I'm not ashamed of it, and I'm not about to act as if I were.
As for sex…*[pauses]* I don't blame what happened when I was twelve on sex; I blame it on him. Like the song says, I'm pretty sure he took up with my Mom just to get a stab at me. And he got me drunk, every time but the last. To break down my resistance, rob me of my will.

Which is why you don't drink now.
Or do drugs. I can't stand the feeling of losing control. Of…surrender.

A trait that must make weathering depression all the harder. Earlier, you described it as having "stolen your mind."
Right. But I got it back. *[laughs]* Got *someone's* back, anyway! But before we leave the topic, I have to say that his getting me drunk ended up being, in a twisted way, the silver lining to the whole nightmare: by the time I achieved "rock star" status, I was immune to whatever allure such…indulgences otherwise may have offered.

But sex was different.

Yeah. Granted, my very first time after, at seventeen, was…rough. Realistically, how could it not have been? But then it got better; I was pretty determined that it would! I guess I always figured, "I'll be damned if I'll let him ruin *that*."

So you redeem sex by having it?

Something like that. You hungry? *[Clay produces a banana from her jacket pocket.]*

Sorry there's no conference table here for you to slam it down on.

[smirking] My reputation precedes me. Want to split it?

I'm fine; thanks. Shall we sit for a bit? [We seat ourselves at the foot of the mountain toward which we've been walking.]

[Clay peels the banana.] I was into oranges for a while, but I've had a taste for these lately. *[chewing]* When my potassium level gets low, my body lets me know.

You sound pretty integrated to me.

Getting there. You know, Hugh, you've done an artful job of hitting all the hot-button topics. We've covered abuse, depression, religion and sex. What's next, politics?

How about music?

Didn't we already…? *[Her voice trails off; she points toward a row of distant mountains.]* Look—there. Look at that range.

What about it?

[long pause] This may sound crazy, but that range—it's telling me something. Something that never hit me before. Telling me by its very nature. By its peaks and dips, its ups and downs.

What's it telling you?

That every decline ends in an incline; that even the lowest low leads back up. *[looks away]* A cliché, I suppose. Corny as hell…yet somehow, it gives me hope.

Do you experience these sorts of epiphanies on a regular basis?

Regular enough to keep me looking. Come out here to beat back an illness, and I swear, *everything* is a metaphor: the land, the wildlife, even the weather. It's as exhausting as it is illuminating. Sometimes I have to put my mind on "pause" and just soak it all in. Y'know, if…yeah, here's an idea: let's stop talking. Let's walk all the way back in silence.

There are still a few questions I wouldn't mind…

We'll cover those when we get there, but first, let's just walk. It's the best way I know of to explain what it's like — to show you why I'm here. OK?

OK. [We stand and begin our trip back to the motel. Throughout, I find myself less intrigued by the land than by its admirer, whose comfort with and engagement in her surroundings is palpable. Upon our return to Clay's motel room, we sit down: she on her bed, I on the lone chair. I reactivate the tape recorder.]

Well?

Well, it's certainly peaceful, if stark. I don't know what else to say, Dayna; this land just doesn't resonate with me the way it does for you.

Oh.

But it doesn't have to, does it? You've tapped into something out here that's helpful, something that you need. I only hope that if I ever find myself in similar straits, I'll end up where I need to be, too.

Well put. *[pauses; then, quickly]* Let's knock off those last questions of yours.

OK. First of all: your voice. Where'd it go?

Damned if I know.

Did you strain it on tour?

Must've. But there's a kid who can fill in for me in a pinch.

Did you catch his appearance on "Letterman?"

[nodding] He's a natural.

Were you aware that, in the wake of his performance, your five-year-old debut album [featuring "Karma Bomb," the song that thirteen-year-old fan Justin Gould performed on the show] has cracked the Billboard Top Twenty?

Jesus. This whole thing…it's a juggernaut, isn't it? Completely out of control. No wonder the cynics think it was a set-up. I swear, Hugh, I never intended any of this to happen: the…intrigue, the speculation. I never meant to become…

The Anastasia Romanov of rock?
[smiles thinly] Promise me that won't be your headline.

Done.
I may have to come out of hiding just to undercut the mystery and make it all stop. [shakes her head] The Top Twenty? It didn't make the top *fifty* the first time around.

Meanwhile, Oblivion *has spent the past month at number two.*
My God. Jayce [Burke, Clay's notoriously aggressive agent] must be delirious. She must be in, like, a state of perpetual orgasm.

If you did come back right now, and if you went out on tour, here or abroad…
Mega-success. The top tier. Record-breaking attendance. Numbers beyond my wildest dreams. The bands I used to open for would be opening for me. That all may be true. But like I said before, nothing could interest me less.

Y'know, a few months back, I visited a certain extremely successful recording artist at…his or her palatial residence. This person had found something to admire in my work and was nice enough to invite me over. I went for a swim in the pool, and when I went under I noticed that recorded music — this person's own music — was being piped into the water. I'd never heard of that before; I didn't even know it was possible.

Was it The Artist Once Again Known As…
No. Anyway, a while later I went into the house to use the toilet. And

when I flushed, the thing didn't make any noise at all. Not a sound! I stood there and clapped my hands to make sure I hadn't lost my hearing—an occupational hazard, you know. But it wasn't me; it was the john. It was a silent john. I asked my host about it, and this person…

Sting?
…who shall be nameless, said something like, "Oh, you noticed. I don't know how they do it; some cutting-edge technology. Cost me a small fortune, but it's worth it." At that moment, I got this mental image of myself in a few years, rattling around some neo-modernist castle with a pool that should've been silent, but wasn't, and a toilet that should've made noise, but didn't. And I'll tell you, Hugh, it made me want to scream.

But Dayna, that wasn't why you got into this business in the first place—for the financial rewards.
No, but "this business" has a way of changing people. Assimilating them. I've seen it. And if I'm gonna be changed, I'd prefer the kind of changes I've been undergoing out here.

What about the music itself—writing songs for their own sake?
I seem to be all written out.

Do you miss performing?
[*sighs*] It's been…I don't know, a long, long time since playing for an audience brought me even a shred of satisfaction, let alone the visceral charge it used to give me.

What was that like, the charge?
My memory's kind of dim; it feels like another lifetime. Which, in fact, it was. [*pauses*] I guess the feeling was most…acute…in between songs. When the crowd was cheering, chanting my name, hollering for more. Hanging on every motion or gesture, look or word. It would've been hard not to get off on the power such…devotion confers. [*reclines on her bed*] Sometimes I'd just stand there, soaking in the anticipation, teasing 'em with my silence. Challenging their patience, milking the moment. Letting the tension build.

And then…*[closes her eyes]* Then something…odd would happen. At that point when the crowd should've been most apparent, should've loomed largest in my mind, it…disappeared. Just slipped away into the ether, leaving me alone with my guitar. Then I knew it was time, and when I brought down my pick and sent that first chord shooting out into the void, it was like…there was this…shift. As if…*[opens her eyes]* Well, it always moved me in a way I can't begin to describe.

You're doing fine so far.
It's like…the song's not mine anymore; I belong to the song. I'm conscious of having brought it into being, having "given it birth"—but now it's out there all around me, filling the room, louder than life. On some level, I cease to exist—as flesh and blood, at least. I merge with the music; I become the song.

Then the audience returns; I can see and hear them again because now that song, the one I've become, is making a concert hall full of strangers clap and scream and sway. Strangers who know the song and, because they do, think they know me. As the song hurtles out in all directions, I give it voice—my voice—and again, the audience responds. They love the voice; they love the song; they *think* they love me. *[long pause; softly]* And sometimes, for an instant, I…let myself believe.

They love what you stand for: endurance, perseverance, strength. They love how you make them feel about themselves. And they…
[sits up] They love a good riff. Anyway, I've answered your questions; time for mine.

That was the agreement, yes.
I thought I'd covered my tracks pretty well. Someone must've tipped you off.

That's right.
Not my doctor.

No; your landlady. The proprietor of this fine establishment.
You're kidding! Old Outskirts talked? I wasn't even sure she *could.* So she knew who I was all along?

Not when you got here; later on. She recognized you from TV, called our offices…and collected a tidy little finder's fee for her trouble. The good news is, she's barred from telling anyone else; it's an exclusive arrangement.

Well, exclusive or not, it's obviously time for me to check out.

Where will you go?

Now *there's* an item I'd love to see in print. Don't worry, Hugh; I have somewhere in mind. *[standing up]* I'll be fine.

Speaking on behalf of the outside world, we'd love to welcome you back.

Thanks anyway, but I'll stick with oblivion. It's starting to grow on me.

<center>❖</center>

Dayna started her car…

"When you're makin' that all-important decision about which feed lot to bring your cattle to…"

…and turned off the radio. The drive would be a short one, and she needed to compose her thoughts. Rolling down her window, she drew in a healthy dose of morning air and pulled out of the motel parking lot for what would be the final time.

Her first impulse had been to head for Spearfish, but the flaws in that plan had surfaced simultaneously with the notion itself. She probably could find a motel or an apartment near campus…but putting up stakes in Kayla's turf would be too much, too soon. On top of that, the chance of being recognized was too great in that college town. And besides, Dayna didn't relish the idea of leaving the Badlands—not for an extended period.

"Plan B," however, made sense on several levels, so after phoning a late-to-class Kayla and receiving her blessing, Dayna had packed her bag, dropped her room key on the bed and hit the road. She wondered, now, whether she should have disclosed the real reason for her relocation, should have come clean to Kayla about who she was. Dayna squirmed in her seat. The topic would have to be broached at some point; she'd nearly felt ready at the playground a few nights before.

Somehow, though, the interview with Hugh had changed things. She had sensed, while answering his questions, a subtle shift within. It was as if by again playing the role of Dayna Clay, Rock Star, she had taken that moribund persona into her arms, pressed her mouth against its and, if not fully revived it, then given it a breath of life. How could she disclose her identity to Kayla if she was no longer sure whether to use the past tense…or the present?

Dayna glanced at her hazy reflection in the passenger window. The change was probably temporary, the short-term effect of an unexpected development—the interview—that was still quite recent. It was a function of her recovery; she was in an impressionable state. "It's OK," she said aloud. "It'll pass."

And by the time she pulled up outside Drake's, it largely had.

The shed door was open, so Dayna parked, then ambled up to the rickety building and stepped inside. Drake was hunched over a massive work bench with a hand saw, his back turned. Hesitant to interrupt, and feeling slightly skittish in view of the way their last interaction had ended, Dayna leaned back against the wall, hands in her pockets. In silence, she watched.

He took a moment to shake the kinks out of his wrist and flex his fingers. Then he turned back to the vise and the saw and the cedar, and soon the dust began to fly as the blade groaned into the grain. Head bowed, feet planted, he tore into his work with weary determination. Sawdust lay caught in the wet tangle of his arm hairs as Drake's elbow lurched forward and back, forward and back, bending the will of the wood to his own.

Goose bumps rose on Dayna's bare arms; she hugged them to her chest. When Drake again stopped, this time to measure the depth of his cut, she mustered her nerve and cleared her throat. His head turned quickly, his expression startled.

"Sorry," Dayna said, "I didn't mean to sneak up on you."

Drake set down his ruler and ran a hand through his silver hair. "You'd think I woulda heard ya comin'. Guess I get a little distracted sometimes. Lost in the work."

"What are you making?"

"A bed; this'll be the headboard. Custom order for a couple in Hewlett. King size, double-extra-long." He folded his arms. "I ain't seen

these people—only talked to the fella on the phone—but they must be enormous!"

Dayna stared at the saw; the job seemed to her a monumental undertaking. "Don't you use power tools?"

"Jigsaw's on the fritz; haven't had a chance to fix it. Truth be told, I ain't been in any hurry. Feels good to use the hand tools. To prove I still can—remind myself what I can do."

"I know exactly what you mean."

He placed an elbow on the bench. "Been gettin' good material for your book?"

"Yeah. Although at this point, I'm out here more for myself, really."

He picked up a glass tumbler filled with some dark, ambiguous liquid—"Grows on ya, doesn't it?"—and took a gulp.

"Seems to."

"And the bighorns…I hope they've shown up, at least a time or two?"

"Sure have." She wanted to tell him more—to relate the entire history of her interaction with the breed, perhaps even offer a discreet flash of her tattoo—because Drake had seemed, she recalled, to understand. But that was a conversation for another time.

He looked her in the eye. "How're you feeling?"

"Better. Thanks." She stuck her hands in her pockets. "Dr. Eaton…he helped."

"Thought he would. Meds workin' for ya?"

"Yeah. I had a rough day yesterday, but I'm better now. There are still ups and downs, but the downs are…less frequent. And pretty brief. And generally less severe."

"Good to hear." He took another drink.

Dayna shifted her weight from one foot to the other. "Tell me something."

He put the tumbler down. "What's that?"

"Does it…ever really go away? I mean, for good?"

Drake mulled it over before replying. "For the most part, it does—at least, it did for me." He knocked twice on the headboard-to-be. "Though I have to say, I know it's still there. Somewhere off to the side, just out of view. Like a road that ain't on the map because the map doesn't go that far, but if it did…"

"Gotcha," Dayna said. "It's on the periphery."

"Right. You feel like yourself: the connections are gettin' made, the signals are being received. But you know deep down that…"

"…it could change any day."

He nodded. They stared at one another, then, for several seconds. Drake seemed a bit anxious, and Dayna had a hunch why. His brow furrowed, and he looked away. "Listen," he mumbled, "about that whole business with the…the fire and the hose."

Dayna swallowed. "Yeah."

"I'm sorry. You have to understand…"

"I do."

He looked back at her again and nodded slowly. Then he turned around, picked up his saw—"So, you here to see Blizzard"—and resumed his exertions. "…or me?"

"Well, I might go riding in a bit…"

"Feel free."

"…but first, I wanted to ask you a question."

He continued sawing. "Shoot."

Dayna spotted a wooden crate off to one side; she walked over and sat. "I was talking to Kayla…"

He spoke in choppy phrases, in between strokes: "I hear that…the two of you've…really hit it off."

"Yeah. She's terrific." How much, Dayna wondered, did he know about the nature of their friendship…or of his daughter? There had been no time to go into this with her on the phone; hopefully "that issue," for now, simply wouldn't come up. "Anyway, she said that ever since she left home, it's been kind of difficult. That you've…" Dayna paused, revising. "She wishes you didn't have to live out here all alone. It bothers her. She said you probably wouldn't mind some company."

A trickle of sweat ran down the side of Drake's nose; his cheeks began to redden. "*Can* get awful quiet…in between visits…that is to say… when Kay's not around."

"And as for me, I need a place to stay."

Still sawing, he said nothing. The smell of the wood grew.

Dayna took a deep breath. "So I thought…*we* thought…"

"Her room…does sit empty…most of the time."

"I could give you a hand around here, help out with the horses. Or I could pay you."

Again, Drake stopped. Catching his breath, he placed the saw on the bench and wiped a palm across his brow. "Don't need to be chargin' rent, not to any friend of Kay's. Just chip in for groceries."

"No problem."

"And, sure, you can give me a hand in the stable, if you like." He smiled. "Not exactly a 'glamour job,' Lenore, but…"

She stood. "I'll take it."

Drake nodded. "Well, then." Stepping forward, he extended his right arm. "Welcome."

His palm was damp; just by taking her hand in his own, he inadvertently coated her skin with a grimy paste of sawdust and sweat. It was, on the face of it, one of the most unpalatable handshakes Dayna had ever received.

And one of the best.

Declining Drake's offer to help with her bags, Dayna left him to his work and carried her own knapsack and guitar case upstairs and into the first bedroom. After flicking the light switch, she couldn't help but smile. The walls—festooned as they were with riding-related memorabilia, framed cast photos from high school theatrical productions and ragged-edged posters of actresses, horses and horseback actresses—positively screamed "Kayla as a kid."

Dayna set her knapsack down on top of the full-sized cedar-frame bed, then set herself down there as well. The mattress felt good and firm as she lay staring at the ceiling, just as Kayla no doubt had done many times before. The girl's essence permeated the room; Dayna closed her eyes and drank it in. Sleeping here wouldn't quite be sleeping with Kayla, but it would be the next best thing.

Turning, Dayna glanced over at her guitar case. *Might as well put it away*, she thought, then slid off the bed and reached for the handle. But when she knelt and tried to shove the case under the bed, something obstructed it. Peering beneath, Dayna realized why the room appeared so orderly: most of the girl's earthly possessions had been crammed into a bed-sized, bed-shaped mass wedged tightly between floor and frame.

Dayna sat on the carpet and stared at the case. Unopened since her

arrival in South Dakota, it had remained out of sight and mind throughout her stay at the Tip Top; in fact, she'd nearly neglected to take it, had recollected its presence beneath *that* bed moments before closing the locked door to Room 4. Now she placed the tip of her index finger against the mottled exterior and wrote her initials in the dust...then added a question mark.

Go ahead. It won't bite.

Dayna flipped up the latches, one, two, three, then opened the lid, reached in and removed her old Gibson acoustic. The instrument looked the same as always but felt lightweight in her hands, as if it had wasted away with disuse. Or...

Or as if I've grown stronger.

Dayna didn't play it; she merely held the guitar against her body, cradled it in her arms. It felt good there; it fit. Then, gazing over at an old Drama Club ribbon, she remembered something the prize's recipient had shown her, a place to which Kayla had taken her. A place, it now occurred to her, that just might do.

Dayna stood. She slung the strap diagonally across her chest, the instrument's back lying flat against her own and its neck sticking up like a bayonet behind her. Thus armed, she marched through the doorway, down the stairs and out of the house.

Blizzard was as vocal as ever, tossing superfluous neighs and whinnies into the brisk October air at every turn. His rider, however, barely noticed, so focused was she on re-creating Kayla's route of two weeks earlier. Wending her way eastward, Dayna adjusted her guitar, nudging it higher on her back, and kicked her mount into a trot.

Soon the first of the great, dusky stumps came into view, then two more behind it, then an entire row. Some of the flat-topped mounds were little taller than Dayna herself, while others towered above her, nearing house-height. Just shy of the closest, Dayna dismounted. She led Blizzard over beside a scraggly, almost leafless cottonwood and tied him off to its lowest limb. Then she turned and began wading through the thigh-high prairie grass that surrounded the sod tables on all sides.

And wading it was, for the sweeping winds had had their way with

the dense grass: twisting it here, slanting it there, molding it into a curling, swirling gray-green ocean—or rather, on this breezeless day, a *snapshot* of an ocean, the waves frozen in place, defying the passage of time. And so those waves would remain…until the next big wind came through.

Stepping out of the grass and into the buttes' midst, Dayna headed for a medium-large table a short distance ahead. If this was, as she'd christened it, "the chess set of the gods," then this piece was a rook: flat-sided, stolid and blunt, rising a dozen feet straight out of the ground. Dayna walked into the rook's shadow and, circumnavigating its base, located a meager, meandering incline—a way up.

Even with her guitar bouncing lightly on her back, Dayna scaled the table with relative ease, pausing only as she neared the top. For there, along the edge, stood a cluster of fist-sized prickly pear, their arrow-straight needles nearly as long as the cacti themselves. Dayna considered climbing over them but opted to work her way clockwise to a cactus-free zone. There, she grasped the sod and heaved herself up over the edge and onto the grassy plateau.

Scrambling to her feet, she gazed out. Kayla was right; standing here did feel like occupying the stage in an auditorium or theater…or, for that matter, a rock club or concert hall. Dayna turned in a circle. A few of the surrounding tables were taller than hers, but most were of comparable height or shorter, their tops visible from where she stood. Viewed en masse, the buttes reminded her of an audience: silent and expectant, assembled there before her, watching. And…

…and waiting.

Dayna moved her guitar around to the front of her body. Her left hand closed over the instrument's neck, each fingertip finding its appointed place between the frets. Then she raised her right hand and, for lack of a pick, curled her fingers inward, nails poised just above the six taut strings. Her wrist trembled; closing her eyes, she stood up straight, took a breath and willed the shaking to stop. Then she swept her arm down toward the ground, her nails catching the edge of each string along the way, piercing the silence.

As that first chord, an eerie, reverberant B minor, shot out into the still air around her, Dayna shivered. It was like hearing the first chord ever played. She felt transported back to the time when this land began

to take its current form, the ground around the table-tops just starting to recede. The time before statehood, before settlers, before even the Sioux; the time, as Kayla had described it, of mammoths.

And yet, as she found and played another chord and then another, tentatively reconstructing one of her old compositions from scratch, it was a far less obtrusive creature that appeared on the scene to investigate. From behind a patch of ground-level scrub, a desert cottontail hopped into view and froze before her in profile, wary and alert, its black eye trained on this musical intruder.

As Dayna reached the song's chorus, a magpie alighted atop the shorter sod table just in front of her. Drawn there, it seemed, by her alien chords, the bird cocked its head to one side and countered with a sound of its own: its call, a kind of "Huh? Huh?" that, in this setting and situation, was a little *too* appropriate.

By the time a pair of upright, stiff-tailed prairie dogs popped into view, the whole experience had become just a bit more than she could bear. "All right," Dayna said, halting her performance in mid-verse. "This is not a Disney cartoon, and I sure as hell ain't Snow White."

But the novelty of her presence and her music had, by then, run its course: the cottontail already had continued on its way; the magpie, having found a seed, was struggling to break it open; and the prairie dogs turned out to be less interested in watching her than in wrestling with one another. The local fauna now paid her little mind because she had, it seemed, become one of them.

In addition, the so-called silence she'd broken was, she noticed, anything but. There were the calls not only of the magpie but of other birds, the chirping of crickets, the drone of a distant cicada and, with the wind's return, the faint, rain-like patter of a nearby tree's few remaining leaves. The sound of her guitar was but one among many, for she was far from alone.

Somehow, this knowledge freed Dayna from whatever pressure she had been placing upon herself. When she again began to play, it was with new poise, new confidence…or perhaps not so new after all. For she played now with the same fervor, the same unbridled assurance she had known early in her career, when the songs still mattered, the world was hers for the taking and the stage was her home.

Standing tall, swaying to the rhythm within, Dayna strummed not

only with her hands but with her heart. She couldn't sing—her throat was still a wreck—but it scarcely mattered; the guitar had become her voice. Chord after chord came spilling out of her as she offered up her wordless hymn of thanksgiving, serenading the birds and the beasts, the crickets and the cottonwoods with an emphatic psalm of survival: theirs and, against all odds, her own.

NINE

IT WASN'T UNTIL HER fourth night at Drake's that the realization hit her, though in retrospect, it had been positioning itself to do so ever since her arrival.

The groundwork had been laid that first evening, when Dayna had returned from her ride and walked in to find Drake hunkered over the kitchen counter, chopping up carrots, celery, potatoes, tomatoes—the makings of a hearty stew for two. She had offered to help, and he'd handed her a cutting board, a knife and an immense onion, fresh from the earth. "Watch out, now," he'd advised. "It's awful strong."

"I don't mind a tear or two," she'd replied, blithely bisecting the vegetable—only to find herself weeping uncontrollably the next second. "You weren't kidding," Dayna sobbed, turning in her host's direction and grabbing the handkerchief he had proffered before blade and bulb had even touched.

Then there had been that incident the next day, while Drake was "showing her the ropes" out in the stable. Demonstrating the proper way to groom a horse—Kayla's, to be specific—he'd responded to one of his pupil's queries by doubling over in laughter. "I guess," a red-faced Dayna had added quickly, "that was a stupid question."

"No such thing," he'd said, steadying himself against Mojo's side. "What's stupid is to have a question, *not* ask it…and, later on, wish you

had." He shook his head, patted Dayna's shoulder—"Your question wasn't stupid, Lenore"—and, despite himself, started laughing again. "Just funny as all get-out!"

Then too, on the third night, there had been that moment after they'd finished watching one of Drake's favorite movies on video. It was a John Wayne western—*Rio* Something-or-other, *Bravo* or maybe *Lobo*; Dayna hadn't paid much attention at the outset, assuming that she wouldn't care for the film. But the mythic themes and iconic characters had engaged her, and by the end credits, she'd found herself deeply moved.

She'd sat up on the couch. "Wow," Dayna had said, and turned to Drake, only to find him sound asleep in his reclining chair, the half-empty popcorn bowl tilted precariously on his lap. She had stood, set the bowl aside and reached for the still-warm Indian blanket under which she herself had been lying. Gently so as not to wake him, she'd placed the blanket over Drake, then turned off the lights and gone upstairs, strange new feelings swirling within.

Still, it wasn't until the next evening, during a round of penny-ante poker played on the kitchen table, that those feelings coalesced into a conscious thought. As she stared at her cards, it finally struck her: *This must be what it's like…how it feels to have a father.*

He slid a single coin across the table, placing it just in front of her. Dayna looked up. "Drake, you…already paid me for the last hand."

"This one's for your thoughts."

"Oh." She picked it up. "Don't miss much, do you? Now I know where Kayla gets it from." Dayna spun the penny on its edge. "I was just thinking about how generous you've been. And how grateful I am for your hospitality. And how…glad I am to be here." She couldn't bring herself to say any more; somehow, she didn't dare. *And maybe*, she found herself thinking, *maybe that, too, is what it's like to have a father.*

Drake grabbed the coin in mid-spin and returned it to her.

"Thanks," Dayna said.

"You're welcome."

She smiled shyly. "I can tell."

The next morning during breakfast, the recurrent ache in the back of

her mouth edged past painful and into a whole new dominion of dental hell. Drake wasn't on hand to recommend anyone, having hit the road early to pick up some wood. But there was always the kid at the Stone's Throw, whose prior referrals had led Dayna not only to her current car but also to Dr. Eaton and, by extension, Drake…not to mention his daughter. *Pretty good track record*, Dayna thought, grabbing her keys and heading for the door.

The boy looked up from a paperback as she stepped inside; he inserted a napkin as a bookmark. "Hot enough for ya?"

Dayna hadn't really noticed—the pain had eclipsed everything outside her mouth—but it was rather warm out. "And so late in October," she concurred, walking up to the counter.

The boy nodded, his long, black bangs bouncing lightly on his forehead. "Yeah, we're havin' a real Caucasian Summer. You here for a bite?"

She winced at the suggestion. "Actually, I've got a wicked toothache. I was wondering if you could recommend a dentist."

His reply came as no surprise: "Well, I know of two in the area. One of 'em…"

"I know," she cut in, raising a hand to her throbbing jawbone. "Just—just tell me about the 'pretty decent' one. Please."

He looked confused. "They're both decent."

"Oh."

"It's just that one's an oral surgeon."

"Better give me that one. I think something's gonna have to come out."

Armed with name and directions, Dayna headed for the dentist's office, hoping to parlay her pitiable state into a same-day appointment. As it turned out, the practitioner—a woman in Wall—was able to see her on the spot. "I had a cancellation this morning," the tall, middle-aged dentist said, motioning Dayna to follow. "Mr. Beymer's toothache 'went away,' whatever that means. Guess it's your lucky day."

"Not as lucky," Dayna muttered, "as Mr. Beymer's."

Dayna's lower right wisdom tooth, the dentist discovered, was coming up crooked, crowding the molar in front of it: "It's nearly impacted. There's a good-sized sore at the gum line, and the area around it's inflamed. No wonder you're in pain."

"It's got to go?"

"It's got to go."

"Any chance you could take it out today?"

The dentist glanced at her wall clock, then looked back at Dayna and folded her arms, her reply a terse, Clint Eastwood-esque murmur: "It's history."

As the Novocain hit its mark, Dayna closed her eyes, then kept them shut through the probing, the cutting, the prying, the yanking, the suction, the stitching, the whole ordeal. Throughout, she took slow, deep breaths and imagined herself back in the Badlands at magic hour, watching the formations redden and glow, their massive shadows stretching across the grassy plain below. So total was her immersion that once the procedure was finished, the practitioner had to grab Dayna's arm and all but shake her back into the room.

"Excuse me. We're done here. Hey, you with me?"

"Uh-huh," Dayna mumbled, eyes flickering open.

"You were worlds away!"

No, she thought, *only a couple dozen miles.*

Driving back to Drake's, a folded gauze strip packed in where her tooth used to be, Dayna reflected on what had happened during the procedure. It was not, she knew, a true out-of-body experience, if there even was such a thing. She had not been transported to another place; rather, she'd stayed put, and the Badlands seemingly had come to her. Perhaps the land by now was so deeply ingrained that she could reach inside herself and bring it out at will.

Instead, she reached inside her pocket and brought out her wisdom tooth, which the dentist had managed to extract intact. Dayna ran her thumb across its enameled top. The tooth made for a most peculiar memento, solid and small and slightly grisly; she had asked to keep it without knowing why. But now, the answer came to her in a flash.

With a weak smile, she returned the tooth to her pocket. She knew what to do with it, but there was no rush. If there was one thing Dayna had, it was time. All the time in the world.

The yellow Lumina parked in Drake's driveway was unfamiliar, but its bumper stickers ("I Brake for Werewolves" and a rainbow flag) and

vanity plate (MOJO 1) left little question as to the owner's identity. As Dayna pulled her own vehicle up alongside Kayla's, the door of the house swung open and out she stepped, once again in classic girl-next-door mode: way-too-big college sweatshirt, faded jeans, bare feet. "You," Kayla said while descending the front steps, "are a sight for sore eyes."

"Ad you," Dayna slurred while getting out, "are a shight for shore gumzh."

"What's the matter?"

"Duthig dow; it'sh all taken care ub." Reaching one another, they embraced. "Wizhdub tooth," Dayna added, relishing the contact. "Jush cabe out."

"Does it hurt?"

"A little."

Kayla drew back, her hands on Dayna's hips. "Where?"

Dayna pointed to a spot on her right cheek, to which Kayla promptly applied her lips. "Amazing!" Dayna said, trying—and nearly succeeding—to talk normally. "It's all better. You should get a patent for that kish!"

Kayla smiled slyly. "If you think *that* kish was something…"

"I cad only imagine."

"They give you anything for the pain?"

"Yeah. But I'm on sho many medzh already, I figured I'd jush tough it out."

Kayla nodded, then hooked a thumb in her own pocket. "Any idea where my Dad is?"

"Well, he went to the lumberyard thish morning…"

"Oh. Don't expect him back till nightfall, then. The fella that runs that place is another old stunt man; they'll be topping each other's tall tales for hours."

"I had no idea former shtunt men were sho prevalent."

"Y'know, it does seem like there are a lot of 'em around. I guess it's 'cause they get worn out after a while and end up having to switch careers."

"Like greyhounds," Dayna said, laboring, again, to talk normally. "You know—retired racing dogs. Their kneezh give out, and then families adopt 'em."

Kayla laughed. "Be sure to share that, uh, analogy with my father."

She walked over to her car and opened the front passenger door. "Take ya for a spin?"

Dayna followed and got in. "Where to?"

She closed Dayna's door. "Grocery store." Kayla walked around to the driver's side and sat. "I'm gonna make us all some dinner." She started the car — "Y'know, surprise Dad when he gets back" — turned it around and headed down the road to town.

"You certainly surprised *me*," Dayna said. "We didn't expect you till tomorrow."

"Just between the two of us, I'm playing hooky. My anthro class sucks. The prof can't stand me; I figured I'd give us both a break."

The idea of anyone not being able to stand Kayla seemed a premise straight out of science fiction. "Why doesn't the professor like you?"

"Probably because the day he handed back our midterm, when he asked if we had any questions or comments, I told him he'd tested us on the wrong stuff. He'd asked for, like, the exact time frame in which certain crucial developments occurred, instead of why they were crucial in the first place." She rolled down her window and stuck her elbow out. "I told him his test focused on memorization instead of comprehension and wasn't appropriate for a college-level course. At which point half the class broke into applause."

Dayna grinned. "That would do it."

She shrugged. "He *did* ask for comments."

"By the way, speaking of bald-faced candor…"

Kayla looked at her sideways. "This should be good."

"There's something I've been dying to know. A couple of things, actually."

"About me and Dad."

"Right. And now that you're here…"

"It…forces the issue, doesn't it?" Kayla shifted gears and turned left. "He knows who I am. I came out to him a couple weeks after my Mom died. I'd been afraid to tell him before, but her death — especially coming as unexpectedly as it did — well, it brought Dad and me closer. We'd always gotten along kind of so-so, but after her death we got really tight, really fast." She was quiet for a moment. "And, yeah, maybe there was something a little bit…calculated about my timing."

"How do you mean?"

"On some level I hoped that, having just lost his wife, there was no way he was gonna risk losing his daughter, his…only child." She shook her head. "Sounds terrible, doesn't it?"

"No," Dayna said. "It sounds realistic."

"His world view's pretty rigid, traditional…pretty John Wayne. So I guess I was daring him to buck all that and accept me. To be there for me now that Mom no longer could. And you know what, Lenore? He did. He was." She smiled faintly. "He is."

Dayna gazed down the road. "He's a good man."

"As for us—you and me—I don't know what he thinks. But I suspect that he suspects. I assume he assumes we're 'more than friends'—or heading that way."

"If so, then it's pretty telling that he had me move into your room."

Kayla nodded. "I guess that's his way of saying that it's OK. That he wants me to be happy"—she looked at Dayna—"whatever that may mean. Either that, or…"

"Or he's in denial, and he's still thinking in terms of a slumber party."

"Yeah," Kayla replied. She said nothing else then, just stared ahead.

"Well," Dayna offered, "at least he knows I won't get you pregnant."

"You *will* be patient," Kayla said, eyes on the road. "Right?"

"Kayla, you have no idea how long I'd be willing to wait for someone like you."

She smiled. "With talk like that, you may not have to wait at all."

They reached Interior in short order, drove to the grocery store and parked in the shade. Walking the aisles a pace behind Kayla, Dayna couldn't help but notice the other customers—all three of them—casting glances in their direction. The townspeople's scrutiny seemed unrelated to Kayla's bare feet…but if not that, then what? Did Kayla and she really look that much like a couple, as opposed to a couple of friends?

Watching Kayla nod first to a middle-aged woman stocking up on Cheerios and then to a bespectacled man in the produce department, Dayna surmised that the Drakes probably knew just about everyone around here…and vice versa. Hands in her pockets, she fell another step behind. It dawned on her how much more of a challenge it must be to live honestly and openly, to be oneself, in a small South Dakota town than it was in the heart of Chicago.

Then again, in so tiny a place, did you even have a choice? Like it or not, people eventually would come to see—or "hear tell of"—your every wart. There could be few confidences maintained, few secrets kept in such a town; everything was out in plain view. *Maybe*, she mused while following Kayla to checkout, *they should've called it Exterior.*

The cashier rang up their purchases, and they paid the tab, Dayna insisting on throwing in a few bucks of her own. Then they each grabbed a bag and headed out the door. "Kayla, do you know all of these people?"

"Just about."

"How…much do they know about you?"

She shrugged. "I try not to give it a lot of thought." She placed her grocery bag on the hood of her car—"They're decent folks"—then glanced over at the medium-sized figure just now approaching from across the road. Unexpectedly, Kayla's features tightened into a border-line scowl. "Present company excepted."

Dayna deduced his identity even before she'd finished turning her head. "Right on schedule," she muttered, "my biweekly harassment."

"You've met?"

"Oh, yes. We've met." By then, he had stopped in front of the women and was standing with arms folded, openly ogling the both of them—especially Dayna. She decided, for variety's sake, to try a new tack. "Afternoon, Walt."

Smiling, he tipped his Stetson. "Ladies."

"I know how much you enjoy objectifying us," Dayna said, "but you could save yourself the trouble."

"How's that?"

"Find someone who's an object already. You can buy her mail-or-der. Some inflation required."

He laughed. "Fire inside—that's what I like. 'Cause where there's fire, there's heat."

Kayla opened the back door of her car. "Tell me, Lindstrom. Does this routine of yours work with anyone, anywhere, *ever*?" She deposited her bag and closed the door. "Or at this point, is it just force of habit?"

"You got me all wrong, Miss Drake. I have deep, lastin' feelings for your li'l friend here."

Kayla opened the driver's door and got in. "Just like you did for me,

right? And for Sally Tierney and Kris Babcock and Marci Sprague…"

"It's different this time," Walt replied. "Ain'tcha noticed? There's something mysterious about this one. Somethin' hidden." He looked straight at Dayna. "Somethin' I can't quite figure out."

Dayna got in the car. "Let's go."

"Besides, she already told me who she's lookin' for, and it's clear I don't fit the bill." He stepped up alongside Dayna, lifted his hat off his bald head and held it to his chest. "But that don't mean I can't admire you from afar, does it?"

"Not at all," Dayna answered, peering out her half-open window as Kayla gunned the engine. "Let's start now." Then she watched in the side mirror as the quickly-receding figure placed its hat back on its head, raised a hand and waved.

"So," Kayla asked, "you told him who you were looking for?"

"When I first got here. He was laying it on pretty thick at that bar…"

"The Rusty Spur?"

Dayna nodded. "So I said I had my heart set on finding a man who was different from him in every way: tall and elegant, a bit of a dandy, with an Old World accent, a full head of hair and a beard. I guess he believed me, because the last time I saw him, he asked me how it was going—my search for a 'Euro-sissy.'"

Kayla turned on the radio. "Sorry I don't qualify."

"Oh, you'll do."

"Walt's a piece of work, all right. There's not a woman under thirty from Redfield to Rapid City he hasn't put the moves on."

Dayna fiddled with the tuning knob, trying to locate some decent music. "He's kind of a walkin', talkin' advertisement for lesbianism, isn't he?"

"I asked him once, 'How's it feel to be a living cliché?'"

"What'd he say?"

Kayla tipped an imaginary hat and executed a dead-on impression: "'Just playin' my part in the Circle of Life.' Can you believe it? I was like, where'd he get *that* from?"

"Maybe he'd just seen *The Lion King*." Giving up, she turned the radio off.

Kayla pointed to the glove compartment. "I've got tapes; find something you like."

Doing so, Dayna soon discovered, was going to prove difficult. Riffling through the dozen or so weather-beaten cassettes, she read the artists' names aloud: "Richard Marx…Peter Cetera…Wilson Phillips…REO Speedwagon…Survivor?"

"Yeah." Kayla eyed her a bit defensively. "That's the music of my childhood."

Not mine, Dayna thought, but said nothing. She had anticipated finding either folk-inflected "womyn's music" or foot-stompin' country and western…but *this*? Kayla and she had much in common: their only-child status, the loss of their mothers, their tendency toward outspokenness, their attraction to one another. They were kindred spirits in so many ways; how, then, could Kayla ever have been sucked into listening to such pre-programmed, paint-by-numbers pop, such soulless, corporate rock 'n' rote? It was as if the girl had grown up in some parallel universe where everything else was the same but the music really sucked.

Kayla seemed to read her mind. "What were *you* listening to back then?"

"Soundgarden, the Smiths, Tori Amos, Liz Phair…"

"I…like Tori Amos."

"…Ani DiFranco, Darling Buds, Jane's Addiction, Kate Bush…"

"Well," Kayla said, "you *are* older. It's probably an age thing."

"No. I knew people…I had classmates who were into this…stuff," Dayna said, putting back the last of Kayla's tapes. "It's just that…" She looked away…. *Those were the people I despised.* She closed the compartment with a definitive *click.*

"That music means something to me." She shot Dayna a look. "OK?"

"Yeah, but…*Survivor?*"

"What are you saying?" Kayla demanded, her throat catching.

Maybe it was the catch that did it—that triggered in Dayna's mind a memory of the three-word phrase she'd heard on the radio that one morning, weeks ago, when she'd packed up and hit the road. It was a phrase that would mean nothing to anyone else but that for Dayna spoke volumes: *Ed in Joliet.*

"Nothing," she replied, re-opening the glove compartment. "I'm sorry." She grabbed the Survivor cassette—a tape that, she now suspect-

ed, somehow had made a survivor of Kayla herself—and slid it into the deck.

Kayla sat in silence, her body tense. But as the first song—an inspirational, go-for-it rock anthem—began, she started to relax, visibly reassured by its confident chords and the familiarity of its lyrics. "I swear," she said softly, "I must have listened to this tape twice a day for a couple of months, right after…" She left the sentence unfinished.

"I wish I could've been there for you," Dayna said. "I'm glad this music was."

Kayla nodded slowly—"Me, too"—then turned to her. "On both counts."

Back at the house, they collaborated on dinner, each practicing her own distinct style of cooking. Kayla, following her mother's recipe, painstakingly prepared a consummate lasagna. Beside her Dayna, in scattershot fashion, threw together a colorful, chaotic garden salad—and an authentic one at that, having just picked its ingredients from the plot out back.

Drake returned just past sunset as they were setting the dining room table; famished, he scrubbed up quickly, and the three of them took their seats. Seeing father and daughter bow their heads, Dayna did the same. "Lord," Drake mumbled, "bless this meal. Show us your will; help us to follow. Amen."

"Amen," Kayla repeated, then reached for the tray in front of her. "Pass your plates," she instructed, serving her father as Dayna helped herself to some salad. "Now try and tell me this isn't Mom's lasagna."

Drake took a bite, closed his eyes, shook his head and smiled. "I'll do no such thing."

"Lenore made the salad," Kayla said, taking some and passing the bowl along. She picked up her fork, took a bite: "Fan*tas*tic."

Chewing with care on the "safe" side of her mouth, Dayna watched Drake serve himself a generous portion of greens and begin to dig in. "You two," he said between forkfuls, "make quite a team."

After dinner, the three of them cleared the table and loaded the dishwasher, then sat down for a few rounds of cards: a local, rummy-type game that Dayna, try as she might, just couldn't get the hang of. Each time she thought she understood it, Drake or his daughter would bring up some arcane rule—"Even-numbered spades can act as clubs"; "In

the first three tricks, red kings are wild"—that dragged Dayna back to square one. Finally it dawned on her, and she threw down her hand. "You're making it up!"

"What do you mean?" asked Kayla, all innocence.

"This game doesn't exist!"

The Drakes exchanged a look. "Does now," they replied in unison, then burst out laughing.

After cards, they assembled in front of the TV—Drake in his recliner, the women on the couch—for the latest installment of "Shock Theatre." To introduce *The Creature from the Black Lagoon*, Ivana Viktimm appeared "underwater," lounging atop a garish, fiberglass-looking treasure chest and dressed not in her usual shroud but in a skin-tight black wetsuit. Discreetly, Dayna closed a hand around Kayla's knee. "Nice outfit."

"Thanks," Kayla said, watching tropical fish as big as she swim past her TV image.

"I'm surprised they let you get away with something so revealing."

"All they noticed was that it covered my whole body."

"As opposed," Dayna mumbled, "to *how*."

Kayla pointed at the screen. "Know how they did that…put me underwater with all those fish?"

Drake stirred beside them. "Blue screen."

"Right. They had one camera on me, doing my shtick in front of a blue wall. The other camera was on the aquarium, zoomed in tight so that the fish, which are tiny, look enormous. Then they blended the images. I could see the composite on the monitor, which let me coordinate what I was doing with what was going on in the tank. In fact, watch this…"

On the screen Ivana, in mid-sentence, unleashed a mighty, sub-aquatic sneeze; the several fish in her vicinity scattered in all directions.

Dayna turned to Kayla. "How…?"

"I had one of the stage hands tap on the tank with a ruler."

"Ah, yes," Drake nodded. "The acclaimed techno-wizardry of Channel 19."

By the show's final segment he had nodded off, so the women snuggled close. Ivana, by now back on her usual set in her standard costume, paused to shake some water out of her left ear, then bade her audience

adieu with a timely reminder: "Don't forget to join me at the 'Shock Theatre' I-Scream Social, which we'll be broadcasting live on Halloween night. It'll be a monstrously good time…"

"Hey," Kayla cut in on her alter ego, "you want to come?"

Dayna gasped. "You're asking me to the I-Scream Social? Why, that's every girl's dream!"

Kayla grabbed the remote, turned the TV off. "You'll need a costume, of course. Any ideas?"

"Well…" Dayna checked to make sure Drake was still asleep — he was — but lowered her voice anyway. "One of us could go as Peter, Peter, Pumpkin Eater, and the other could go as a pumpkin."

Kayla smirked. "No dice; I'll be hosting the proceedings as Ivana. We'll have to figure out something for you."

"Whatever. You decide."

"I'll sleep on it." She stifled a yawn. "Speaking of which…"

They placed a blanket over Drake, turned off the lights and walked upstairs to the bedroom. Grabbing her toothbrush out of an overnight bag, Kayla gestured toward the stereo. "All my newer stuff is on CD; you may actually find something you like."

As Kayla headed for the bathroom, Dayna scanned the titles of the forty-odd CDs stacked beside the amp. She spotted the work of several artists she disliked, a few she didn't mind, two that she liked and one that…one that she *was*. Pulling her own latest release out of the pile, Dayna stared in amazement. It had been weeks since she'd laid eyes on a copy. She turned the CD over in her hands as if it were some relic from another era — which, in a way…

"Whatcha got?"

Startled, Dayna glanced up. "Just, uh, this."

Kayla took it from her. "Oh. Not the best mood music."

"I wasn't suggesting we play it. It just…caught my eye." Despite her better judgment, she couldn't resist asking: "What do you think of it?"

"I bought it on a lark a few weeks back. It's not my usual fare, but everyone was talking about her, and I guess I was intrigued."

"And?"

Kayla shrugged. "Nice voice. Good lyrics. A little…dark for my taste."

Dayna nodded. "Mine, too."

"Though Ivana might like her."

Forcing a chuckle, Dayna took the CD back and turned to replace it on the shelf.

"Wait," Kayla said, snatching it away a second time. She peered at the stark, murky photo of Dayna on the back, then at Dayna herself, then at the photo again. "Oh…my…God."

Dayna felt a rush of dizziness; she took a breath. "What is it?"

"This!" Kayla enthused, holding the CD aloft. "This is it!"

"What?"

"Your costume!"

It took Dayna a moment to respond. "You're joking."

"Dayna Clay!" She grabbed Dayna's sleeve. "You've *got* to go as Dayna Clay. She's all over the news, 'whereabouts unknown'…so why not here? Oh, it'll be perfect! Plus, I don't know if anyone's told you, but you do look like her."

"I've heard that, yes."

"Your hair's all wrong, but I've got a box of my Mom's old stage wigs, and one of them's bound to work." Her smile took on a hint of naughtiness. "Plus, dressed up like a tough little rocker chick with an electric guitar…well, you'd look really hot."

"Thanks, but…"

"Besides, you said I could decide."

Dayna sat down on the bed, weighing her options. She could refuse, acquiesce…or throw caution to the wind and come clean. This certainly would seem an opportune moment to do just that. It wouldn't be easy, but if she were serious about Kayla, then it was probably time. "Here's the thing," she said quietly, staring across the room. "I…I *am* Dayna Clay."

After three seconds, maybe four, Kayla erupted in laughter. "Not bad!" she said, giving Dayna a shove. "I nearly bought it. Getting me back for the card game, huh?"

"I'm serious."

"This family's starting to rub off on you! But here's our one and only rule about bullshittin', Lenore: when the person figures it out, you've got to stop."

"But…"

She placed a finger to Dayna's lips and spoke slowly, as if to a child.

"You've got to stop."

Dayna hesitated. She'd tried…but then, maybe it wasn't the right time after all. She nodded, forcing a smile.

Kayla removed her finger. "Getting back to Halloween…"

Deep down, Dayna didn't feel ready to reclaim her old identity, especially in such a public way…but pretending might be good practice. Maybe falling back into the role would force her hand, make her decide just how much of it to retain. And besides, it was what Kayla wanted. "Sure," Dayna said, "OK. I'll go as Dayna Clay."

"Fan*tas*tic!"

As Dayna brushed her teeth, assiduously avoiding the area around her extraction, she eyed her mirror image uneasily, already second-guessing herself. But when she stepped back into the bedroom to find the lights dimmed, classical piano playing low on the stereo and Kayla—in gray cotton tank-top and matching briefs—sitting cross-legged on the bed, Dayna's worries receded. She closed the door behind her. "Guess I'm the envy of every 'Shock Theatre' fan tonight."

Kayla primped her hair like a starlet. "Ever slept with a celebrity before?"

Every night, Dayna thought, *for all the good it does me.* She unzipped her jeans, slid out and dropped them next to Kayla's. "Once. About a year ago, I spent a weekend with a member of the Toronto Raptors. They're…"

"I know: a team in the NBA. Guess that explains your cap."

"Right."

"How on earth did you end up with someone like that?"

She had played at a benefit in Toronto; he, an admirer, had greeted her backstage, and they'd hit it off. So he'd invited her to come see him in action at the arena; after *that* game, they'd headed over to her hotel room for a few of their own. "It was a fluke," she said, sitting down beside Kayla. "We met through a mutual friend, a…musician. But I didn't 'end up with' him; I ended up with you."

"Was he…big?"

She tapped a fingertip against Kayla's chest, right over her heart—"Not where it counts"—then leaned forward to kiss the spot.

Kayla took Dayna's head in her arms. "Listen. About tonight…"

"As much or as little as you like."

"Hold on; let me…let me explain. The last time I got involved with someone, we went pretty fast. So by the time it fell apart, which was only a couple months later, I was already in deep. *Too* deep. And it left me…" She paused. "I was devastated. I tried not to be. I tried to separate the sex from, y'know, my feelings for…"

"Don't," Dayna said. "When they go together, it's for a reason."

"Maybe." She stroked Dayna's hair. "I'm not saying I expect *us* to fall apart. To tell you the truth, I have…high hopes."

"Me, too."

"Which is a lot scarier than any of the movies on my silly show."

Dayna sat up straight. "You set the pace. What's right for you is right for me."

"So if all we do tonight is hold each other…?"

"I'll be the happiest woman in the world."

"Thank you," Kayla said, visibly relieved. "Actually, there is one other thing I'd like to do." She scuttled over to her bedside table, on top of which stood a book of matches and a single, white candle. She turned back to Dayna, who had followed and was now kneeling beside her. "Would you light this with me?"

"Sure. How do you want to…?"

"Like so." She tore out two matches and struck them at once: the twin flames flared, then retreated. Kayla handed one match to her companion and kept the other; she glanced down at her own flame, then looked Dayna in the eye. "You're my light."

Dayna nodded. "And you're mine."

Slowly, they raised their respective matches closer and closer to the candle. Then, met in an instant by both flames, the wick offered up one of its own. Shaking their matches out, each woman—Dayna still kneeling and Kayla seated beside her—placed an arm around the other. They stayed there for some time, savoring the warmth of one another's presence and watching, in silence, the single flame that remained.

Dayna awoke once, at 2:38, for no apparent reason. Unaccustomed of late to sharing a bed, she was alarmed to discover her limbs entwined with someone else's…but then, remembering, she relaxed. She moved

her head closer to Kayla's and drank in the scent of her. Kayla squirmed, made a single, unintelligible sound and then was still.

Groggy though she was, it dawned on Dayna that she'd never felt this close to anyone in her life. Physical intimacy was still a way off, yet none of her many lovers had touched her as Kayla had already. The most sensitive and skilled of Dayna's women, the most eager and enthusiastic of her men—never had any reached a place as private, struck a chord as deep.

Hidden by darkness, Dayna mouthed the three words that, as yet, she dared not speak —words she hadn't spoken in ages. On tour, countless fans had hurled the words at her night after night, from coast to coast and up into Canada, draining them of all meaning. But now, they meant something after all—and lying there beside her was the reason why.

Drake, having risen first, made breakfast. In an unplanned reversal of the night before, the women joined him just as he was setting the table. "One good meal deserves another," he said, and proceeded to serve up just that.

Dayna scrutinized him as she ate, watchful for any telltale signs of discomfort. Taciturn by nature, Drake remained hard to read, but he neither said nor did anything to suggest he was upset. Having been in comparable situations before, Dayna reminded herself that from such a man, the absence of a negative reaction should be read as positive. Thus encouraged, she turned her attention to her French toast and fritters and set about cleaning her plate.

She and Kayla cleared the table, then ambled down to the stable and tended to the horses. That accomplished, they saddled up and headed out onto the land that both women—the one to whom it had come by birthright and the one who'd come to adopt it as her own—so loved. They rode farther than before: past the sod tables, through a stretch of scrubby near-desert, up and over a massive, sloping ridge and, finally, down into a serene, tree-lined valley. Here, they tied off Blizzard and Mojo in the shade, found a similar spot for themselves and sat. There were long stretches when they said little out loud, and yet, in the gentle ease with which they passed Dayna's canteen back and forth, they said quite a lot.

They returned in mid-afternoon; Kayla had a paper to write for a Monday class and was intent on making a dent before another day went by. So by mutual agreement, once they'd watered their horses and returned them to the stable, the women went their separate ways: Kayla up to her room and Dayna, on foot, off to the nearest series of badland formations.

As Dayna's hike escalated into a climb, she couldn't help but notice how good it felt knowing that someone, not to mention the *right* someone, was back there even now, waiting for her. This knowledge bestowed upon her new vigor, new strength; she lengthened her stride and picked up her pace.

She'd climbed this same formation earlier in the week and, in so doing, had spotted another off to the east that appeared to merit attention, one whose peak loomed high above a ground-level field of oddly-shaped concretions jutting out in all directions. Now, reaching this second formation's base, she found the bumps to be roughly her own size: smaller than sod tables but firmer, immutable, less mounds of dirt than knobs and slabs of stone.

Some of these concretions resembled otherworldly mushrooms; others looked like the visions that might result from *ingesting* such mushrooms. Dayna didn't know what had brought these peculiar obtrusions into being, but somehow, they seemed to mark the contiguous formation as a worthy target. Placing her trust in this notion, she pushed on.

It took her an hour to reach the summit. And there, Dayna found the quarry for which she hadn't even known she was looking: a crescent-shaped crack the width of her hand, roughly hewn into the otherwise unblemished clay. She knelt by the chasm and reached in to her elbow but felt only air, her fingers tickling space. Inside, all was shadow; there was no telling how far into the formation the gap extended, though she guessed it was far indeed.

She reached into her pocket and pulled out the tooth. Dropping it into the chasm, she watched the blackness envelop it and listened for the sound of its impact…a sound that was not to come. The tooth had fallen quite a distance, perhaps into the formation's very core.

Only fitting, she told herself, and turned to begin her descent. The Badlands were and ever would be a deep-seated part of her; now the reverse was true as well.

After dinner, Dayna and Kayla grabbed their jackets, strolled out to the corral and clambered onto the top rail, where they sat listening to the coyotes and staring at the stars. Dayna gazed down. "Wish you didn't have to go back tomorrow."

"I know. But Halloween'll be here in just a few."

"That's true."

A lone, boisterous neigh sounded from within the stable; the women looked at each other and, smiling, spoke as one: "Blizzard."

Kayla leaned back, legs outstretched, idly balancing on the beam. "My Dad always says, 'In a past life, that horse was either an auctioneer or a politician.'"

"Or maybe," Dayna suggested, "a lead singer."

Kayla sat up straight. "I have a question for you."

"Shoot."

"And no matter how you answer, it's OK."

Dayna looked right at her. "OK."

"Do you want to go to church with me tomorrow?"

This was unanticipated. "Church; a...Sunday service?"

"I try to go a couple times a month."

"And Drake—does he go, too?"

"Not since Mom died. He keeps his faith private."

"So it'd be you and me."

"Right."

Looking down again, Dayna kicked the middle rail with the back of her boot. She hadn't been to church in fourteen years...not since Rozzie Bailey had invited her one sunny Sunday morning. Dayna hadn't wanted to go but had consented as a good faith gesture; after what had happened, she owed Rozzie, owed her big—a debt she could never fully repay...

History, Dayna told herself, and pushed the thought aside. "You want me to go?"

"I do."

"Then I will."

"Fan*tas*tic!"

Up in their room at bedtime, they again lit the "sharing candle," as

Kayla called it, then sat with arms entwined and watched it glow. "You can light it and think of me when we're apart," Kayla said, "and I'll light one just like it in my dorm room for you. OK?"

Blinking back sudden and unbidden tears, Dayna nodded and looked away. "OK."

They blew out the candle. And this time, once they'd slid under the cozy comforter, Dayna found the urge irresistible and reached to take hold of Kayla, seeking and finding her lips in the darkness, pressing up against her, hips to hips, stomach to stomach, breasts to breasts, aching to touch her everywhere at once, to feel and reveal and revel in each part of her, seen and unseen, inside and out. And Kayla, though startled at first, soon reciprocated with an urgency that startled Dayna in turn—and shook her back to her senses.

Reaching down, she found Kayla's right hand—which had worked its way rather quickly in between Dayna's thighs—and took it in her own. "Kayla."

Silence; then a whisper: "Yeah?"

"Are you sure about this?"

More silence; then, "Pretty sure."

Dayna shuddered; she, herself, was ready. Even now, in rippling waves that nearly made her swoon, her body was reminding her just how ready she was…yet she knew that some part of Kayla was not. "Oh, sweetheart."

"But I'm so close."

Releasing her, Dayna placed a kiss on her forehead. "I'm not going anywhere."

"So very close." She had never sounded younger.

"I know," Dayna said. "And when you get there…I'll be around."

The next morning, to her passenger's surprise, Kayla steered not toward town but in the opposite direction. Dayna glanced back the other way. "We're not going to that little church in Interior?"

"Nope." Kayla shifted gears. "An even smaller church in an even smaller town."

"Smaller town?" Dayna laughed. "That hardly seems possible."

Kayla accelerated. "You'll see." They rode for a while in silence, the

road twisting and turning with abandon; then, her tone one of practiced nonchalance, Kayla spoke again. "I take it you're not much of a church-goer."

"You could say that." Dayna rolled down her window: it was shaping up into another warm, if windy, late-October day. "I do remember my last time, though. Distinctly." She looked off toward some faraway formations. "Didn't exactly make me want to join the flock."

"What happened?"

"A friend invited me. Kind of…like today." Dayna paused, lost in thought.

"And?"

"And…the minister," she continued, calling his image to mind, "this tall, young guy—good-looking, I guess, in a white-bread way—he had a little chalkboard up there next to his whatchacallit, his…lectern. And at some point during his sermon, he walked over to it and wrote the word PRAY, vertically, in capital letters. And then he said, 'The word itself tells you how to do it. P is for Praise: begin by praising the Lord. Next, R is for Repent: beg His forgiveness. A is for Anything else. After you've done all of that, you may talk about Y: Yourself.'"

"Interesting," Kayla said. "But kind of patronizing."

"I was all of thirteen, and I felt talked down to. Oh, and then he told us, 'A lot of folks do it the other way around. But those people aren't PRAYing, are they? They're YARPing!'" Dayna shook her head. "He thought he was really funny, really cute."

"There is no 'right' way to pray," Kayla said, her manner diplomatic. "I mean, a system like that may work fine for some, and if it does, more power to them. But there's no need to go…enforcing it on others." She started to slow down the car. "God meets us wherever we are."

It was, as promised, a smaller town than Interior—so small, in fact, that Dayna didn't realize they were *in* it until they'd come to a complete stop. There were eight buildings in all, none more than a story tall. The term "one-horse town" came to mind, but the place appeared to be a horse shy of qualifying. And as for the church, not only was it minuscule—the size, roughly speaking, of Drake's work shed—but everything about it was abbreviated: the door was barely taller than Dayna, the sole stained-glass window was no bigger than an old LP album cover, and the truncated symbol atop the short, squat steeple

looked more like a plus sign than a cross. Perhaps, Dayna thought, that last detail was a good omen; where organized religion was concerned, she was overdue for a positive experience.

They entered, sat down on the second of three long benches and waited while the room continued to fill. The congregants greeted one another with a kind of restrained familiarity, though no one, Dayna noticed, bothered to approach Kayla or her. Setting aside the photocopied program—a single white sheet, folded in the middle—Dayna looked up at the candles, the velvet-on-felt dove banner and the simple, wooden altar, and she silently vowed to keep an open mind.

Soon the minister, a round-faced man of about fifty, stepped to the front and bade the twenty-some worshippers welcome. He then led them in a "Call to Awareness," an opening prayer and a hymn, sung *a capella* by the choirless congregation. The hymn, something about following in the footsteps of Jesus, was pretty; if she'd had a voice to sing with, Dayna would have joined right in. She relaxed a bit. *So far, so tolerable.*

The pastor sat down, and a slightly younger woman stood to read aloud three passages of scripture. The first, from Psalms, was a kind of fan letter to God, praising this, that and the other thing about the Almighty. But it was a verse early in the passage—"My tears have been my food, day and night"—that caught Dayna's ear; reflecting, she heard little else until the psalm had ended.

The second reading, from Paul's epistle to the Something-or-others, didn't impress her much either way; its rhetorical structure was so confusing and its syntax so convoluted that by the end, Dayna was left wondering what, precisely, had been said. The piece, she thought, could have used a good editor.

The third and final reading, from Luke, chronicled a rather poignant encounter between Jesus and a naked, raving man possessed by demons. Christ found the wretch in a graveyard, "living amongst the tombs." Kayla's TV persona made a cameo appearance in Dayna's visualization of the scene, but she quickly dismissed it; the tale was engaging enough in its own right. For when Jesus asked the man his name, the demons, speaking through their host, replied, "My name is Legion, for we are many"—a nice bit of writing, divinely inspired or not.

The story rang a bell; she had either heard or read it somewhere before. More to the point, she understood it, *felt* it. Dayna didn't believe in demons, but she certainly knew the experience of being seized and tormented and robbed of her true self by forces beyond her control. As the lector described Christ's successful effort to heal the man, Dayna picked up a pencil, scrawled across her program MENTAL ILLNESS? and showed it to Kayla, who considered it before nodding in assent.

Another hymn was sung and an offering taken (Dayna and Kayla each tossing a couple of bucks onto the plate), and then the pastor began to preach. His style was quasi-charismatic; he didn't pace—he hadn't the room—but rather stood in place, arms alive and fingers flying in earnest accompaniment to his words. He spoke with such intensity that he sometimes seemed to be shouting, although in truth, not once did he raise his voice.

Expounding upon the passage from Luke, he stressed the ability of "each and every one of us" to change, by the grace of "God through Christ Jesus," no matter "how damaged or despairing, how wayward, misguided or lost." As a few congregants began to chime in with the occasional "Amen," Dayna's mind drifted yet again; staring at the floor, she contemplated the recent changes in her own life…the healing and, yes, the grace that she had received.

"The Lord provides us such a firm foundation that no one is beyond hope, no problem beyond help. Through Him, the alcoholic will put down his bottle and drink no more; the addict will forsake his drugs and make pure his body's temple…"

But what was the source of this healing, this grace? Was this force at work in her life God, or simply nature? For that matter, was there even a difference between the two?

"…the adulterer will learn fidelity; the belligerent will practice peace…"

Maybe that was the answer; maybe it was just that simple. Maybe…

"…the homosexual…"

Dayna's head snapped up.

"…will renounce his base corruption and sin no more."

She glanced over at Kayla, whose own disappointment, though muffled, was apparent. Seething, Dayna stood, moved to the edge of the bench and looked at the pastor, whose eyes, like everyone's now,

were riveted upon her. "Love your neighbor," Dayna all but spat at him, then turned and stormed out the door.

With anger to burn, she stalked past Kayla's car and across the parking lot of a long-defunct Tastee-Freez, finally coming to a stop in the middle of an old dirt road, the closest thing to a main drag this piddling burg had. Hands in her pockets, she glared down at the earth under her boots, the wind blowing her short, blonde bangs to and fro. Spotting a rock, she stooped to pick it up; glancing over her shoulder, Dayna found herself wondering whether that stupid plus-sign cross was within her range. Instead she spun on her heel and, as hard as she could, cast the stone into the ground.

Dayna squinted into the wind. Part of her wished that, like the Dayna Clay of old, she'd stayed in the church and shouted the man down; another part of her wished she'd stayed away. She wasn't welcome there; never had been, never would be. What on earth had made her think…?

"Lenore."

Kayla, too, now stood in the road, perhaps ten yards behind. Her arms hung at her sides; she looked hesitant, unsure. As they peered at one another across the dead space between them, Dayna couldn't shake the notion that Kayla and she were characters in some western movie. There was no denying that this place looked like a ghost town, and all the more so with every one of its two dozen citizens tucked away in church. The crowning touch—as the wind picked up and the women began walking toward one another, showdown-style—was the lone tumbleweed that, behind Kayla and off to the right, began bumpily rolling by.

It was almost enough to make Dayna laugh. But not quite.

"I'm as shocked as you are," Kayla said, stopping just in front of her.

"Oh, I'm far from shocked."

"He's never talked that way before. Not that I've heard."

"Was it because we were there? Together?"

"I…don't know." Kayla moved to place an arm around her.

"Someone might see."

"Let them."

"*God* might see."

Kayla held her at arm's length and looked Dayna dead in the eye. "God," she said, her chin quivering but her voice steady, "put you in my life."

Equal parts moved and confused, Dayna softened. "That's sweet of you to say."

"It's true."

"Guess I'll have to take your word."

"You believe in God...don't you?"

"You're the second person this week to ask me that question." Dayna sighed. "I don't know. Maybe. I try...but they don't make it easy. The Almighty's p.r. people are doing a piss-poor job of representing their client, y'know?"

"I know." Reaching out with her left hand, she took Dayna's right; they left the road and headed back across the lot. "The church I go to in Rapid City is better." She glanced over at Dayna, then straight ahead.

"I believe in *something*," Dayna went on. "Sure; call it God. Yeah, I guess I do. It's just that God and me—we're not exactly on speaking terms."

Kayla turned toward her. "Why's that?"

"People always talk about how we ought to repent for our sins, tell God we're sorry." She kicked a jagged stick out of her path. "And I suppose I see some point to that; it's good to hold yourself accountable for your actions. But I also think every relationship ought to be a two-way street."

"What do you mean?"

By now they had reached the car. "This is probably some kind of blasphemy," Dayna said, "but as far as I'm concerned, God ought to repent to me."

Kayla opened the driver's door and got in. "What for?"

Sitting down beside her, Dayna closed her own door and stared at the dashboard, trying to decide how much to reveal. She was unaccustomed to having someone with whom she could talk like this. "I don't want to go into any detail; not here. But it involves something that happened to me when I was twelve. Something...God-awful."

Kayla reached for her left hand; Dayna closed it into a fist, quickly offering her right instead. Kayla took it...but stared at the fist. "Does it have anything to do with that?"

They locked eyes; *Jesus*, Dayna thought, *this girl is sharp*. "It...was something I prayed would end. I prayed for weeks—for all the good *that* did me."

"But God didn't cause it."

"Didn't stop it, either." She released Kayla's hand and turned away. "This may be pride talking, but I can forgive someone who lets me down—I can focus on the good and excuse the rest—as long as they say, 'I'm sorry.' Like…" She looked back at Kayla. "Like your dad did. But God's never said anything of the kind."

Kayla stuck the key in the ignition. "Not in so many words."

"What do you mean?"

She started the car. "Look at how you're feeling—I mean, compared to before. Look at the…the hope and the healing you've received." She grabbed Dayna's leg and gave it a shake. "Look at who you're with! If all that doesn't add up to an apology, then I don't know what does."

As Kayla shifted into gear, Dayna began to reply but then stopped, reconsidered, remained silent. Kayla's was a novel, even off-beat way of looking at the world, quite different from her own. But the girl did seem to have her shit together, so maybe there was something to what she'd said. Maybe she had a point.

The thought lingered, potent and persistent, as Kayla turned her car around and drove them away from church, out of town and back down the winding road home.

TEN

THE AMBIVALENCE didn't set in until after the rattler had vanished from sight. Only then did it occur to Dayna: never had she felt so conflicted about having saved a life.

When she'd first spotted it—a dusty, gray-brown reverse-S half again the length of her leg, sprawled under the beating sun on Badlands Loop Road—she'd mistaken it for a molted snakeskin. As she drew closer, she saw that this particular skin had substance and was very much inhabited. Dayna halted but didn't retreat, staring at the reptile with keen interest from a remove of eight yards. The swelling halfway down its length suggested that some cottontail or prairie dog had ventured into the wrong place at the wrong time; apparently the satiated rattler, ignorant as to the concept of "road," had proceeded to do the same.

The snake, moreover, had situated itself within that notoriously winding road's sharpest curve. Granted, traffic was sporadic, but the rattler, basking and digesting, looked to be in position for the long haul. It was only a matter of time before some pickup would zip around the bend and, well, that would be that. The only thing standing between the snake and its impending demise was Dayna herself.

She picked up a stone, skipped it onto the road; her missile scuttled toward the rattler but hit a bump, bouncing over its target. On her second try, she flattened her throw and struck the snake dead-on, near its

swelling, but the rattler didn't budge. It either was asleep or didn't perceive as threatening such small-gauge artillery.

"Hey!" Dayna shouted, stepping forward. "Move it! If you know what's good for ya…" But the snake clearly *didn't* know what was good for it, and might not be able to hear her anyway. She recalled having read that snakes were deaf and so stamped her foot in the road, attempting to rouse it with the vibrations, but this, too, proved fruitless.

Looking around, she saw a spot where a truck had pulled off the road through a patch of mud—mud that since had hardened and dried into sizable knobs and ridges flanking the still-preserved tire tracks. She walked over to this area, drawing slightly nearer to the snake, and broke off a clump the size of a cantaloupe. Dayna hefted the object to her chest, feeling its weight, then stepped forward and, like a juvenile bowler, rolled it two-handed onto the road.

The knob hit the snake's back half and kept going; the rattler flinched, moved away—a foot or so, a partial undulation—then froze, again, in place. It seemed to regard the object as an isolated phenomenon that had come and gone and would trouble it no more. Thus assured, it resumed lounging, as placid and inert as before…and little farther from harm's way.

And so Dayna proceeded to break off and "bowl" clump after clump of hardened mud toward the slow-witted serpent, nudging it off the road bit by grudging bit. At no point did it activate its rattle or, thank God, switch directions and slither toward her; it was in no mood for a fight, or perhaps didn't connect the loitering blonde figure in the distance with this odd, horizontal avalanche. Either way, Dayna's persistence paid off, and when the snake finally slipped into the brush on the other side, its deliverer felt a giddy elation. Grinning, she hopped in place. She'd done it. She had saved a life.

Moments later, as she hiked back to Drake's, the euphoria receded. Sure, she'd saved a life: a *rattlesnake's* life! Not the best news for the other fauna…or for the local human population. What if the snake came out of hibernation next spring and caught some wandering tourist child unaware? The scenario was purely hypothetical. But that hypothetical blood, and the venom within, would be on Dayna's hands.

Sharing the incident—and her belated doubts about her actions—with Drake at dinner, she was taken aback by his initial response: a spir-

ited chuckle. "Christ, Lenore," he said over a forkful of casserole, "you can't win for losin', can you?"

She glanced away. "Always glad to...entertain."

"We could head back there in the mornin', try and hunt the bugger down." He reached for his milk. "'Course, that rattler may have a nest somewhere, eggs to tend; you wouldn't want to make orphans of those poor little..."

"Could you please try to take this seriously?" She looked him in the eye. "It bothers me. Because I honestly...I wonder if I did the right thing."

"'Right thing.'" He grabbed a hard roll and leaned back in his chair. "Afraid I can't answer that one. You're in kind of a gray area."

"Well, would *you* have done it?"

"Lord, no!" he said, beginning to laugh again but then catching himself. "No, I wouldn't. One less rattlesnake around these parts is no skin off my nose. But that doesn't make what you did wrong." He took a bite from his roll and, chewing, gave it some thought. "You saved a life. And life, I suppose, is grateful. Let it go at that."

She eyed him for a moment, then nodded slowly.

A coyote howled off in the distance; Dayna turned her head to follow the sound, gazing out the kitchen window toward the still and shadowy plain beyond. *I saved a life, and life is grateful.* It might not address every implication, assuage every last concern. But it worked for her.

Later, after Drake had turned in, Dayna returned to the kitchen and placed a credit-card call back to Chicago. The line rang twice; then, "Hello?"

"It's Dayna."

"Am I glad to hear from you!"

"Listen, Susan, I've moved."

"I know; I read about it in the interview."

"In the...Is that out already?"

"Needless to say, you're on the cover. They used a shot from your last concert: you handing the kid, Justin, your guitar."

"What'd you think?" She twisted the cord. "Of the interview, I mean."

"Dayna, you were brilliant. To tell you the truth, it made me wish

we'd met today instead of way back when; I think the *new* you and I would've really hit it off!"

How flattering, Dayna thought, *in an insulting way*. "Thanks."

"I totally get why you're out there. Of course, Jayce is another story."

"She didn't care for the piece?"

"Oh, she loved it. But what she said was, 'With that interview and the media coverage it'll generate, the sky's the limit.' She doesn't quite…"

"Clearly."

"Speaking of Jayce, she gave me a message for you: the movie people need an answer. All the publicity surrounding your disappearance has certainly, y'know, sustained their interest in using you…"

"Using me," Dayna icily repeated.

"…but they can't wait forever. In the interview, you said there was no way you'd do the part, so I *told* Jayce…"

A sudden inspiration: "Tell her to keep 'em hanging."

"Seriously? You might do it?"

"No. I'm all wrong for it; I'm not gonna do it. But that's between you and me. Just…have them keep it open a little while longer."

"Whatever you say." Susan paused, and when she spoke again her tone was less professional, more casual. As if she were trying to draw her client out. "By the way…happy almost-Halloween."

"Thanks. You too."

"I know it was always your favorite holiday. Any plans for tomorrow?"

"If I told you, Susan, ya wouldn't believe me."

"Try me."

"Do you have access to a satellite dish?" No sooner had Dayna asked the question than she changed her mind, cutting in before her attorney could reply. "Never mind. I'll tell you all about it…another time."

Dayna gave her Drake's phone number—"emergencies only"—thanked Susan for all of her help and hung up. She headed upstairs and got ready for bed. Then, seated atop the covers, she struck a match, lit a candle and watched the flickering flame, envisioning another flame, another candle and another lone watcher sixty-some miles west.

After a minute, she blew the candle out. As her head hit Kayla's pillow, Dayna found herself filled with gratitude: for having been able to save the rattler, for Drake's subsequent words of wisdom, for Susan's

loyal assistance, for another full day free of depression, for her imminent reunion with Kayla at the next night's TV taping, for the softness of these sheets, the smell of this pillow, the warmth of this bed. "Thanks," she said, eyes sliding shut.

Just whom, or what, are you thanking?

Dayna took a deep breath, then released it. "Whatever," she murmured, and drifted into sleep.

The next morning, Dayna slipped out of a tranquil dream and awoke into a peculiar disquiet. She gazed out the window: another sunny day. Yet there was about it that proverbial something-in-the-air for which she couldn't account. "Halloween," she muttered, rolling over…but that wasn't it. For it felt not as if uncanny spirits had been loosed upon the earth but as if the earth itself were in one singular, spooky, weird-ass mood.

Still, it beat depression. Better for the world to be out of sorts and she stable within it than vice versa. *Anything could happen today,* Dayna thought, then slid out of bed and got dressed, willing—if not quite eager—to put that proposition to the test.

Whatever it was that she was either intuiting or imagining, she was doing so alone. The horses, at feeding time, betrayed not a hint of distraction, preternatural or otherwise; Drake, at breakfast, was his usual good-natured self, reading "Marmaduke" aloud from the morning paper; and a phone call to Kayla found her keyed up for her TV event but otherwise normal. Everything was as it ought to be.

While out riding that afternoon, Dayna made a concerted effort to focus on the sights and sounds around her and shake the feeling…yet it lingered still. Then, an hour out, in a stretch of prairie west of the sod tables, validation arrived when an old acquaintance made an unexpected—and unwelcome—return visit.

Blizzard sensed it first. But unlike the spooked horses in the adventure movies Dayna had grown up watching, hers registered his distress not by rearing, but by stopping in his tracks; not by tossing his head, but by staring ahead; not by whinnying—his usual behavior—but by falling into an ominous hush. "What's wrong?" Dayna asked, eyes moving from her mount to the sky above…and then down to the horizon.

The air to the north was dusky, dense and alive, whirling and swirling, consuming itself—and working its way toward the two of them. A chill of recognition wended its way up Dayna's spine: it was back. Only this time she had no sheltering car in which to cower and hide. This time, she was utterly exposed.

But there was another difference as well. *This time*, Dayna thought, *I'm me*.

She yanked the reins sideways and gave Blizzard's ribs a kick, determined to turn around and outpace the advancing maelstrom, but her horse stood rooted, transfixed. She yanked again—"H'*yah*!"—kicking harder, but her mount remained a statue. As the surging cloud crept closer, Blizzard's shoulders began to quake. Still he made not a sound, and his silence frightened Dayna even more than did its cause, which by now was seconds away.

Dayna dismounted. She wrapped one arm around Blizzard's neck and the other around his eyes, then dug her boot heels into the ground, head tucked, eyes shut tight as the whirlwind moved upon them, blotting out sound, expunging sight, erasing the world. The gale beat and buffeted Dayna from all sides, working her like a chew toy, but she held firm. Heart pounding, she placed her lips next to Blizzard's ear and whispered, just as she'd done with the dying ewe, in some strange, preverbal language. The pummeling blasts glazed her teeth with grit; she turned her head and spat, but the spit flattened back into her face. She closed her mouth and tightened her embrace.

That other time, the gale had seemed a vast, unruly extension of herself, as if the cyclone of sadness had escaped her head and filled the sky. But this was different. For this time, pressing her forehead deliberately into Blizzard's jaw, Dayna saw the incident for what it was: a dust storm. A dust storm, and nothing more.

The wind around them gradually abated, then ceased, the whirling currents continuing past horse and human alike. Dayna opened her eyes, released her hold and stepped back. She and Blizzard regarded one another in silence, each shaken but intact. Her mount lowered his head and snorted; he appeared to be getting his wits back. Physically, though, he was some other horse entirely, his Appaloosan pedigree thoroughly hidden behind a layer of gray.

Dayna raised a hand to her own face and wiped it clean. Then she

patted the horse's left flank—producing the expected cloud—stuck her boot into the stirrup and remounted. "C'mon," she said, turning him back toward home. "We could both use a good groomin'."

Returning to Drake's, Dayna hoped that the departing storm would prove to have taken the day's air of oddness with it…but no such luck. The feeling returned in the stable as she gave her mount an exhaustive cleaning; it persisted as she headed into the house to give herself the same. Lathering up her hair, Dayna put the best spin on the situation: if her response to the dust storm were any indication, then whatever the day might have in store, she'd be ready.

It was time to get set for the evening's events, so after toweling off she grabbed the paper bag by the sink and removed her recent purchase: one bottle of chestnut-brown hair dye. Kayla had offered her a wig, but Dayna had declined; returning her own hair to its natural color, even artificially, struck her as slightly less silly than wearing a brown wig over blonde locks with brown roots. Granted, her hair wasn't as long as "Dayna Clay's," but she considered the deviation her prerogative.

Once the dye job was complete, the born-again-brunette got dressed—boots, jeans and black tank top, her usual concert attire—and returned to the mirror to replace her eyebrow ring. The hole, vacant for weeks, had just begun to fill in; the band briefly demurred, then slid into place. And it was then that Dayna noticed the sole difference between her current visage and the one she recalled: there, above her nose and slightly to the left, was an extra wrinkle. Furrowing her brow, she saw the wrinkle deepen, revealing its apparent source: the anxious knot into which she'd twisted her forehead during the lowest lows of the past few months.

Like anyone closing in on thirty, Dayna was less than thrilled by this discovery, yet there was in the tiny line a kind of poetry. It would serve to remind her of where she had been…in more ways than one. For the wrinkle's shape—sloping sharply upward, then down—recalled the very type of land formation whose daily conquest had helped deliver her from depression.

Her reverie was interrupted by the doorbell. Drake was off delivering a furniture order, so Dayna hustled downstairs to answer the call.

She was feeling less unsettled now, more assured…yet when she grabbed the knob and swung the door open, she could hardly have been less prepared for what she saw.

He towered above her—six-foot-five, maybe taller—but teetered as he towered, unstable as a novice stilt walker, the bulk of his height appearing to reside below his knees. He wore black tie, tails and top hat and carried a brass-headed walking stick in one hand; his other hand drooped limply at the wrist. A golden watch fob dangled from his cummerbund, and he wore a monocle in his left eye. His hedge-thick hair and close-trimmed Van Dyke beard were silvery white. Dayna glanced past him: ten yards back stood a gleaming, black Rolls Royce.

"I beg your pardon, young lady," pronounced the gentleman in the worst attempt at a British accent Dayna had ever heard, "but could you perchance provide me with directions to the borough of Interior?"

Dayna shook her head slowly. "You've *got* to be…"

"I seem to have misplaced my road map," he continued, rolling the *r*, his accent mysteriously traveling eastward into Italy or Hungary, "and I've-a no other means to find-a my way."

"Walt?" she asked, lips pursed on the verge of a grin. "Walter Lindstrom?"

His face flushed. "I'm…sorry; you…" Then, a detour to France: "It would appear zat you have, how you say, miztaken me…"

Dayna collapsed, hands on her knees, and laughed harder than she had in months. "Oh, Jesus," she said, nearly choking, "Oh, God!" When she looked back up, "Baron Walt" was on the brink of capsizing—a glance down at his quivering, seven-inch platform shoes revealed the reason—and was waving his arms about in an effort to regain his balance. In the process, he inadvertently slammed his stick into an overhead drainpipe, which swung down and knocked the monocle off his face and the hat and wig clean off his gleaming pate. At that point Walt lost, at last, his brave battle with gravity and toppled backward, clattering down the trio of porch steps and landing, with a *thud*, squarely on his tuxedo-clad ass.

"Are…are you OK?" Dayna shot forward, trying, but failing, to contain her mirth. It wasn't until after Walt kicked off his gargantuan shoes, sat up and turned toward her that she managed to stop laughing, and

not until she'd stopped laughing that he spoke.

"I guess that's it," he said quietly. "I s'pose that's about as low as a man can go."

Dayna began to reply—to *agree*—but restrained herself and said nothing.

"Truth is, I really meant those things I told ya." He rested a forearm on his knee and looked away. "About you bein' different."

My God, she thought, *could he be serious?*

"So I figured, if this is what you want…"

"Good one," she interrupted, bending to take his arm. "A classic gag."

Standing up with Dayna's help, Walt eyed her warily.

She dusted off the side of his tuxedo jacket. "Coming here on Halloween, dressed up for trick-or-treat, and playing a trick like that on me!" From the look on his face, he seemed to be buying her clueless act, so Dayna proceeded with more of the same. "Sure beats shaving cream on the windows or toilet paper in the trees." She ascended the steps, grabbed his monocle, wig and hat, stepped back down and returned them. "And that pratfall!"

"Yeah," he said cautiously. "How about that?"

"Best bit of physical comedy I've seen in ages."

He replaced his top hat, then tipped it, acknowledging the compliment.

"I'll tell ya, Walt, if I were still available, I might just give you a shot, if only for the laughs." She began walking him back to his car. "Because you're something else. But y'see, I'm already taken. In fact, I…I guess I'm in love."

He opened the door of the Rolls and tossed shoes, hat, wig and cane onto the passenger seat. "I gotcha," he said. "Who's the lucky…?"

"Kayla Drake."

Walt stared at her. On another occasion, Dayna thought, he might have made a crack; but on another occasion, she wouldn't have divulged such information in the first place. Now, he simply pocketed his monocle and said, "Lucky her."

"Thanks." Dayna nodded toward the Rolls. "Nice wheels."

"Yeah." He got in. "You'd be surprised what comes across the lot." And with that, he shifted into DRIVE and pulled away, waving once out

the window as his car sped down the road, around the bend and out of sight.

Turning, Dayna headed back up the steps and into the house. That was, she told herself, the second snake whose skin she'd saved in as many days. And while there were no guarantees, she suspected that no matter what ended up happening with the first, this one wouldn't be bothering her again.

Still, returning to the bathroom mirror, Dayna found herself wondering why she'd seen fit to bail Walt out. Placing a fingertip to the wrinkle above her nose, she smiled wryly. *Getting soft in your old age?* Well...perhaps. Or maybe this was what the Christians meant, but so seldom practiced, by "love thine enemy": not that you should bend over and take it when he has the upper hand, but that when *you* have it, you should show a measure of...

"Mercy," she mumbled, then headed out of the bathroom and, slowly, down the stairs. Throughout her life, two virtues had eluded her. The first, patience, she'd come to learn quite recently; her depression had demanded it. But this second one, mercy, had materialized just now out of nowhere. And she wasn't sure how pleased she was by its arrival.

Dayna yanked her jacket off the hook by the door and left the house—but not her current line of thought. Empathy for the needy and the abused was one thing; that, she'd always had in spades. But mercy? For her enemies? Of what use was that? Reaching her car, she got in, stuck the key in the ignition—but didn't turn. She stared out the windshield at the darkening sky. This wasn't her; she was a survivor, a fighter. Why start pulling punches now? Why not go in for the kill?

The words that came to her then, in that quiet moment on the cusp of dusk, were not her own; they were Drake's. And while they didn't provide a categorical answer, they did help—particularly when she spoke them aloud.

"Life," she said, "is grateful."

En route to the highway, Dayna made an impromptu stop. Pulling up in front of the motel she once had called home, she scrutinized the window of its office—no movement within, not a sign of light or life—then looked over at the roadside placard with its black plastic letters on white:

TIP TOP INN.

BEST RATES IN BADLANDS REGION.

She turned off the engine. There was a time for mercy...but there was also a time for mischief. And this being Halloween night, there was no time like the present.

Dayna got out and hurried up to the sign; she shot another glance toward the office and then, under cover of near-darkness, removed the letters from the bottom line. She had already rearranged them in her head, so it took little time to do so on the marquee. This accomplished, she stepped back—five superfluous symbols clenched in each fist—and examined her work:

TIP TOP INN

LARGEST RATES IN S.D.

She dropped the leftover letters at the base of the placard; they fell at random, a sudden smattering of nocturnal gibberish in the dirt. Dayna returned to her car, started the engine and shifted into gear. "Trick or treat."

Operating, as she increasingly did, on pure intuition, Dayna pulled over again just four miles later. This time, though, there wasn't a building in sight; it was the *lack* of structures or signs that had compelled her to stop, though to what end she wasn't certain. Here too, perhaps, was some unfinished business.

She walked across the road and waded into the adjoining sea of stiff, hip-high prairie grass, the way before her partially illumined by the nearly-full moon. Brushing against her legs, the dry fronds made a shushing sound, *shhh, shhh,* as if the land itself were telling her to be still, keep quiet. Sixty-some yards in she stopped and complied, and it was in the resulting silence that another sound could be heard.

A series of sounds, actually: several coyotes were calling out to one another across the otherwise silent plain. Dayna had heard them many times over the past few weeks—while out hiking, from her motel room and, lately, at Drake's—but this time did so in a new light. She began to grasp their cries as music, to identify the specific notes the animals were hitting, to appreciate the keening, sonorous accord of their inter-

woven yips and yowls.

At that point she noticed that there was, from that braid of voices, a thread missing—a more-or-less contralto part that none of the "vocalists" had seen fit to tackle. On impulse Dayna closed her eyes and gave voice to the missing voice, imparted the missing part, adeptly harmonizing with the unseen coyote choir. Only then, when the night sky was dense with her essence and her own ears full of her rich, supple voice, did Dayna recall that she was no longer supposed to have a voice at all.

She paused, caught her breath. "My God," she said aloud, without a trace of hoarseness. "My voice!" Then she threw back her head and resumed singing—more loudly than an instant ago, more clearly than ever before. *It's true*, she thought; *it's back.*

I'm back.

After a few minutes, Dayna lowered her volume. Not having sung in several weeks, she wasn't sure how long she'd last; *Best not to find out.* So, grudgingly, she fell silent…as did the coyotes mere seconds later. Reflecting on this odd consonance, she turned and made her way back through the grass.

Dayna was elated but discomfited. She could sing again, and that was great…but sing what? Animal calls would get old fast, for her *and* her audience! She did have a back catalogue, but that was yesterday's news; Dayna was too young, and her career to date too brief, to start resting on her all-too-few laurels. She had a voice, but nothing to say. She was a writer who'd forgotten how to write, a musician without a muse, a singer with no song.

All in good time.

Reaching her car, she started the engine and checked the clock. It was getting late; she should proceed to Rapid City without further delay—yet the gas gauge's needle was hovering just above "E." Dayna pulled back onto the road and headed straight for the nearest Vet's Whoa 'n' Go, determined that the establishment live up to its name.

She scraped the top stratum of bugs off the windshield as her tank filled, then stepped into the station and paid the tab. Nature, to whose entreaties she had become so receptive, now "called" in the more familiar sense, so on her way out she took a right and hurried along the

outside wall to the women's room. The door knob wouldn't budge: locked from the inside. Then, a voice from within: "Just a sec'."

Moments later, the door opened, and the occupant—a pretty young mother in a beige windbreaker, carrying a dozing, runny-nosed baby boy—stepped out. As Dayna moved past her and into the bathroom, the two women exchanged a cursory smile…and then froze, turning back to one another in stunned, mutual recognition. Each raised a finger and pointed; in unison, they spoke: "You're…"

The woman cast a furtive glance to her side, followed Dayna into the rest room—her infant stirring a bit at the sudden movement—and closed the door behind her.

"Tess," Dayna said. "You're Tess! I recognize you from those flyers."

"And I recognize *you* from—jeez: TV, magazines, everything! You're about the last person on earth I'd have expected to run into." She glanced at the toilet. "Last *place* I'd have expected, too."

Dayna leaned back against the wall. "Y'know, when I woke up this morning, I had this weird feeling. It was like, 'Today, anything could happen.' And, over and over…it has!"

Tess shifted her baby higher on her shoulder and caressed his back. "The whole world's been lookin' for you."

"You, too."

"Naw. Jus' one sad little corner of it."

Dayna folded her arms. "Why did you leave?"

She sighed. "Lots of reasons. Long story short: my life wasn't workin'. Figured I'd trade it in for another model, y'know?"

Dayna nodded. "I know."

"So I picked up and left. Got a sister in Chicago; I stayed with her for a bit."

"Chicago!" Dayna laughed. "That's where I…"

"I know," Tess cut in. "And you been out here the whole time?"

Dayna nodded.

"Seems you and me had ourselves a little…exchange program goin' on, doesn't it?"

The symmetry of nature, Dayna thought—then found herself dwelling on the ramifications. If one returned home, did that mean the *other*…?

"Somethin' wrong?"

Dayna hesitated. "Why do you ask?"

She rocked her baby. "That lemon-suckin' look on your face."

"Tess, are you…back for good? Here to stay?"

"Guess that depends. I need to have a little chat with someone."

Dayna nodded toward the child. "His father?"

"Yeah. I ain't sayin' the man deserves a second chance. But I may give him one, anyway." She paused. "Emphasis on 'one.' And on my terms."

Dayna considered asking what, precisely, "the man" had done to earn his lover's ire; if serious mistreatment were involved, maybe there was something she could say to steer the woman away. Then again, Tess didn't seem the type to tolerate abuse. What's more, the whole topic of the baby's father had the words "can of worms" written all over it…and Dayna was late already. She stood up straight. "I really hope it works out for the two of you." She glanced at the infant. "The three of you."

"If it don't, my best friend says Zack and me can come stay with her. She lives upstate, in Loyalton." She shrugged. "Maybe we'll put that name to the test."

"Listen," Dayna said, "I have to be somewhere…"

"But you ain't told me *your* story yet."

"It's pretty much the same as yours." She moved past Tess and reached for the door knob. "Just substitute 'career' for 'man.'"

"Does that mean you're gonna give *it* a second chance?"

Dayna turned back. "I'm…thinking about it. But like you said, on my terms."

Tess looked down at her baby. "Maybe I should wake Zack up before you go. You know, so that years from now, I can tell him how *he* got to meet *Donna Clay!*"

Dayna smiled, amused by the notion and, especially, the error. "Tell him that…that Donna Clay met *him*, and it was her honor—but that she wanted to let him get his sleep."

Tess smiled back. "It's a deal."

"But listen. I haven't gotten everything figured out yet." She placed a hand on the woman's surprisingly hard forearm—"So for the time being, Tess, please don't tell anyone you saw me"—and squeezed. "OK? Could you do that for me?"

Tess leaned forward and gave her a hasty but sincere hug. "I'll keep your secret."

Dayna hugged back. "Thanks."

"Keep ya in my prayers, too."

"And I'll...I'll...keep you in mine." Dayna's own words sounded strange to her—but she'd said it. And she knew, as she stroked the child's head and then opened the door, that she'd meant it.

Preoccupied as she was, it wasn't until she'd hit the highway and was on her way to Rapid City that Dayna recalled what she'd meant to do before leaving. Her stop at the Vet's station bathroom had been enlightening, but it hadn't served its purpose. *I am this body, and this body* really *has to take a piss.*

Given the day's track record, though, she feared making another stop. *Anything could happen today*, she had thought upon awakening that morning. *Anything*, she thought now, *fine—but everything?* God alone knew what bizarre episode lay waiting at the end of any given exit ramp. So she kept driving, faster than before, doing her best to focus on the road ahead rather than on the bladder-sized tug within.

Decades later, she reached Rapid City. Using Kayla's exacting directions, Dayna promptly found the mid-sized banquet hall from which "The 'Shock Theatre' Halloween I-Scream Social" was to be telecast. She parked at the lot's far end—there were few spaces left—and dashed inside. Mercifully, the women's room was just past the coat check; hurrying by a handful of costumed strangers, Dayna at last reached her long-sought oasis.

On her way out, she glanced into the mirror above the sinks. No doubt about it: she looked a lot like the Dayna Clay of old. All that was missing, she thought while heading back into the hall, was her guitar.

"Your guitar," said Brad, reaching to sling the strap of a black Fender electric over her shoulder. "You're late."

"Hello to you, too." Dayna took the guitar in her hands: it was heavy but hung right, felt familiar and good there in front of her hips. "Nice. Whose is it?"

"Compliments of Kayla, on loan from a classmate."

"Where is she?"

"Follow me."

He led Dayna past assorted creatures, movie characters and imitation celebrities—a few of them eyeing her, but most indifferent—down the hall, through an unmarked door and into a kitchenette doubling as a dressing room. Leaning against the Frigidaire was Ivana, her black hair arranged high on her head, her skin as deathly pale as the script she was perusing. She glanced up and took in the new arrival. "As I live and breathe, it's Dayna Clay."

Dayna stepped over, and they embraced. "But do you live and breathe, Ivana?"

"A valid point."

Brad turned to leave. "We go live again in five, Kay. Remember your cue."

"Yes, sir," she said, offering a mock salute to the closing door. Then, turning back to Dayna: "Look at you."

"Glad you like it."

"And *listen* to you!"

"Yeah, my throat got better. Finally."

"Fan*tas*tic." They disengaged. "Though I must admit, that husky sound was definitely doing it for me. Not *too* butch, but just enough." She grabbed a roll of wild cherry Lifesavers off the counter—"Gotta keep my own throat moist for the show"—and popped one into her mouth. "You want one?"

"A Lifesaver?" Dayna took the roll but placed it back on the counter. "From you, my dear, that would be redundant."

Kayla grinned. "Don't make me blush; I'm going for pallid here."

Music, loud and dreary, began playing nearby. "Is that a live band?"

"Yeah," Kayla said, picking up a hand mirror and checking her hair. "They're not bad. I usually don't go for Christian rock, but…"

"Christian rock—on Halloween?"

She grabbed a tube of gel. "The station owner has certain…reservations about this particular holiday. 'Devil's night,' y'know?" She picked up a comb and began stacking her elevated hair higher still. "But he also saw the potential for 'Shock Theatre'—the station's third-highest-rated program, thank you—to score big with a special installment."

"So he brought in a Christian band as, what…damnation insurance?"

"Kind of. He hired The Mustard Seeds, this folk group out of Cody…"

Dayna pointed toward the stark, cheerless drone emanating from beyond the door. "I've got news for you: that ain't folk."

"No; it's not." Setting down her mirror, she checked the placement of her cordless lavaliere microphone. "The Mustard Seeds canceled at the last minute. Something family-values related; I think the singer went into labor. So we scrambled and found these guys. They're a Christian goth band, and…"

"You're joking."

"I'm not. They're called Last Rites."

"This, I've got to see."

"Oh, you will."

The door swung open, and a man in a skeleton suit peered in. "Two minutes."

"Thanks, Gene." She grabbed Dayna's arm. "All set?"

Set for what? Dayna wondered—but nodded. She would have to be set for anything. It had been that kind of day.

They followed Gene into the main room, which had been made over impressively for the occasion. Yard upon yard of orange and black crepe paper festooned the walls, skeins of fake cobweb dangled from the overhead lights and an assortment of cleverly-carved jack-o-lanterns sat glowing on plaster pedestals. A rumbling metal box in the corner spewed fog into the air at regular intervals. Most strikingly, all three camera operators were dressed, like Gene, in skeleton suits—and wore expertly-applied skull make-up to boot.

As the two women worked their way through the crowd, a number of bizarre scenarios unfolded before Dayna's eyes. Over on the right, the Phantom of the Opera and the President of the United States vied for the attention of a doubly disinterested Xena, Warrior Princess; off to the left Yasser Arafat, on hands and knees, appeared to be helping a comely mermaid search for her missing contact lens. Then a tiny but tough-looking brunette wearing an eyebrow ring and clutching a prop guitar turned away from her Klingon consort, looked Dayna up and down and sighed mightily. "Aw, fuck it," the woman said. "I might as well just go home."

Dayna smiled. "There's room for two of us."

"Try seven."

By now Kayla had taken the stage, and her companion was only too happy to lose herself in the sea of vampires and VIPs, Pocahontases and pantomime horses, dungeon-masters and Dayna Clays that stood gazing up at their revered hostess from the parquet floor. Ivana strolled over to Last Rites' lead singer, a becloaked, desiccated-looking young man with a rather graphic crucifix tattoo on his forehead and grisly stigmata on both hands. Standing side by side, they made quite the couple.

"Welcome back," Ivana said. "How about a hand for the band?" As the audience applauded, Ivana offered the singer what looked for all the world like a severed human hand; with a solemn bow, he accepted her gift, pressing it graciously to his chest. Ivana turned back to the crowd. "You may have noticed a few glitches in tonight's program. We're understaffed, you see." She gestured toward the bone-suited man behind Camera 2. "We've been operating with a real…skeleton crew."

And so it continued, Ivana cracking wise and her fans cracking up, dutifully acting as if they hadn't heard these jokes, or jokes like them, many times before. It was, Dayna thought, all in the delivery. What made the act work was the fact that Kayla pretended to take it all so seriously; it was less the lines themselves than her tendency to treat them like Shakespeare.

As Last Rites kicked into another somber, salvation-themed dirge, Ivana descended the steps and, flipping her microphone to OFF, rejoined her date on the main floor.

"Nice job," Dayna said.

Kayla responded, in imitation of the lead singer, with a stately bow.

"Do you ever get sick of playing Ivana?"

"Sure. I'd love a part with a little more range. But it's a steady gig. I mean, I'm a sophomore theater major at Black Hills State; Hollywood casting agents aren't exactly breaking my door down."

"I…" Dayna hesitated, then went ahead: "I could get you an audition. For a major motion picture. Just promise me that if you get the part, you won't drop out of school."

She laughed. "No problem. But how…?" Kayla stopped, then nodded. "Oh, right. You must have *major* connections. I keep forgetting: you're Dayna Clay."

While some of the costumed characters wandered off in search of

refreshments, others stood chatting and still others—those who'd come as couples—were beginning to dance. Noticing this, Kayla stepped closer. "Would you do me the honor?"

"Is the station cool with that?"

"With what?"

"You, dancing with another woman. On live TV."

"Happens in honky-tonks all the time. Just try to, y'know…keep it clean."

Dayna shifted her instrument onto her back. Kayla took hold of her, and they began moving together, slowly rocking in time to the music. Dayna had no idea whether they were attracting stares—her eyes had slid shut at Kayla's touch—but frankly didn't care. All that mattered now was the arm wrapped around her waist. All that mattered now was the heart pressed to her own.

"I've been lighting my candle," Dayna said. "Every night."

"Me, too. I look at the flame, and I think of your face. Your beautiful face."

"My…?" Dayna shook her head. "That's a…minority view. 'Striking'—I get that a lot. 'Distinctive.' 'Noticeable.' But 'beautiful?'"

"But you are."

"Not with these…harsh features. I have a decent body, but…"

"You're beautiful," Kayla cut in, "like an unfinished sculpture. Your face is so bold, chiseled—rough-hewn. It has such…stunning severity." She touched her chin to Dayna's temple. "You're beautiful like the Badlands are beautiful."

"Wow." Her voice was a whisper. "What higher praise?"

"And you're so composed," Kayla continued, "so serene. I love that about you—your serenity. And your warmth, and your positivity, and your open, loving heart."

Eyes welling, Dayna tightened her hold. "If I…" Could it be she that Kayla was describing; had she, Dayna, truly become that person? "Kayla, you're…" A tear worked its way down her cheekbone. Again she tried to speak but, overcome, managed only to stammer; her tongue couldn't quite form the words she wanted to say: *If that's who I've become—if what you say is true—then it's because of you.* It seemed like a mouthful in her present condition; she swallowed, tried again. "Kayla…"

"Yes?"

"…marry me."

Kayla stiffened slightly—there was the slightest catch in her other-wise graceful step—and then relaxed; she laughed, gently, to herself. "Just who, may I ask, is proposing here: you, or Dayna Clay?"

As if on cue, the band began to play a familiar series of chords: the opening riff, Dayna realized with a start, of "Give Me Oblivion." Doing her best to ignore the music, she released Kayla; she took out her wallet, removed her driver's license and handed it over. "Both."

At once, a dozen hands were motioning to Dayna at close range, then tugging at her arm, then pulling her back, up, away. Her head darted about: "Wha—what are you doing?"

A male voice, right behind her: "You're the best Dayna Clay here."

A second voice, female and frenetic: "And they're playin' your song!"

Before Dayna understood what was happening, several audience members—Joan of Arc and Bart Simpson among them—had directed her, guitar and all, up the steps and onto the stage. She glanced at the band, and only then did she notice that these four eye-shadowed Jesus freaks were pulling off quite a wicked version of her song. The intro was mesmerizing, just as she'd composed it to be. And that *beat*…

Dayna allowed her own music—played by others, but hers still—to envelop her. She took a breath, drawing the rhythm and chords into her core. The notes invaded her, filled and pervaded her. The song came home.

The lead singer leaned in close. "Can you, like, fake it at all with that guitar?"

"'Fake it?'" Dayna grabbed the microphone out of his hand and stuck it on the stand in front of her. She lifted her instrument. "Plug me in."

As the young man rushed to comply, Dayna slid the pick out from between the strings and began to play. As soon as her amplification kicked in, the audience cheered—a cheer that gave way to an attentive hush once Dayna, still strumming, stepped up to the mike:

I said a prayer and pitched a bottle out to sea
Then sat in silence as it drifted back to me
Begged for a rescue that this world did not allow
I needed something then, but I need Nothing now

She'd planned to give them less than she was capable of giving—to get a word or two wrong, go a little flat on the high notes—had intended, that is, to imitate a pretty good Dayna Clay imitator. But once she'd given it voice, the song had begun calling the shots; underselling it *or* herself wasn't an option. Even the sight of a thunderstruck Kayla glancing back and forth between the rocker and her driver's license failed to distract Dayna as she tore into the chorus:

> *Take my plants and pets, all I've earned or won*
> *Take my debts, my regrets, just give me…oblivion*

The audience was riveted. Masks were peeled off, soft drinks ignored and all eyes on her as Dayna plunged through the second verse. She then unleashed an incendiary guitar solo that brought one of the skeletal cameramen dollying up for a closer angle. All the while, Dayna threw every cell of herself into the impromptu performance, thinking of—and living for—only the moment.

Not until the song was over, the crowd standing in dazzled silence before erupting into an ovation, did Dayna escape her spell. For it was then that she understood just what it was she'd done, then that she began to consider the repercussions, then that she saw, in the eyes of at least a few faces, the glint of recognition.

And it was then that she became afraid.

Dayna whipped off the Fender and set it on the nearest stand. With a curt wave, she jumped from the stage and dashed around the clamorous crowd, heading for the dressing room. There, she stood in the far corner, bent forward, hands on her knees, staring down at the rust-colored carpeting, asking herself over and over, *What have I done, what have I done, what have I* done?

The applause subsided; Ivana apparently was back on stage, making a quip designed to cover Dayna's butt: "With imitators like that, who *needs* the real deal?" She then changed the subject, lauding the band, which responded by launching into a funereal cover of "The Monster Mash." Seconds later the dressing room door swung open, then closed.

Dayna didn't look up.

The voice was flat, controlled: "Why didn't you tell me?"

"I tried to, Kayla."

"Not very hard, you didn't."

"No," Dayna said, "not very hard. I'm sorry. I thought…" She stopped, reconsidered. "It had to do with…not knowing who I was any-more—because of the depression—and wanting to keep my options open till I had it figured out. See, I wasn't sure I still *was* Dayna Clay, and I didn't want to…mislead you." She shook her head. "I guess that's what passes for irony."

"I guess."

"Look, Kayla. I don't expect you to understand…"

"Oddly enough," she said, "I do."

Dayna glanced up. Standing there with her back against the door, Kayla looked—even in her shroud and make-up—so vulnerable, so un-guarded. And so heart-breakingly alone. Dayna straightened up, took a step toward her. "Yeah?"

"Kind of. It's just a lot to take in all at once. Especially since it means that…well, that proposal of yours…you must have been serious."

"I was." Dayna stepped closer. "I am."

"Jeez," Kayla said, "I'm barely twenty. You're aware of that, right?"

"Yes. And I'm also aware of what a short time we've known each oth-er."

"Right. I mean, is it just that you've been through hell, and you need someone to…?"

"No," Dayna said. "It's not the depression. It's you, Kay. It's every-thing you are."

"But…" She hesitated.

"But what?"

Kayla looked down. "But how do I know you wouldn't leave me for…for some guy? I mean, if the right one came along."

Dayna sighed. "I swear, if I had a nickel…" She stepped up along-side Kayla and lowered her voice. "As a matter of fact, I *did* leave a woman, once, for a man. I've also left men for women. And women for women, and men for men. See what I'm saying?"

"That for you," she ventured, "it's…not *what* someone is; it's who."

Dayna nodded. "And the only 'who' I want is you."

"Well." Kayla paused. "That is…flattering."

"Don't answer yet." She reached for Kayla's hand—receiving instead the driver's license. She slid it back into her wallet and stood in silence,

arms at her sides. It was an awkward moment, made no less so by the incongruous strains of Bobby "Boris" Pickett's ghoul-laden novelty hit playing in the background. But Dayna pressed on. "Take your time. I'm not trying to push you; I'm only saying…"

"I hear ya. But right now I have a show to do." She gestured toward the main room. "Can you go back in there and pretend…?"

"No way," Dayna said. "That was too close. I think some of 'em are already beginning to wonder."

"I think you're right."

"I'd better head back to Drake's."

Kayla nodded. "I'll be there this weekend; we can talk then. In the meantime, I'll think about your…offer, and you think about whether you really, truly want to make it. No matter how sure you *believe* you are, promise me you'll do that."

Dayna nodded slowly—"OK"—and they embraced. "Thank you, Kayla."

"You're welcome…Dayna."

After a near-sleepless night spent wrestling with bed sheets and bedeviling notions alike, Dayna filled her canteen, stuck into her backpack some food, her flashlight, her compass, her pocket knife and her meds, and left behind for her sleeping host a note:

> D—
> I have a few things to sort out, on my own.
> Hope this doesn't leave you in the lurch;
> will resume my chores upon my return.
> Thanks for everything.
>
> ♥, L

She was halfway out the door before it occurred to her that it probably was time to come clean to Drake as well. She could wait till he woke up and tell him over breakfast—or could she? The land was all but pulling her out of the house…or perhaps that impatience was her own. Dayna settled on going back and scrawling a terse P.S.:

There's something Kayla knows about me now
that I guess you ought to know, too. Ask her.

Dayna drove out to a particularly secluded area, pulled off and parked behind the nearest foothill formation, hiding her vehicle from view. She got out and put on her backpack. And then…then, she started walking. She walked for one hour, two hours, three hours, four, pressing ever deeper into the wilderness. Ordinarily, by mid-afternoon she'd have turned back, but not this time. This time, she hiked farther than ever before, for today the land's summons seemed an open invitation.

It was the first day of November, a fact of which the day itself seemed blissfully unaware: the weather was mild, the sun bright and Dayna's jeans jacket unbuttoned from the outset. Better still, yesterday's pervasive strangeness had passed, and Dayna was able to give herself over entirely to the present. Granted, when she'd left Drake's, her head had been swarming with thoughts. But soon her focus had shifted to the tangible, the physical, the real: to the ground beneath her feet, the blue sky above and the ever-enticing formations that, with confident steps, she hastened to climb.

Charging up an incline and through a narrow passageway, Dayna stopped. Inches in front of her, a single strand of spider's web stretched across her path at hip height. Odd, she thought, that this solitary thread should appear in front of her like the world's most tenuous tollway arm, as if to block her way. She tapped the taut strand lightly with one finger; it quivered like a guitar string but made, of course, not a sound. Was it there to keep her out? Dayna watched its tremble subside. *It's there*, she told herself; *it's simply there.* Dropping to hands and knees, she crawled under the strand, then rose and continued on. On…and up.

It was with relative nonchalance that Dayna navigated even the most treacherous ledges and narrowest ridges, so sure was her footing, so potent her poise. Indeed, when the stretch ahead seemed especially foreboding, more often than not she picked up her pace. It was as if she were trying to mislead the cliff—*to bluff the bluff*, she thought—into believing that it posed her no threat at all.

Consequently, over the next few hours she penetrated deep into a rugged region that, from an earlier overlook, had appeared inaccessible. The area in which Dayna now found herself was so packed with

peaks and valleys, cliffs and canyons that she'd lost track of how high—or low—she was. It dawned on her that when up and down alternated as drastically and as constantly as they did out here, "ground level" ceased to exist.

Whatever her elevation, Dayna herself was beginning to decline—small wonder, after a full day's hike on precious little sleep. Soon the sun would set, and she would be spending her first full night on the land. It therefore made sense to find shelter, so she set about scaling one last formation, one marked by a dark, oval-shaped indentation near the top. This turned out to be the entrance to a subsurface crawl space, a not-quite-cavern that promised to provide some warmth and, should the wind pick up, cover from every direction.

Dropping onto her seat, Dayna worked her way down into the hollow. Reaching the bottom, she took off her backpack and stood. She couldn't quite do so without remaining bent at the knees—not enough head room—but found that she could both sit and lie down in comfort...and, more to the point, in safety, for the space's natural floor, walls and ceiling were solid to the touch, felt stable and firm.

On a hunch, Dayna sang a few notes. Sure enough: the acoustics were remarkably similar to those in the dorm-basement storage room where Salt Lick used to rehearse. She leaned back against the wall, hands in her pockets, satisfied. Not only did her temporary shelter look right; it even *sounded* right. It struck her as strange, but rarely had she felt so at home.

Dayna took off her hiking boots and socks, flexed her aching toes...and then, on a whim, removed her other clothes as well. She took inventory, considering for once the *external* changes the past six-weeks-minus-two-days had wrought. Her arms were more tan, her muscles more toned than when she'd arrived. Her hair was shorter now, and she could feel with her fingertip that small, sloping crease in her brow. She had lost a tooth and gained a tattoo. This body was different, yet the same. *Just like the rest of me.*

She made her way back up to the top of her borrowed burrow, hefted her nude form out and sat cross-legged on the edge. Dayna closed her eyes, soaking in the sensation of being unclothed in that space, relishing the lack of barriers between earth and self. The Badlands had disclosed themselves to her utterly, and she had returned the favor. In so

doing, Dayna was now no different from the coyotes, the bighorns or the other denizens of this strange and sacred land. And she rather liked it that way.

She opened her eyes and gazed at the vista before her. Crag upon chasm, gorge upon gully stretched off endlessly in every direction, while the rising moon and setting sun staked out their respective spots in the ever-darkening sky. Dayna shivered without knowing why.

Her attention wandered to a neighboring formation, a vast, back-lit mass of earth and clay towering skyward some eighty yards to the northwest. Quite far up, just shy of the summit, was a hole…not like the one below her, but a roughly circular gap that went all the way through, as if popped out with an enormous paper-punch. The gap, probably five to ten feet in diameter, acted as a natural window, for through it Dayna could see the azure sky on the other side. In fact, it almost looked as if the spiky peak above had poked a chip clean *out* of that sky—a chip that now lay leaning, part way down, against the mountain's mighty facade.

The image lingered as Dayna descended again into her adopted den. She took a swig from her canteen, closed it up tightly, put it away and lay on her back, the unyielding terrain strangely reassuring against the bareness of shoulder blades, buttocks and heels. She grabbed her pants and jacket, pulling them over her like a blanket; she took a deep breath, then released it. The hollow was dark, quiet and relatively warm, and Dayna's intuition told her it was also a place of safety. Thus assured—and having been awake for some thirty-six hours, nearly all of them arduous, momentous or both—she was asleep within seconds.

All things considered—no mattress, no pillow, no heat—Dayna slept well. She awoke twice, but both times the reassuring *tat-tat-tat* of cottonwood leaves lulled her back to sleep. It wasn't until late the next morning, as consciousness crept back a third time, that it finally hit her: it was November. Even the hardiest cottonwood had lost its last, straggling leaf a week or more before. And if it wasn't the rain-like patter of leaves she'd been hearing all night…

She bolted to her feet, bumping her head, and scrambled toward gray sky all the way up to the shelter's entrance. A peel of thunder

sounded: angry, eruptive thunder that seemed to be rumbling out of the Badlands themselves. Rain was falling in sheets—had been for hours, the peaks and valleys dotted with pools and covered in mud as far as the eye could see.

"No…"

Dayna recalled the second time she'd ever attempted to climb—weeks earlier, right after her first trip to Wall. The time she'd tried to scale an apparently foot-friendly formation, only to find it prohibitively slippery due to the recent rain. A *wet bar of soap*, she had thought then, and thought again now. A mountain *of soap. Impossible to climb. A lost cause.*

Fingers gripping the edge of the cavern entrance, Dayna stood silent and trembling: a small, naked girl stranded miles from home, miles from anyone who could hear or help, staring straight through the ominous hole set high in the neighboring summit. She stared, it seemed, through a window into her future…for what she saw on the other side was nothing at all.

ELEVEN

TEARING HER EYES FROM the grim vision before her, Dayna looked down. Markings of some kind had been pressed into the mud: paw prints leading into and out of the cavern entrance. And beside the tracks, overlapping them intermittently, was another impression, a "drag line," as if the creature—a coyote?—that had visited her shelter had towed some sort of bundle into it. Into it, or…

Dayna whirled, all but throwing herself back into the cavern. Losing her balance, she skinned her knee on the wall; ignoring the sting, she traced the tracks down to the spot—a yard from where she had too-soundly slept—where she'd set her backpack for the night. It was gone, along with its contents: the food, whose scent doubtless had drawn the coyote there in the first place; the compass, without which she'd be hard-pressed to find her way home; the flashlight, whose absence would be sorely felt come nightfall; and the pocket knife that had been her only means of protection.

Oh, and the canteen. That could prove to be the most dire loss of all, for it appeared she might be there a while. And without water…

As if in response, a gurgling sound drew Dayna's attention below her: fallen rainwater was trickling underfoot, sloping down the center of the cavern floor in a thin, contained stream. Dayna knelt, cupped her hands, scooped, drank—and hacked it out. Drake had warned her

about this. "White water," he'd called it, and had the lighting been better, she'd have seen it for herself: like all badlands run-off, this stream was dense with the silt and sediment picked up en route. Dayna spat out the last of it, then stared at the tainted stream. Water, water everywhere, but…

A clap of thunder: the storm showed no sign of abating. At least it was still warm out, upwards of sixty degrees. Then again, the temperature could drop drastically at any time…could and probably would, for this warmth was an anomaly. *Spring* was supposed to be the temperate, rainy season here, not late autumn. Dayna settled into a seated position and dug one bare heel into a cranny; she wrapped her arms around her knees. *Well*, she thought, *at least there's not a whole lot else that could…*

It was then that she felt it, that familiar sensation, a kind of trickly tickle in her vagina. Dayna tucked her head and lifted her hips to view the dark stain just now appearing below her. Her flow began modestly but soon became heavy; her body, having failed to menstruate in three months, seemed intent on making up for lost time. Possessing nothing with which to stanch the flow—and loath to sacrifice her clothes to the cause—she squatted over the rivulet of rain water, letting it carry the blood of her womb into that of the formation, deep, deep down into parts unknown.

Huddled there in silence, elbows on her knees, Dayna struggled to put the best face on this latest development. As with the other capacities she'd lost and then recovered—to think clearly, to make decisions, to play guitar, to sing—the return of her period bespoke her renewal and restitution, her ever-growing wholeness. In each case, what had been dammed up now proceeded unimpeded; what once was blocked had been unplugged.

But none of that mattered much now. "Renewed" or not, she was still stranded without food or water in a meager crawl space atop a mountain of mud in some far-flung corner of a vast, barren wilderness. There was no one around for miles. The only other creature in evidence was the coyote…and coyotes had quite a nose for blood.

Dayna scowled. The stream even now carrying her own blood away…could it be used as a trail? Would she have surprise visitors—a pack, perhaps—come nightfall? The last time she'd faced them, she'd

had something to offer: the dead ewe. And then, last night, a coyote had helped itself to her backpack. But this time she would be empty-handed. How aggressive did they get; what would they do? *It depends*, she thought, *on how hungry they are.*

All in all, the outlook was bleak—so bleak, it threatened to overwhelm her: Dayna sensed the nearness of a crushing depression. Even now it was lurking, as Drake had described it, "just out of view, somewhere off to the side," biding its time, awaiting its opportunity. And that—the possibility of falling back into *that* hole—frightened her even more than being stuck in this one.

Thank God, she thought, *for the meds*…then remembered that they had been in her backpack as well.

Dayna fell forward onto her knees. She pressed her palms together, fingers entwined. She closed her eyes and spoke:

"I'm not gonna ask you to get me out of here; I'm not gonna ask you to…to save my life. I put myself here, so it's up to me to get back down. Right?"

She paused, but heard only the gurgle of the nearby stream, the patter of falling rain; she took a breath and continued:

"But if I lose myself again, now, up here, I…" She swallowed. "Well, I won't have a chance. So what I'm asking for…"

Dayna stopped. She'd sought divine intervention, had *begged* for help in another crisis fifteen years before, to no avail. Who was to say her current plea wasn't falling on equally deaf ears?

"Listen," she said, her tone testy, "I don't understand how you operate—how you decide when to 'step in,' if you 'step in' at all. But if you could see fit to help me stay sane, I'd…" Catching herself, Dayna softened her delivery. "I'd appreciate it. Really. That's all I'm gonna ask for. Amen." Then, an afterthought—"Oh, and please look after Tess and her baby"—because a promise was a promise.

Dayna stood, glanced at her clothes—*Might as well get dressed*—and reached for her underpants. They were destined for ruin, though she could reduce the damage with a well-positioned sock. But standing there, panties in one hand and sock in the other, it dawned on Dayna that her clothing might serve a more vital purpose.

She grabbed the other sock, along with her boots, jeans, T-shirt and sweatshirt—everything but her jacket—headed back to the entrance

and hoisted herself out. She stood her boots just outside the hole and stacked her pants, socks and shirts on top. Arms crossed, she admired her handiwork. The rain would hit her clothing directly, drenching it with pristine water straight from the sky. Once her clothes were nice and soaked, she could suck the rain out of them, could squeeze the clean, clear water right into her mouth.

Dayna's smile faded as she realized that it had stopped raining.

She glared up at the cement-gray sky—"Hilarious"—and, with curt, irate tosses, sent pants, shirts, socks and boots back into the shelter from which they'd come. Then she cupped her hands around her mouth and shouted, as loudly as she could, "Can anybody hear me? Is anybody there?" It was a pointless gesture: not even a fellow hiker, of which there were few this time of year, would be out today in the muck and the mud. God knows *she* wouldn't, if she could help it. Adding insult to injury, the wind was blowing right at her, carrying her voice not into the hinterlands but back into her face.

Then again, if the wind direction precluded her being heard, it also reduced the chance of predatory guests after sundown. And anyway, Dayna envisioned herself and the coyotes as being in a state of truce. They'd helped her get her voice back…then helped themselves to her supplies. They would trouble her no more because they'd already evened the score.

Her head began to swim, and one knee gave way; she reached to brace herself against the formation's side. The feeling receded, but not entirely. It was a function, she suspected, of her menstruation; she was losing iron, and her body was crying out for replenishment. Dayna sat down. "Strength," she whispered. "Please."

Seated there, head bowed, on the lip of the cavern entrance, she again became conscious of depression's invisible proximity. "Like a road that ain't on the map," Drake had said, "because the map doesn't go that far. But if it did…" She willed herself to look on the bright side. The rain had stopped; perhaps the sun would return and begin drying out the formations, turning slick mud back into grippable clay. Then she could climb down and, with luck, find her way home.

Of course, that drying-out process would take time—not hours, but days. And already she was thirsty. And hungry. And faint. And bruised and crampy and weak and…and afraid.

On wobbly legs, Dayna descended into the darkness of her lair, de-
termined not to descend into that other darkness as well. She retrieved
her clothes and got dressed, positioning one sock between her thighs
and keeping the other in reserve. She sat down, her back to the wall,
and listened to the streamlet of rain water gushing by.

"Think," Dayna muttered, then labored to comply. She wracked her
brain, calling to mind all the Badlands-related reading she'd done. She
reviewed every topic—geologic features and fossil preserves, weather
and climatic patterns, flora and fauna, topography and terrain—and
though she couldn't help but marvel at how much knowledge she'd
retained, none of it addressed the crisis at hand.

Still, as much as she'd picked up from those guide books at night,
she'd learned more from the region itself during the day. Dayna closed
her eyes and returned to her arrival: the night of the new moon six
weeks before, when destiny had led her by the hand along a jagged path
into this uncommon land. After a night spent curled up, quivering and
afflicted, on the still-warm hood of her old Mystique, she'd rolled off
and fallen, hard, to the ground—little knowing what solace that self-
same ground would come to provide.

Dayna began with that instant of impact and worked her way for-
ward, recalling all she could about the month and a half since. She took
her time, pausing to re-inhabit each episode in turn, whether it seemed
relevant or not. She observed, again, the clumsy, hinged gait of the lone
pronghorn following the elusive magpie across the prairie; tasted, again,
her first steaming bite of Lakota taco; felt, again, the chilly stillness of
the air as she plummeted down an unstable formation in free-fall;
heard, again, the way Kayla had sounded—a slight western twang with
a mouthful of caramel apple—the moment they had met. "Help ya?"—
those had been her first words. And time and again, the girl had pro-
ceeded to do just that.

Because there was so much to remember—and because the inci-
dents involving Kayla often led into detours of longing and desire—the
process consumed the rest of the day. Night fell, and with it Dayna's
hopes; for all her efforts, not a recollection had surfaced that could lead
her down the formation and safely home. Mentally exhausted, she
sprawled out on the cavern floor and slipped quickly into sleep.

She awoke the next day, throat dry, stomach empty, a dull cramp in

her gut and a nasty stickiness between her legs. That last, at least, she could do something about; she unzipped her jeans and replaced the first sock with the second. Pulling up her pants, she had a sudden recollection: didn't some Native American tribes equate menstruation with energy, with mystical power—with transcendent, creative force? "Bring it on," Dayna mumbled, and headed for the entrance.

She clambered out into the morning air and sat, legs dangling, on the lip. The wind was still strong and the sun still in hiding, but at least yesterday's rain clouds were nowhere in sight. Dayna rubbed the sleep from her eyes and gazed off to the northwest, where the neighboring formation's natural window showcased a "chip" of slightly overcast, blue-gray sky—a sky that just might be starting to clear. "Sun," she whispered. "We need sun."

If only there were a way to *exploit* the slipperiness of the surrounding mud, use it to her advantage. Dayna fantasized about fashioning a crude toboggan and riding it down the formation's side...the only problem being that she possessed neither the tools nor the materials for such a project. All she had to work with were her boots, her clothes and herself—none of which seemed of much use at all.

She spent the morning sitting in place, the north wind in her face, keeping watch. During some of her hikes, Dayna had seen the Park Service helicopter buzz by; perhaps it was out today on a wildlife-tracking mission...or maybe someone had found and reported her vacant car, prompting the rangers to launch an aerial search. Maybe all she had to do was sit tight and wait, and eventually the chopper would come into view.

If it did, she would bolt to her feet, whip off her jacket and wave it overhead in a wide arc while screaming "Help!" at the top of her lungs. No—no, she wouldn't scream; the lower the pitch, the farther the audible distance. She'd bellow in a deep voice at the bottom of her range. And if that didn't work...well, *then* she'd scream.

She ran a drill, leaping up to execute the procedure in real time. Afterward, Dayna turned her jacket inside out—exposing, for heightened contrast, the lighter-colored denim within—put it back on and took her seat. The drill had gone well, and she'd managed to holler in a loud, low tone that seemed to penetrate deep into the air around her. She was all set.

Then again, how could the pilot of a distant chopper ever hear her voice over his own whirring blades? She might as well be shouting into a hurricane. She could use a megaphone—hell, she could use a p.a. system and *microphone*—and the result would be the same.

With that sober recognition, the rest of Dayna's plan unraveled before her eyes. No one would stumble upon her car; you'd have to go out of your way to find it. The helicopter probably wasn't out today…and if it were, how likely was it to visit this remote corner of a 244,000-acre region? Even if it did, what were the odds of the pilot spotting her tiny form? *Slim to none*, she thought, and shivered. Discouraged, Dayna rose, turned and made her way back into the cavern.

It was too soon to be tired—she'd slept well the night before, and it was early in the day—but tired she was. Sleep, if so permitted, would take hold within minutes. And Dayna could think of no reason to prevent it.

Maybe I'll wake up stronger, she thought, eyes closing, *or with a clue of what to do.*

But such was not the case. Instead, she emerged from sleep late that afternoon drenched with dread, trembling from a nightmare she couldn't quite recall. Her throat felt gritty, constricted; her hunger was a fist, clenching and unclenching in the pit of her stomach. Why hadn't she eaten at the TV taping, or bolted some breakfast before leaving Drake's? For that matter, upon arriving here, why hadn't she consumed some of the food she'd packed…and kept her canteen on her person? Dayna kicked the cavern wall. *As long as we're rewriting history, why not hike home before it starts to rain—or never leave Drake's in the first place?*

"Real constructive," she croaked…alarmed to hear her voice, so recently returned to her, threatening to deteriorate once more.

Dayna stood—taking care, this time, not to bump her already light head—and slowly ascended the now-familiar pathway to the shelter entrance. Just as two days before, the rising moon and setting sun hung in eerie alignment over the horizon; now as then, Dayna shivered at the sight. The only difference seemed to be that the moon, a *near*-circle before, was now full.

A solitary shape crossed in front of that full moon, and Dayna's heart leapt…but no, it wasn't a chopper, couldn't be, for it made not a sound.

The great bird—an eagle?—flew eastward, its dark wings stiff and un-flapping, then angled south, heading in Dayna's direction. As it drew near, she caught a glimpse of its knobby head: not an eagle after all, but a turkey vulture. It was on death watch, no doubt, making the rounds in its perpetual quest for carrion—and proceeding to encircle the very formation on which Dayna stood.

Coincidence? Probably. Yet she couldn't help but wonder if the bird had some inside information.

She sat and gazed down to the muddy ground far, far below. How, then, was it all to end? In starvation? Dehydration? Exposure, once the warm front passed? Or—if she dared try to make her way down—a probable broken neck? The irony was not lost on her: she'd survived a series of suicidal gestures and one serious attempt only, it appeared, to commit *accidental* suicide, the involuntary manslaughter of herself.

Dayna lifted her head and stared once more at the looming forma-tion with the "punched-out" hole near the top. Why did her eyes keep wandering back to that pointless gap, that window to oblivion? There was nothing inside it but space, nothing beyond but sky. Yet for some reason—a nod back, perhaps, to her old nihilistic streak—that very nothing laid claim to her gaze time and time again.

She stared and stared, the wind whistling in her ears, and as she did it dawned on her that the sky inside the window was now a lighter blue than the sky above. An instant later, that same "chip" of sky was light-er still. And then as the wind, with a tearing sound—of earth, of paper, of flesh?—gusted and was gone, the sky within the window turned dead white.

It occurred to Dayna that she might be hallucinating—that her weakness, hunger and thirst might be conspiring against an all-too-sus-ceptible brain. This was a notion the next few seconds did nothing to dispel, for now the window, impossibly, began to widen and grow, ex-panding across the horizon to fill her field of vision. Dayna twisted her shoulders, shook her head, struggled to look away but found she couldn't. It was as if some unseen entity on the other side had reached out and taken hold of her. And now that same entity was proceeding, hand over hand, to pull her in.

Though still seated, she could barely feel the contours of her perch; it was evaporating, the formation itself dissolving beneath her. Was this

a delusion? It felt authentic, legitimate, *real*…but if real, it was a reality unlike any she'd known before. It was as if she had cracked through one layer of being and stepped into the next—as if that hole in the neighboring formation had led her out of the physical world and into…into what?

At that moment of uncertainty, when panic would have been apt, Dayna instead found herself filled with an abiding calm. There had been times, while climbing or hiking alone on the land, when she'd been able to draw some of its stillness and serenity inside her…but this was different. For this time the effect was not partial but absolute; every fear faded, each anxiety abated as the interior chatter of thought upon thought dissolved into silence.

"To experience, to see, simply to be"—that had been her dream. Now "being" was the sum total of her existence. She was neither fretting nor reflecting, weighing nor plotting nor praying; she just was. And *as* she was, from out of the silence that pervaded her came…a voice? Yes—of sorts. But this voice spoke without words, without even sound, and she didn't so much hear as receive it, in her mind or, perhaps, her spirit.

The voice made a request. It asked for Dayna's forgiveness.

Unable even to wonder as to the "speaker's" identity, Dayna still managed to respond. "I forgive you," she said aloud, her own voice small and muted and far, far away. "I do." Without thinking—she was somewhere beyond thought—she added: "Forgive *me*."

The voice told Dayna to forgive herself.

"How?"

The answer, the voice told her, was in the palm of her hand.

Dayna waited in silence, hoping for direction…but none was forthcoming. Whatever the voice's source, and whatever it had meant, it had said its piece.

An image began taking shape beside her. Its outline was indistinct but soon became clearer: it was a person, a…a young female figure. Kayla? No. Younger; smaller. Dayna herself, as a child? No. Wait—she knew this face. It was…it was Rozzie. Her girlhood playmate, Roslyn Bailey, at age eleven, maybe twelve. Why had Rozzie kept coming up in her thoughts lately…and why was she here now?

An object slid into view, rising up in front of the girl's delicate

features—some device clenched in her hands, pointed at Dayna. A camera; the Baileys' camcorder. And in that instant, realizing where she was—her old bedroom—and *when*, Dayna felt the calm falling away.

She recalled this incident all too well, had thought of it often in the intervening years. Was it truly necessary to relive it? She shuddered. *No, I won't go there*—yet she seemed to have no choice, for when Rozzie lowered the device and looked at her, Dayna found herself speaking again the words she'd spoken then: "Is it working?"

"Yeah; it's fine. But Dayna, I…I dunno about this."

"It's the only way my Mom's gonna believe me."

"Couldn't you just tell her that…?"

"I tried. Twice. She won't listen; she, like, thinks she's in love."

"But you could say…"

"Roz." She grabbed the girl's arm. "Please. I just…I can't take it anymore. OK? This has gone on *way* too long. It's happened, like, eight times now. And it's gonna happen tonight, too, soon as he gets home; I know it. But after that, it's never gonna happen again, 'cause"—she tapped the camcorder—"I'm gonna have it on tape. And I'm gonna show the tape to my Mom. And if that doesn't do it, I—I swear to God, I'll take it to the police. But I can't do *any* of that if you won't…"

A sound from behind: the back door.

Rozzie's eyes opened wide. "Oh jeez."

Dayna leaned in close and whispered: "Please."

The girl stared back with frightened eyes, then nodded quickly and, camcorder in hand, backed into the bedroom closet. Dayna closed the door almost all the way, leaving just enough space—two inches—for her friend to get a clear shot. Then she jumped up on her bed, grabbed the latest issue of *Spin* and pretended to read.

A knock, then his voice—"Dayna?"—and then, before she could reply, the door swung open. He stepped inside. "Hi."

"Hi." She felt the weight of his eyes.

"I like that top."

"Thanks."

"Your mom got stuck with second shift again."

"I know." She turned the page. "So?"

He closed the door behind him. "So we've got a little alone time tonight."

She stared hard at a full-page ad, some ridiculous cartoon character hawking anti-acne pads. "I don't wanna do that anymore."

"You say that now." He stepped closer. "But once we get going, you…"

"I say what you tell me to say." She turned the page. "I mean, *duh*."

He was silent; then: "Want a drink, kiddo?"

It was hard, but she looked right at him. "Go away."

Bending, he grabbed her—"Look"—and gave her a shake. "You know the drill. This can hurt…*or* it can feel good. So which way's it gonna be, Dayna: easy, or not-so-easy?"

"Easy." She looked away. "Please."

He was gentle with her then, and she hated him for it. Hated him for the almost dainty way in which he folded each article of clothing he pulled off her. Hated him for all the hollow compliments he paid her in the process. Hated him for every stroke of her hair, every smile, every kiss. Hated him for the three and a half months of inculpable kindness he'd shown before forcing himself upon her—for "earning" her trust under false pretenses, presenting himself as a father figure on the way to becoming *this*. Hated him for the confusing yet potent flattery of his attention, improper though she knew it to be. Hated him for the feeling, right now, of his finger quivering inside her—for the fact that he knew what he was doing and, when he bothered to, could make her feel good. Yes, she hated him for that most of all. And she hated herself for it, too: for answering "Easy" and letting herself enjoy what he did to her. Dayna longed for the moment when he'd flip her over as he always did, unable to face her, unable to face up to whom it was he was fucking. When that moment came it would be a relief, because then it would stop feeling good; it would hurt. It would hurt like it should.

Tonight, though, he was in no hurry.

And so she lay waiting, silent and still, touching him only when he told her to—and then, with her right hand alone. Her left, as always, lay by her face, a compact fist of ineffable sorrow, closed to him and to the world. *You've touched me everywhere, my face and neck, my stomach and breasts, between my cheeks and between my legs…but you will never touch me here.* Dayna choked back a sob as he took hold of her hips and, at last, turned her over. *Never*, she thought, the first knuckle now

clenched between her teeth. *Never* as he spread her legs, *never* as he slid inside, *never* as her eyes filled and overspilled, anointing her left hand with a stream of tears. *Never never never—you will* never *touch me here. In fact...*

"...no one will."

The sound of her own voice startled her, jolting Dayna back: to her body, the Badlands, the here and now. She had no idea how many minutes, or hours, she'd been away. Long enough for night to have fallen; the moon shone out of a starry sky, illumining the neighboring formations from higher than before. Dayna wiped the tears from her face and looked to the northwest: the window had returned to its original dimensions, the sky above it now the same color—black—as the sky beyond.

She hugged her arms, feeling suddenly...disclosed. Earlier, she'd sat in this same spot without a stitch of clothes. But only now did Dayna feel naked, for it wasn't her body that had been laid bare but her soul.

She stared down at her left fist, recalling the rest of the story. Once he'd left to go shower, she'd rushed to the closet and found Rozzie quaking in the corner, the camcorder pressed to her chest, her task completed—and the girl herself forever changed. After sneaking her down the hallway and out the back, Dayna had stayed up late and shoved the tape into her returning mother's hands. Her Mom must have watched it, because the so-called boyfriend was gone the next morning, never to show his face in their home—or their lives—again.

But none of that mattered now. The crucial instant, the part she'd forgotten—that had come earlier. The purpose of reliving the entire incident, Dayna now knew, was to speak again those three words: "No one will." Because having heard them, she understood at once how misguided they were...not for a girl of twelve, but certainly for a woman of twenty-seven.

Dayna rotated her fist, eyed the underside. She'd been intimate with maybe twenty people, most of whom she'd cared for and a few of whom she'd loved. Yet as uninhibited a lover as she'd thought herself to be, there was one line she'd never crossed. She opened her fist: her left palm looked like a miniature landscape, a frontier of sorts, aglow with the moon's reflected light. Perhaps the answer really was right there. Dayna smiled hopefully. She'd been told to forgive herself, and at last she knew how. All she needed was the chance.

A hunger pang corkscrewed its way through her belly, and her smile faded. The vision and its aftermath had fed her spirit, to be sure…but not her stomach. And as revelatory and affirming as the experience had been, it had gotten her no closer to safety. She turned and descended, again, into her den.

Reaching the bottom, Dayna stared down at the moonlit body of "white water," a motionless pool, now, where once had run a stream. Dropping to one knee, she reached out and tapped the surface; she ran her hand back and forth, the soupy liquid acknowledging her touch before flattening in its wake. Never had she found the properties of water so compelling—but then, never had she been so thirsty.

Dayna plunged her cupped hands into the pool, then drew them up to her mouth, threw back her head and gulped, not so much swallowing as pouring the stuff down her throat. She gagged, she coughed, her throat rebelled…but she kept it down. After a pause, she forced herself to drink a second, equally unsavory helping, devouring the land as it had devoured her, then wiped her hands on her jeans and turned away. The stuff tasted awful, and too much of it would make her sick. But her body needed water, and when her body spoke, Dayna listened.

If only it would tell her a way out.

She lay on her side and closed her eyes. She had little stamina left; sleep began taking hold at once. Perhaps, Dayna told herself while drifting off, she would wake up with a solution; *maybe this time*, she dared hope, *something will come to me.*

And it did…though it wasn't quite the "something" she'd had in mind. When the sun splashed down through the passageway and onto her face, rousing her, she awoke full of ideas not for escape, but for songs—and not just a few but dozens, all drawn from her experiences of the past six weeks. Some inner lens had rotated in her sleep, and everything since her suicide attempt had come into sharp focus. The whole chronology, each sight and sound since the day that she'd intended be her last, had been bathed in a new, transforming light.

Dayna's head pulsed with verses and choruses, riffs and refrains for uncounted compositions waiting only to be written. The supposedly invulnerable warehouse she'd seen burn back in Chicago hours after trying to kill herself was the basis for the ironic "Fireproof Storage"…there was a song about a terrifying dust storm that hits you twice: first to show

you how broken you are, and later to show you how healed…"Little Church" described a house of worship where everything is notably small, right down to the congregants' minds…the solitary weed she'd found sprouting up between her motel room floorboards figured prominently in another piece…Tess was the source of the tongue-in-cheek "Wanted Poster," about a young mother whose demand for fair treatment brands her as a modern-day outlaw.

And then there was "Hand Over Hand," a deeply heartfelt song, minor-key and melodic, about scaling a vast mountain not of rock but of brittle earth, knowing all the while that it might break away beneath you, yet somehow trusting that it won't. By the time Dayna had reached the final, haunting verse of that one—a composition that just might prove to be her finest—she began to fret. Here she had a significant, meaningful body of work, a rich and exhaustive song cycle about illness, recovery and self-reinvention in their wake…yet nothing with which to preserve it.

She pressed her hands to her head as if to contain the commotion. Her inspiration, so long dammed up, now rushed forth too quickly to control; new songs already were escaping half-realized, chord progressions and turns of phrase slipping through her fingers. How could she remember it all? She couldn't; her faculties in that area were mediocre at best. She would have to write down at least a few key words to jog her memory later…but how could she do so here? She had neither paper nor pen nor *anything* to write either on or with—and still the songs kept coming. If she didn't think of something soon…

Dayna glanced forlornly toward the cavern floor, and at that moment of near-resignation, it came to her. Eyes transfixed, she stepped forward; she dropped to one knee and extended her hand. Maybe it would work; maybe not. But she'd run out of options, and there was no harm in trying.

Afterward Dayna reached for her jacket and slid one arm gingerly into each sleeve. Just then, another hunger pang tore through the hollowness that was her stomach; she staggered, shuddered, released a low groan. Again, her body was instructing her, only this time she had no way to comply.

As the sensation ebbed—for now—Dayna noticed on the cavern wall a shadow that hadn't been there before; the craggy entrance, its contours reproduced in silhouette below, somehow had grown itself a brand new bump. No sooner had she spotted it than this bump began, just barely, to move. Heart pounding with hope and fear, Dayna turned around slowly, lifted her head and gazed up.

There, staring down at her from just outside the entrance, stood a bighorn—a large ram. What's more, with its mighty horns sweeping down and around to form a complete circle, it seemed to be the alpha ram she'd encountered twice before, the apparent mate of the ewe Dayna had struggled to comfort. With amber eyes the ram now watched her in silence, the thatch of mud-colored fur above its brow quivering in the wind.

Though the bighorn looked unfazed, Dayna suspected it was as surprised to see her as she was to see it. For a moment, she fantasized that the venerable beast had reached the end of its life span and come here to die…all 200-plus meaty pounds of it. But no sooner had this rather uncharitable thought crossed her mind than the animal tucked its head and, with a dismissive snort, receded from sight.

Dayna shot up toward the opening. Clearly, the beast wasn't about to keel over and separate into steaks on her behalf; still, she'd found its presence reassuring. She still considered the bighorn to be, if not precisely her kind, then a kin of the spirit, and thus was distressed to see it leave so soon.

She pushed herself over the rim just in time to see the ram trot down onto a narrow ledge ten yards below. There it paused, head held high, staring toward the horizon. A beautiful day was taking shape—sunny, mild and dry, with a deep blue sky—and the bighorn appeared to be drinking it in. Finally, the beast glanced back at Dayna over its shoulder—an invitation?—and, again facing forward, proceeded down the next slope.

Dayna eyed the line of hoof prints, fresh and dark and deep, that the descending ram had left in the mud. And mud, not dirt, it still was, for the sun hadn't been out for long. It would be at least two more days before evaporation drained the formation of its accumulated moisture. The surface was still too perilous to climb—yet the bighorn, somehow, was doing just that. *Then again*, Dayna thought, *I'm not a bighorn.*

Absently, she bit her lower lip. *Though maybe, with one as my guide...*

She clambered out of the entrance, placed one boot squarely above the topmost track and...and hesitated. She could stay put, waiting to be found...and, quite possibly, wasting away before that ever occurred. Or she could gamble that, with the climbing skills she'd developed— and the ideal pathfinder to show her the way—she just might make it down alive. What she couldn't do was stand there wavering about it much longer; the ram was in motion, and if she were to adopt its technique as well as its route, then she had to keep it in sight.

Dayna stepped forward. The mud shifted underfoot as she proceeded, knees bent and arms extended, away from the entrance and, haltingly, down the formation's side. Left, then right, then left, then her right boot slid straight off the ridge. Teetering, she threw her weight down, dropping into the muddy slope with an unceremonious *thwump*. She sat there for a few seconds, heart racing, then pried herself out of the muck and got back up. Better to fall three feet than three hundred. If she had to periodically plunge ass-first into the formation in order to keep from toppling off, then so be it.

And yet as she wended her way down—mimicking, as best she could, the fleet and stealthy steps of the ram below—Dayna found her sense of balance growing gradually stronger. Weak from hunger, she had worried about blacking out, but instead she remained conscious and aware, her light-headedness offset by an equally light step. The formation's wet surface still quavered and slid beneath her: it was a veritable Mount Crisco. But as long as she kept moving, the slipperiness was nothing she couldn't handle.

Dayna found the bighorn's occasional backward glances striking yet ambiguous. Maybe it was trying to help her, its pauses timed to let her catch up. Or maybe in its eyes she was attempting, however feebly, to stalk it, and the ram was making sure she didn't get too close. Was the ram leading, or Dayna giving chase? Either way, the result was the same: it was showing her the most, perhaps the only, reliable route to the ground.

Just over halfway down, Dayna came to a halt. The hoof prints before her descended across a nearly vertical fifty-foot slope that she couldn't imagine negotiating. How had the ram managed? From her vantage point a minute earlier, she'd seen its head disappear over this

same ridge, only to pop up safely in the distance—eyes placidly trained on its pursuer—moments later. She'd spotted the ram before and after, but the climb itself remained a mystery.

Had the bighorn run down, or walked, or skidded? The tracks suggested some combination of the three: guided by instinct and the split-second timing it confers, the ram had adjusted its speed and technique constantly and instantaneously throughout its descent. Could Dayna hope to duplicate such a feat? On a good day, at full strength, on a dry surface—maybe. But here, today? She shook her head. *No way.*

The bighorn was nowhere to be seen…nor, as she waited, did its head pop up as before from behind some distant crest. Somehow, Dayna knew that the ram wouldn't be showing up again. She'd reached a turning point. The bighorn had gotten her this far, but from here on out, she would have to find a way of her own.

She backtracked to a spot that might afford her another, more gradual route down…emphasis on "might." Still, there was no way to tell without trying. Muttering a quick prayer, she stepped sideways and pressed on, leaving, for the first time that day, tracks that didn't overlap another's but were hers alone. It was slow going: there was far more pressure inherent in blazing a trail than in following one, and Dayna compensated by taking her time. The slick surface remained daunting, but not overwhelming. Every now and then she slipped, but regained her balance; stumbled, but righted herself; fell…but never far.

She now was moving into an area dotted with patches of scrub—patches Dayna was able to use as hand-holds, trusting the plants to share their groundedness with her. A few proved weak-rooted, but most held firm. Gradually, with patience, perseverance and a kind of awkward grace, Dayna made her way down to the next level.

And the level below.

And, eventually, the ground.

On a normal day under normal conditions, climbing down from the top would have taken her thirty minutes; today, judging by the position of the sun, she'd made it in about three hours. But she'd made it.

Too tired for any displays of exaltation, Dayna sat her mud-caked butt down on the ground and gazed up toward the remote cavern that had served as trap and shelter, cell and sanctuary. Just as at first sight, the entrance was now nothing but a dark, oval indentation near the

formation's top. In that instant, Dayna found herself filled with gratitude: not only for her deliverance, but for her confinement; not only for the end to her ordeal, but for the ordeal itself. Having made it through the darkness, she had a new appreciation of the light…and at least some idea of what to do with her life.

For the moment, though, she had three simple goals: to get some food, to get some water and to get herself back to Drake's. She decided to concentrate on the third goal since it, if attained, would take care of the others. Dayna stood. She'd traveled west three days ago to get here; as it was now afternoon, the sun itself was heading west. If she followed her shadow, it should take her, eventually, back to her car.

And so Dayna, with weary but resolute steps, set out again, chasing her own ever-lengthening shadow across the formidable terrain: through dikes and gullies, around chasms and canyons, in between intrusive formations and, leaping, over brackish pools and streams. A straight line would have been easier and quicker than this serpentine path, but such a route wasn't in the cards. Dayna was reminded of how the region got its name. *Mako sica; les mauvaises terres à traverser*—the Lakota and, later, the French had gotten it just right: "bad lands to travel across."

Especially on the verge of starvation.

Sporadic groupings of prickly pear comprised the only potential food she found along the way, and these Dayna had no way to eat. Their needles comprised an impenetrable shield; without her knife, she couldn't hope to reach the moist, fibrous meat within. That, she thought while passing a particularly hardy cactus, was the thing about the land: it looked out for her, to be sure…but it looked out for the prickly pear, too.

The hike out had taken a full day on strong legs; she would never make it back in an afternoon. As the sun dropped and then set behind her, she considered holing up for the night, then decided against it. The thought of falling asleep frightened her; in her weakened state, there was no guarantee she'd wake up. Better to keep trudging on, fueled by whatever residual adrenaline remained, and to use as her guides the moon, the stars and any landmarks they might reveal. Ignorant as she was of the constellations, this wasn't the most reliable system. But it was all she had.

Trembling in the evening chill, Dayna buttoned her jacket. It was possible that she might get turned around and wander the wrong way: off to the north, deeper into the wilderness and, ultimately, to her death. Still, she had a feeling that she'd be all right, that her direction was sound and her life far from over. But what kind of feeling was this that had nothing to do with the cold, hard facts and everything to do with the longings of her heart?

Dayna smiled to herself. *Call it "faith,"* she thought, and pressed on.

Grateful laughter echoed across the plain as the sky brightened and the sun came into view directly in front of Dayna: she was still heading east, had remained on course through the night. Or had she? The range of formations revealed by dawn's light looked familiar…but how could this be? She was returning not to her car but directly to the land adjoining Drake's place! Without knowing it, she *had* gotten diverted in the darkness — but then, with equal ignorance, had righted herself and discovered another way.

The bad news was that she thus had walked farther than she'd needed to, as evidenced by the blisters on her booted but sockless feet. But the good, the *miraculous* news was that an hour's hike now would get her home. Energized, Dayna unbuttoned her jacket and picked up her pace, chasing not her shadow but the rising sun.

Soon she was making her way past the sod tables, traversing the same stretch of land across which she and Kayla had ridden the day they'd met. And there, to the left, was the plateau Dayna later had scaled on her own, acoustic guitar in tow. There atop it she'd stood, serenading the indifferent prairie denizens with a barrage of chords — unable, then, to sing and with no songs in her, anyway. She smiled. *What a difference two and a half weeks make.*

By the time Drake's house, then the stable, then the work shed came into view, an odd notion had wandered into Dayna's head. She thought that she'd been away four days — that she'd spent three nights in the cave and a fourth hiking home — but who was to say? Maybe, like Rip Van Winkle, she'd spent far longer in her mountaintop hideaway. How long had it been for Rip? Thirty years? Forty? Would Dayna return to find Drake long dead…and Kayla a silver-haired matron, recently retired

from a storied career on the Broadway stage? With a chill, she noted that the structures constituting Drake's homestead looked like absolute relics.

But then, they always had; like Drake himself, the place he called home was as scarred on the outside as it was sturdy within. To her further relief, she heard a whinny and, from the sheer vivacity of the sound, knew it had to be Blizzard. Her eyes shifted over to the house; wasn't that Drake's pickup…and Kayla's car beside it? Body aching and head swimming, Dayna nonetheless broke into a full-out run.

The front door opened, and out stepped Drake. Dayna could only speculate as to her appearance, but his reaction made it an easy guess. Stopping on the middle step, keys dangling from his hand, he squinted at her from sixty feet away. "What swallowed 'n' chucked you up?"

She slowed back to a walk. "Badlands."

"Beats comin' out the other way."

Dayna drew closer, her steps now a series of stumbles; Drake's smile faded as he got an inkling of what the young woman had been through. Rushing forward, he caught her as she collapsed into his arms. "You need water," he said, holding her close.

"Yeah." She clung to his shoulders.

"And a decent meal."

"Desperately."

Drake lifted her off the ground, turned and carried her back to the house. "It's OK," he said softly, climbing the steps. "It'll be all right now."

"Did you get my note—to ask Kayla…?"

"I did," he said, maneuvering through the doorway. "So you're Dayna Clay."

"That's right."

He carried her into the kitchen and set her down on the nearest chair. "One question."

"Shoot."

"Who the hell is Dayna Clay?"

She smiled weakly. "The answer's kind of a work in progress."

Drake looked at her for a moment, then lifted his head and hollered up to the second floor: "Rise and shine." Silence. "You hear me?"

A groggy protest from above: "Lemme sleep."

"Get the lead out! There's someone down here needs ya." He turned

back to Dayna— "That should do the trick"—then turned toward the fridge.

She pointed to his keys. "You were on your way out."

Drake pocketed them and opened the refrigerator door. "It can wait."

"Where're you headed?"

"I finished that gigantic bed for that gigantic couple; I'm supposed to drive it out and throw it together today." He poured her a tall glass of orange juice, then set it—along with a huge slice of coffee cake—in front of her. "Hewlett, Wyoming. A day trip, 'bout three hours each way. Though if you need me to stay…"

"I'm not sick or anything," Dayna said, attacking juice and bakery in rapid succession. "Just run down. I'll be fine."

"Yeah," he replied as Kayla, bare-legged beneath a faded Survivor concert T, entered the room. Turning to his bleary-eyed daughter, Drake added, "I expect you will."

She stared at Dayna for a few seconds, then managed, "Your jacket's inside out."

"Yeah, so's my stomach."

"Are you all right?"

"Getting there."

"Be back for dinner," Drake said, taking out his keys again. He gave his daughter a kiss, then—a first—placed one on Dayna's dingy forehead as well. "You staying?" he asked, turning toward the door.

"You bet."

"Welcome home." And with that, he was gone.

Kayla sat down opposite Dayna and watched her eat. "It's…great to see you," she said. "Even…"

"Even like this?" Dayna laughed. "Turnabout's fair play, Ivana. Usually you're the one who looks like death warmed over."

"Touché." Kayla paused. "So, were you…out there? On the land?"

She nodded. "The whole time."

"Y'know, a cold front's coming down from Saskatchewan." Gingerly, Kayla placed a hand on Dayna's jacket sleeve; she ran her thumb across the fabric. "It's supposed to drop, like, fifty degrees tonight."

Picturing herself stuck without so much as a blanket atop a mountain not of mud but of ice, Dayna shivered.

"If you hadn't made it back today…"

"I wouldn't have made it back at all."

She gave Dayna's forearm a squeeze. "Thank God you're OK."

"I'll second that."

"You must have quite a story to tell."

"I do. But first"—she raised her empty juice glass—"I could use a refill."

Kayla rose and retrieved the carton from the fridge.

Dayna tapped her plate. "And more of this stuff, please. Plus a deep-dish pizza, a couple of sirloins…"

"You been on some kind of fast?" Kayla asked, pouring.

"Not on purpose…but, yeah. Four days' worth." She drank.

"Then you should start slowly. Give your system a chance to readjust."

"But I'm still hungry!"

"You can have more in an hour; I'll make ya some soup, I promise. But right now"—she stood—"let's get you washed up. Because frankly, Dayna dear…you reek!"

Kayla led her upstairs. As they passed the window, Dayna could hear the wind whistling outside, rattling the glass; that cold front was moving in already. She stepped into the bathroom, grateful for the warmth of Drake's house and, especially, his daughter. Dayna kicked off her hiking boots and dropped her jacket beside them. She reached to pull off her shirt, then hesitated. "Do you have some paper and a pen?"

Kayla looked back, baffled, then nodded and headed for her room. When she returned moments later, notebook in one hand, blue Bic in the other, she could scarcely believe her eyes. It wasn't that Dayna was standing there by the tub nude, as Kayla had assumed (and hoped) she would be. It was the fact that, nude though she was, Dayna was anything but bare.

She looked as if she'd gotten up during a lecture, stripped, and stepped in front of the presenter's overhead projector. Dayna was covered, from collarbone to ankles, with myriad strings of half-faded gray-brown lettering; her body was a document, a dense assortment of mostly upside-down phrases, abbreviations, musical notes and sentence fragments. She was clothed only—and almost completely—in words.

Kayla eyed her as she might an extraterrestrial. "What *is* all this?"

"They're songs. Parts of songs; ideas for songs."

Most of the writing was fairly distinct, but in a few areas—the insides of her elbows; in between her breasts—it had all but vanished. "You're losing some of it."

She nodded. "Ravages of sweat. Lucky for me yesterday wasn't any warmer."

Kayla reached to touch Dayna's bicep, ran one finger across the S in STORM. "What did you use? Is that mud, or"—sniffing her fingertip—"or blood?"

"Both. I tried them separately; the mud was too flaky, and the blood was too thin. But when I mixed 'em together…" She raised her arms in triumph. "Voila!"

"Blood? Are you wounded?"

"Six days a month."

"Oh." Kayla seemed unable to stop staring. "So…what do we do now?"

Dayna took the notebook and pen and stepped into the tub. "Grab a wash cloth, and soak it in warm, soapy water. We'll take it from the top: I'll write 'em down, and you wipe 'em off."

This proved an effective if unorthodox system of transcription. Clearly, Dayna had succeeded in choosing the precise words needed to jog her memory, for as Kayla read aloud and then wiped off each title, topic or theme, the corresponding song came hurtling back to mind. Dayna scrawled out line after line of notes—verses, refrains, the occasional chord pattern—Kayla patiently waiting, time and again, for the mumbled directive, "Next."

Forty minutes and eleven pages later, Kayla pronounced their task complete…but then noticed a final, faint scrawl all but hidden in the small of Dayna's back. "Wait; there's one left. Why on earth did you put one here?"

"I'd used up all the room in front."

"It's all…sweated off."

"Shit. Can you make it out?"

"Looks like 'Tackle ten,' or 'Jack antler'…no: 'Jack-o-lantern?'"

Dayna nodded, then began to write.

Kayla wiped her clean. "What kind of song is that?"

"A love song."

"'Jack-o-lantern'—a *love* song? For who?"

"For someone who wears a frightening face, a Halloween face, because it's her job; it's the part she plays." Dayna set down the notebook and pen. "But inside her, there's this...glowing light"—she turned to face Kayla—"a light so steady, so warm and bright that even at her 'scariest,' it shines right through."

"That's sweet. But..." Kayla rolled her eyes—"Jeez"—and tossed the wash cloth aside. "Someone finally writes me a love song, and that's the central image?"

"Could've been worse. I was *gonna* call it 'Pumpkin Head.'"

Kayla reached quickly for her cornered companion and inflicted a punitive tickle. With a shriek, Dayna grabbed her wrists; laughing, the two struggled briefly before falling—inevitably, gratefully—into each other's arms. Their mouths met in a kiss as anxious as it was ardent; Dayna had wondered, in the cavern, whether she would ever have this chance again, and the urgency with which she now clung to her beloved was palpable. "It's all right," Kayla said, "I'm"—but that was all she got out before her lips were subsumed once more.

And so Kayla spoke instead with her hands, running them over the now-blank page of Dayna's body and making, there, fresh discoveries. Here, the gentle dip of stomach into navel and out again...there, the startling pliancy of buttocks freed from their armor of denim and dried mud...here, the lovely row of three, four, five ribs that surfaced as Dayna, yielding, arched her back: a musical stanza needing only the notes that Kayla's own fingertips could provide. Hastening to find and play each note in turn, she leaned in close and murmured a single word: "Fan*ta*stic."

Dayna's shoulders tensed, then relaxed at the first contact with her breast; Kayla's hand lingered, stroking the tender underside before moving lower, then lower still. Soon Dayna felt a single finger tracing the space around her hipbone, then a thumb swinging inward, easing its way toward the tufted juncture of her slender legs.

Weak-kneed to begin with, Dayna placed her palm to the wall for support. She was in no condition for any of this. Prudence told her that a long nap was what she needed...but the rest of her told her something else. Despite all she'd been through, what she felt now was less exhaus-

tion than exhilaration. *Besides,* she thought, *if I fall, Kayla will catch me*—just as her father had done an hour before.

She shifted her stance, parting, and all at once Kayla was inside her, one eager finger and then two, exploring, caressing, curling up and pressing into a space that robbed Dayna of her very breath. With an almost musical moan she closed her eyes, a willing slave to the waves washing over her, the flashes and sparks coursing through her. Kayla's touch was more direct than expected, and her technique relentless, but Dayna was not afraid. Indeed, she'd never felt less fear with, or more trust in, anyone in her life. For it was a trust devoid of qualms or conditions—a trust sanctified by love.

"I am this body," Dayna said softly. With only the slightest hesitation, she removed her left hand from the tiled wall. "And this body," she continued, voice shaking, "is yours." An early, anticipatory tear fell as Dayna raised her palm slowly, steadily in front of Kayla's face; a second tear followed—and a gasp escaped her—as her lover's lips found their mark.

Her body sang; her heart soared; her voice fell to a whisper.

"*All* yours."

TWELVE

FIFTY TO SIXTY VOICES chanted Dayna's name, casting the two syllables in fervent unison toward the twenty-eight-year-old singer as she paused between songs to re-tune. Her task still in process, Dayna stopped, swatted at her forearm—but missed her target. She watched helplessly as her tiny tormentor, victorious and engorged, rose buzzing before her and flitted away.

Mosquitoes. She'd forgotten about the fucking mosquitoes.

Holding a free, unpublicized concert on the wooden Wishing Bridge back in her old hometown had seemed such a good idea. And actually, bugs aside, it was turning out well; the acoustics were good, the mid-September weather pleasant and the woodland setting—complete with babbling stream beneath—ideal for Dayna's current wide-open-spaces sound. As for audience response, the jury was still out; some members of the quickly growing, primarily teenage crowd applauded her hits (like the just-played "Virtual Virtue") but appeared ambivalent about Dayna's latest material, while others eagerly devoured old and new alike.

Unfortunately, they weren't the only ones eating her up. *My kingdom*, Dayna thought, *for some Deep Woods Off.*

"Thanks," she said, running a hand through her dense chestnut hair. Glancing to her side, she met the gaze of her sole accompanist: a boy half Dayna's age standing just to her right with a guitar of his own. He

had, on two occasions, ably carried Dayna's musical torch in her absence, so she'd thought it only fitting to fly him out for the re-launching, such as it was, of her career. She owed him that much.

But did she owe him *this*? "Ouch!" Justin yelped, slapping the side of his neck.

Dayna smiled serenely. "Having fun?"

He smirked—"What's *left* of me"—and shook his head. "The 'great' outdoors."

"It is. But don't ever mistake it for paradise."

Justin rolled down his shirt sleeves. "Don't worry."

Returning her attention to her instrument, Dayna tried a chord; her low E still sounded flat. As she tuned up, the silver band on her left ring finger tapped against the neck of her guitar, reminding Dayna of the matching engagement ring currently residing on a movie set some 2,500 miles away.

It was serendipitous, she thought, the way things had worked out. Kayla had read for the part Dayna had turned down, and though the director had found her too young for that role, he'd been impressed enough to offer her another. It was a small part—two scenes, forty lines—but a good one, the kind that just might get a promising newcomer some well-deserved notice. Dayna missed her now, wished Kayla could be there with her, but took heart in the knowledge that they'd both be home in Rapid City by week's end.

"So are we playing," Justin asked, scratching his neck, "or what?"

Yanked from her reverie, Dayna tried the chord again: perfect. She nodded at Justin, then addressed the crowd: "One more song—just as soon as I figure out which one!—and then we're gonna call it a day." She paused. "I…can't tell you how much it means to me that you guys came out…"

"Dayna!"—a girl seated up front. "When do you tour?"

"No tour," she answered quickly. "I'll be playing two or three dates once the new record's out—benefit concerts, y'know, sharing the bill—but that's it, at least for now." She adjusted her strap. "I may tour again somewhere down the line, but not till it feels right. And I can't imagine that'll be any time soon."

The crowd was still. A couple of kids began talking softly, one to the other.

"I don't expect everyone to understand." Dayna cleared her throat. "Seeing me here like this, you probably assumed I had 'come back.' But that's...not quite right."

She looked out; seventy-some puzzled faces stared back. Bowing her head, Dayna gazed at the supposedly magical planks beneath her feet, wishing she knew what to say—then reminded herself that she didn't believe in wishes, had lost that belief in this very place. If you wanted something, you had to make it happen. She took a deep breath and started again.

"The date of this performance...it's no coincidence. It was a year ago today, in a garage in Chicago, that...that the woman you knew as Dayna Clay tried to take her own life. You've heard that her attempt failed. Well"—she glanced around the crowd—"don't believe everything you hear."

Several of the puzzled faces turned toward one another.

"In a sense," Dayna continued, "she succeeded; *that* Dayna Clay no longer exists. The woman who stands before you—the one who made her way out of that garage, and then out west, and eventually ended up back here—that woman is someone different. Same name, same voice, same face, same body. But the rest..."

She trailed off; the audience remained hushed. She glanced over at Justin, who himself was watching with rapt attention. Dayna took a breath and continued.

"I'm not sure if this new Dayna Clay's gonna be what you're looking for. She's less angry, and she's less ambitious...come to think of it, there may be a connection there. She's pretty much given up on vendettas—doesn't have the stomach for 'em. Some will say she's too tame, she's lost her edge. Others..." She stopped. What *would* others say? "Others..." Brow furrowed, Dayna stared down at her guitar. "Others will say..."

A voice from the crowd: "We'll take her." The comment generated a round of supportive applause, along with a chorus of agreement:

"Sure will."

"You know it!"

"As is, Dayna. As is."

Moved almost beyond words, Dayna swallowed and managed three: "You've got her." Then, with a gracious smile, she lifted her head and

unleashed the opening chord.

The audience eased back into an attentive silence. After the first few measures, Justin set down his instrument and, intrigued, joined the ever-growing assemblage across the bridge, for Dayna hadn't yet taught him this song. Indeed, none of the eighty-plus people there had heard the piece before. Even so, its melody—minor-key yet oddly, bravely buoyant—seemed to first capture, then enrapture the entire crowd.

Debuting material in concert was inherently stressful, yet Dayna couldn't recall a performance during which she'd felt more relaxed, more at peace, happier to be alive. The road she'd traveled had been tortuous, but she was thankful for all she'd learned along the way…and thankful, too, that it had led her to this spot, this audience, this day. There were no T-shirt concessions here, no lasers or fog machines, spotlights or strobes: just a young woman standing tall on the sun-bleached planks of an old, wooden bridge, strumming her guitar and launching her solitary voice into the clear autumn sky:

> *Hand over hand I ascend in a land*
> *Where nothing is set in stone*
> *Progress is slow, and all that I know*
> *Is how little can ever be known*
>
> *Hunger and thirst are more blessing than curse*
> *They remind me that I am alive*
> *So I struggle and try, but the summit's so high*
> *It's uncertain I'll ever arrive*

A sparrow glided by; a pair of squirrels gamboled on a branch to Dayna's left. She closed her eyes and raised her voice, her radiant contralto now fully enmeshed with the chirps and chatter above, the gurgling current below:

> *And I'm miles from a friend or a phone*
> *Yet I'm equally far from alone*
> *If the foundation beneath me gives way*
> *God give me faith in my own.*

AUTHOR'S NOTE

I was aided greatly in my work by four outstanding books: *Badlands: Its Life and Landscape*, by Joy Keve Hauk; *Bi Any Other Name: Bisexual People Speak Out*, edited by Loraine Hutchins and Lani Kaahumanu; *Shamanism as a Spiritual Practice for Daily Life*, by Tom Cowan; and *Trauma and Recovery*, by Judith Lewis Herman, MD.

YOU'VE READ THE NOVEL; NOW, HEAR THE SONGS!

One way in which I developed the character of Dayna Clay was by composing several songs from her point of view, lyrical excerpts of which appear throughout *Unplugged*. Subsequently, I assembled some musician friends (including a dynamite singer) and produced a studio recording of "Dayna and band" performing these songs.

To order, specify CD or cassette and send $12 per copy, postage included, to: Paul McComas, P.O. Box 622, Evanston, IL 60204-0622. (Illinois residents add $0.90 state sales tax.) A portion of the profits benefits the Badlands Natural History Association (605–433–5489) and the Rape, Abuse and Incest National Network (RAINN) (800–656–HOPE).

For more info on *Unplugged*, visit www.paulmccomas.com